Beginner's Guide to Color Photography

Also by Ralph Hattersley:

Beginner's Guide to Photography

Beginner's Guide to Darkroom Techniques

Beginner's Guide to Photographing People

Beginner's Guide to Color Photography

RALPH HATTERSLEY

Dolphin Books Doubleday & Company, Inc., Garden City, New York 1979

To Steven and Meryl Wein

Library of Congress Cataloging in Publication Data
Hattersley, Ralph.
Beginner's guide to color photography.
1. Color photography. I. Title.
TR510.H34 778.6
ISBN: 0-385-14089-4
Library of Congress Catalog Card Number 78-22322

BOOK DESIGN BY BEVERLEY GALLEGOS

Contents

• Where Color Comes From 11

Color Is Light
White Light
The Light Primaries
The Additive Primaries
Color by Subtraction
The Subtractive Primaries
A Color Wheel
Complementary Filters
Kinds of White Light: Eye Adaption
Color Temperature and Color Balance
Color Temperature Conversions
Light Color·Changes

• Reversal Color Film 29

Meaning of Reversal
Three Emulsions
Color Formation
Color Balance and Color Shifts
Over- and Underexposure
Black-and-white Negatives
Exposing Color Reversal Films
Colors from Light

• Color Negative Film 37

Negative to Positive
The Kodacolors
Color Balance
Exposure Latitude
The Film
The Negative
Choices

• Matching Film to Colors of Light 53

Neutrals and Caucasian Skin
What Colors Can You Get?
Ultraviolet (UV) Filters
A Personal Daylight Color
Monochrome Color Pictures
Daylight Colors
Dramatic Sunrises and Sunsets
Cityscapes After Dark
How Green Was My Valley
Fluorescent Lighting
Filters or Not
Daylight Film in Tungsten Light
Tungsten Film in Daylight
Theatrical Gels
Conversion Filters

CONTENTS

• Using Flash 75

Guide Numbers
Kodachrome 25 Guide Numbers
Electronic Flash Guide Numbers Based on BCPS
Computer Dials and Charts
No Information
Flash Modes
Problems with On-camera Flash
Bounce Flash
Bare-bulb Flash
Electronic Flash
Automatic Thyristor Units
Color Temperature
Angle of Coverage
Synchronization
Freezing Action
Fill-in Flash
Electronic Flash Meters
Umbrellas
Two-light Flash

• More About Exposure 105

The Law of Reciprocity
The Correct Exposure
The Reciprocity Effect
Stop Language
More About Gray Cards
How Color Reversal Film Sees an Exposure
Palm Readings
White Card Readings
Substitute Readings
Reflectance (Averaging) Meters
Incident Meters
Existing-light Starting Exposures
Film-speed Comparisons

Extension-tube Correction Factors for 35mm Cameras
Exposure for Color Television
Speed Pushing with Kodak E-6 Color Films

• Processing Ektachrome Film 125

Equipment
Capacity of One-pint Kit
Mixing Solutions
Time, Temperature, Agitation, and Solution Strength
Proper Temperatures
Proper Timing
Loading Reels and Tanks
Agitation: Invertible Tanks
Agitation: Noninvertible Tanks
The Processing Steps
What Happens in the Baths
Variable Speeds with Process E-6
Other Data in the E-6 Instruction Pamphlet

• Making a Cibachrome Print 145

What You Need for Cibachrome Printing
Your First Print: The Process in Brief
The Standard Color Slide
Identifying the Emulsion Side of a Slide
Color Correction
Basic and Adjusted Filter Packs
Cibachrome Chemicals
Identifying the Emulsion Side of the Material
The Reciprocity Effect

Test Print
To Make Changes in a Print
Other Factors That Can Make Changes in Your
 Prints
Latent Image Stability
Judging a Cibachrome Print
Standard Processing at 75F. ± 3 Degrees
Other Processing Temperatures and Times
Handling Cibachrome Print Material
Measuring Chemicals
Consistency
Comparing a Slide and a Print
Adjusting the Filter Pack
Exposure Corrections
Exposure and Processing Faults
Retouching
Mounting Prints
Color Compensating (CC) Filters
Dichroic Color Enlargers
Cibachrome Easy

• Some Questions to Ask Yourself 189

Backgounds
Distance
Camera Angle
Selection
Cropping
Camera Steadiness
Depth of Field
Freezing Action
Focus
Light
Color
Number

Emphasis and Subordination
Prettiness
Right Timing
Idea

• Judging Your Pictures 197

Beauty
The Ugliness Problem
I Like It: The Irrefutable Standard
Faithful Color Reproduction
Stimulus to Memory
Accurate Description
Stimulus to Thought
A Specific Message
Fulfillment of Purpose
Good Composition
Effective Propaganda
Documentation
Interpretive Photography
A Decisive Moment
Self-expression
Poetry

• Storage and Care of Film and Slides 217

Store in Original Package
Warm-up Times
Protection from X-rays
Protecting Film After Opening the Package
Desiccating Film with Silica Gel
Protection of Processed Films
Cleansing Films
Conclusion

This is my fourth Doubleday book for beginners in photography and is thus somewhat more advanced than the others. To fill in your photographic background you should read *Beginner's Guide to Photography, Beginner's Guide to Darkroom Techniques,* and *Beginner's Guide to Photographing People.* The first will get you started in photography. The second tells you all about black-and-white printing. And the third tells you how to handle people.

This book is about color photography, a very complex subject. However, the material is greatly simplified and at the same time comprehensive. You will learn all that you need to know—no more, no less. If the writing is a little bit sticky at times, bear with it. Had I simplified it further you just wouldn't see what color photography is all about, and that would be a shame. It is a fascinating subject that deserves to be discussed in considerable detail. So read on and enjoy yourself.

Ralph Hattersley

Where Color Comes From

Oddly, color photography is extremely complex, yet it is the place where most people begin. The complexity is well-hidden, so to speak, and doesn't really bother beginners at all. In fact, they don't even notice it and have no direct way of finding out about it. They just shoot their pictures, take them to the drugstore, and in a few days pick up the results, which are usually to their satisfaction. If they are entirely pleased with what they see, there is no need to investigate the complexity that underlies what they do so easily.

Such beginners can work in abysmal ignorance of what color photography is all about and never even notice the difference. In fact, the photographic manufacturers have intentionally made this possible so that they can sell more equipment and materials. From another viewpoint, they have given essentially ignorant people free access to the wonders of photography. You don't have to know much to make fairly good pictures.

However, if you wish to make really good pictures you may have to know a fair amount about color, especially if you wish to make prints. For printing, a substantial knowledge of color materials and processes is imperative. Even if you just wish to shoot pictures and let the drugstore's lab (Kodak, Berkey, etc.) do the rest, you may have to know what you are doing in order to get the results you want.

The starting point is to see where color comes from and what its nature is. From there we will see how this information is embodied in color materials and processes and how you yourself can use it in order to get the results you want.

● Color Is Light

All the color that you see is light, pure and simple. And when there is no light there is no color. We think we see colored *things*, and in a sense we do. However, it is more accurate to say that we see the colored light reflected, transmitted, or emitted by things. It is the light alone that we see, not the things themselves. Thus our only visual contact with things is through light, light that enters our eyes.

Psychologically, we project ourselves out to things and seem to contact them somewhere in front of ourselves, but this only confuses what actually happens. By reflection, things project their colors into our eyes, and this is where we see them. The only colors that we see are light, and as we are seeing them this light is falling on the retinas of our eyes. Were it not for light and the light-sensitive retina, we would see no color at all. Remember: color is light.

● White Light

We are mainly familiar with so-called white light, which will shine on a white sheet of paper and make it look white and nothing else. Actually, white light contains the most vivid colors, though

this is impossible to see directly. Indeed, it is almost impossible to even imagine that this is so, although an understanding of color photography demands that you do so.

The truth is that all of the colors, all of them vivid, are in white light. That is, white light is made up of these colors and, oddly, they are what make it look white. It is traditional to think of white as no-color, but it is more accurate to describe it as all-color. If one of the hues is missing, you won't have white light but a chromatic color—blue, for example. If yellow is missing, you will have blue light. If magenta (bluish red) is missing, you will have green light. If cyan (greenish blue) is missing, you will have red light. And so on . . .

As you read on in this book it will be helpful for you to think of a color (colored light, remember) as being white with something missing. For example, blue is minus yellow, as we have already seen. Conversely, yellow is minus blue. Remember also that all color is light. Finally, white light is all-color—that is, a combination of all colors in certain proportions.

• The Light Primaries

Though white light is made up of all colors, you need only three basic ones, called light primaries, in order to create it. They create white light and all the other colors as well. These so-called primaries (or hues that you can start with to get everything else) are red, blue, and green. With these three colors of light you can get any color you want, including white.

For example, imagine a red, a green, and a blue spotlight shining on a white wall in a darkened room so that their circles of light partly overlap. There are places where only two colors overlap (as in the illustration on page 17), and one place where all three do. In the three areas of two-color overlap you get three distinctly new colors—magenta, cyan, and yellow. Red plus blue

gives you magenta, or bluish red. Blue plus green gives you cyan, or greenish blue. And green plus red gives you yellow, or greenish red. Where all three primaries overlap you get white.

At this point we find a fly in the ointment—it is very difficult to believe that red and green light would create yellow, but such is the case. Moreover, it is difficult to think of yellow as greenish red, though that is what it is. The thing is that it looks neither greenish nor reddish but seems to be something quite separate from either of the light primaries that create it.

In order to keep yourself oriented in the material that follows, it would help if you remember most of the things you have just read. Specifically, magenta is bluish red, cyan is greenish blue, and yellow is greenish red. This will help you remember the colors of light that make up magenta, cyan, and yellow, which are called the light secondaries, which means that they are what you get when you mix the primaries. They are second-step colors where colored light is concerned.

• The Additive Primaries

The additive primaries are simply another name for the light primaries. The new name indicates that you can add certain light colors to each other to get distinctly new hues, which we have just seen. That is, you can get new colors from the primaries by addition.

At this point you should know that color films and papers have three separate emulsion layers, sensitive respectively to red, blue, and green light. Since they are sensitive to the light primaries, they will, when working together, record all colors. In these emulsion layers three separate, exactly superimposed images are formed. Viewed simultaneously, they will give you a full range of color.

However, the color formation is not direct. For example, in a typical color slide film a cyan

image is formed in the red recording (or record) layer, a yellow image in the blue record, and a magenta image in the green record. It is these three dyes—cyan, yellow, and magenta—that give you all the colors you see when you project a color slide. They are called the subtractive (as opposed to the additive) primaries.

● Color by Subtraction

We have seen that color is white light that is missing something—for example, blue is white light minus yellow (or red plus green). Now, it happens that certain objects can subtract (or absorb) some of the hues from the white light that falls upon them. For example, a vividly blue ball subtracts (absorbs) the yellow (red plus green), making it invisible, so that only blue light is reflected from the ball. This is why we see it as blue. Something has been subtracted from the white light falling on it.

All the colors that you see in things—objects, dyes, pigments, etc.—are due to subtraction. This is true whether we look at them or through them—i.e., view them by reflection or transmission. For example, if you look at an apple or through a color slide you are experiencing the results of subtraction. Some colors are subtracted from white light to give you the colors that you see. As already suggested, the subtracted colors are themselves invisible. In effect, they no longer exist after subtraction.

● The Subtractive Primaries

Remember that primaries are the colors you start with to get all the other colors, which is why they are called primary. They are the basic starting points. Two primaries mixed together will produce a secondary, or second-step, color. Remember that the additive (light) primaries are red, blue, and green. When you are working with light they will produce all the other colors, as we

have seen. However, they won't do this when you are working with dyes or pigments. For example, red and green dyes cannot be mixed together to produce yellow, though red and green lights will create that color.

For colorants (dyes, pigments, colored things) we need another set of primaries, which happen to be magenta, cyan, and yellow. They also happen to be the additive (light) secondaries. You can mix colorant primaries together to get the other colors. For example:

magenta + cyan = blue
cyan + yellow = green
yellow + magenta = red

These colorant primaries—magenta, cyan, and yellow—are called subtractive because they work by subtracting certain colors from the light falling upon them. The colorant secondaries—red, green, and blue—also subtract certain colors of light. As we have seen, anything that is colored is subtracting something from light. Grouping the colorants (dyes, pigments, etc.) together, we find that subtraction goes on as follows:

red subtracts green and blue (or cyan)
magenta subtracts green
blue subtracts green and red (or yellow)
cyan subtracts red
green subtracts red and blue (or magenta)
yellow subtracts blue

The amount of subtraction that a specific color can do depends on its hue. Each of the subtractive primaries—magenta, cyan, and yellow—subtracts one third of the visible spectrum. Each of the subtractive secondaries—red, blue, and green—subtracts two thirds of the spectrum.

The idea of color by subtraction is a little bit sticky, but you must accept it in order to understand how color photography works. Its whole structure nowadays is built primarily on so-called subtractive processes. In other words, color photography depends on getting color by subtraction. There were systems for getting color by addition, but they are no longer in general use.

15

● A Color Wheel

It is convenient to make a graph of the colors in the form of a wheel containing two overlapping triangles (see illustration on page 18). This wheel can help you keep your facts straight, which is no easy task. Though both additive and subtractive effects can be explained with one wheel, it is best to call it a subtractive color chart and let it go at that. This is because color materials embody mainly subtractive effects.

Partly, it is a diagram showing how dye or pigment colors can be mixed from the subtractive primaries. Any two primaries will produce the hue between them on the wheel. For example:

> yellow + magenta = red
> magenta + cyan = blue
> cyan + yellow = green

Equally important, the wheel shows the color pairs that will neutralize each other. They are called complements (or complementaries) and are located right across from each other on the wheel. When colorants are fully neutralized you get grays or blacks, which are called neutral densities. As you can see, the neutralizing pairs are:

> yellow and blue
> red and cyan
> magenta and green

Depending on the relative strength and amounts of these pairs, the neutralization may be either full or partial. For example, equal amounts of full-strength green (cyan + yellow) and magenta dyes will yield a fully neutral density, whereas a weak green and a strong magenta would product a grayish magenta.

● Complementary Filters

The information on the color wheel with respect to which colors are complementary is mainly applied in color photography by the use of color filters, which contain dyes. Overlapping two filters will give you the same effect as mixing two dyes of the same hues. The filters, which are used both in shooting and printing, give us a way of subtracting color from light before it reaches a photosensitive material. For example, if you wished to subtract blue from light, which is sometimes the case, you would use a yellow filter.

In shooting you use color filters for subtraction now and then. In printing you use them all the time, always to subtract a particular color. You can decide which filter color(s) will subtract it by finding its opposite on the color wheel. For example, if you wish to subtract some magenta from the enlarger light you would use a green filter (actually, a cyan + a yellow, which makes green, unless you are using CC filters—this will be explained later).

● Kinds of White Light: Eye Adaption

So far we have talked about subtracting color from white light but haven't said what white light is, except to say that it makes a white thing (paper) look white. This would seem to be a sufficient definition, but it's not. It happens that the eye will accept all kinds of things as being pure white from a light source. It adapts to fairly substantial color shifts in a presumed white light source and doesn't even notice their effects on white objects. Thus a white piece of paper may be tinted with any of the colors without your being able to detect it. This eye adaptation to a color shift is automatic and almost impossible to overcome.

Unfortunately, color films and papers can't automatically adapt themselves to color shifts in light sources. A given material is "balanced" for a particular kind of white light, and any other kind will produce noticeable color shifts in the images. Thus white or gray things won't look neutral at all, and colored things will have a cast of the wrong color, often quite obvious.

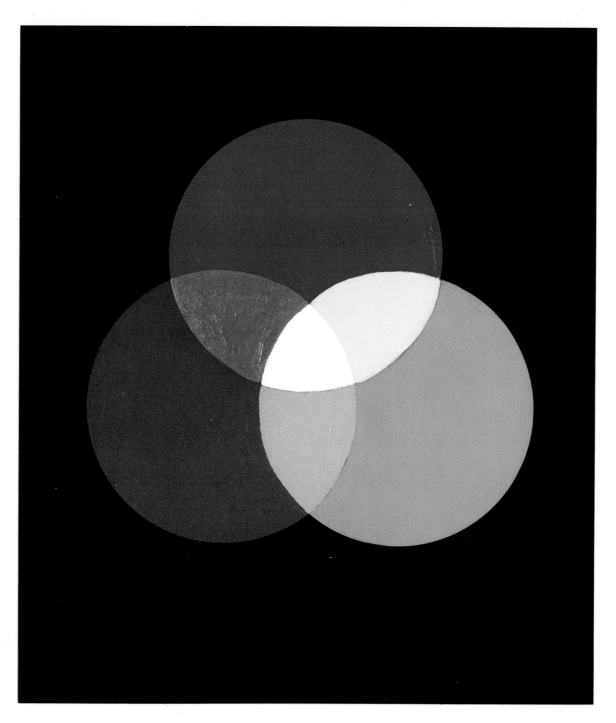

A painting showing red, green, and blue spotlights overlapping on a white wall in a darkened room. Note that yellow is produced when red and green overlap, though this seems improbable. Where all three colors overlap we get white, also improbable. Red, green, and blue are the light primaries. By mixing these colors of light you can get all the other hues.

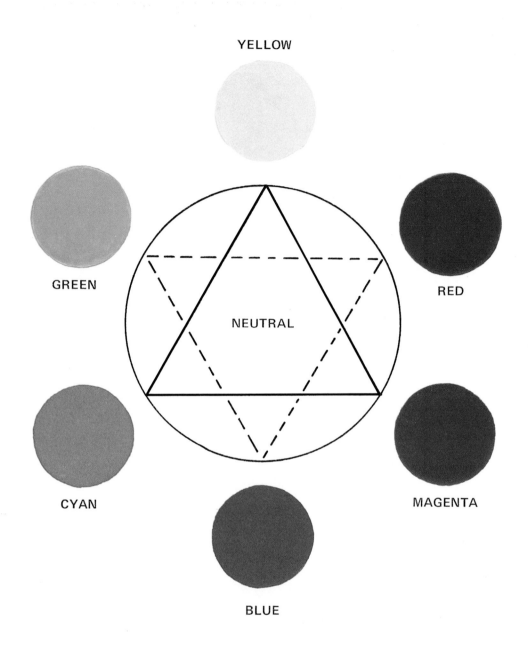

YELLOW

GREEN

RED

NEUTRAL

CYAN

MAGENTA

BLUE

SUBTRACTIVE COLOR CHART. A color wheel for pigments and dyes. Solid lines connect the subtractive primaries; dotted lines, the subtractive secondaries. Hues directly across from each other on the wheel, called complementaries, produce neutral colors when mixed together. Any two primaries, when mixed, will produce the secondary between them on the wheel. This diagram is mainly of use in color printing, because it tells you what hues are produced when colored filters are overlapped.

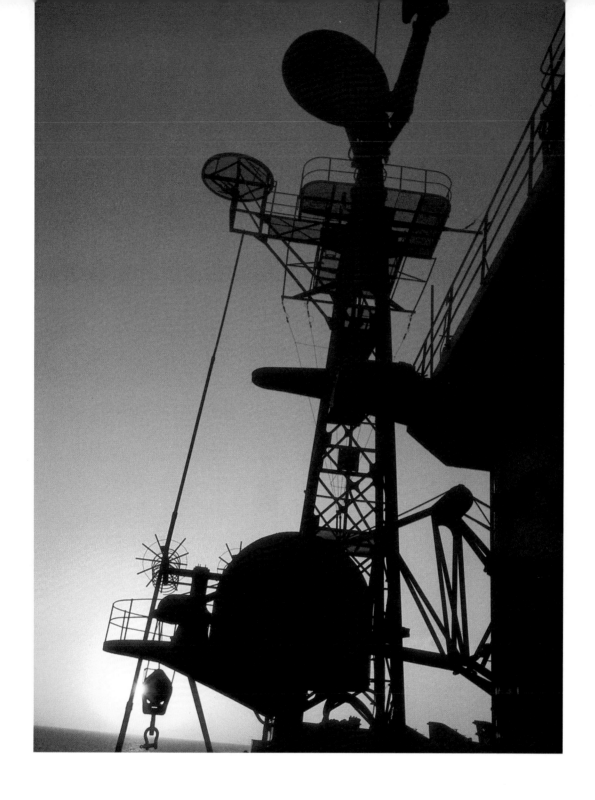

A silhouette is especially effective at sunset. The black radar mast in this picture is beautifully set off by the evening colors.
[Photo by Douglas E. Throp]

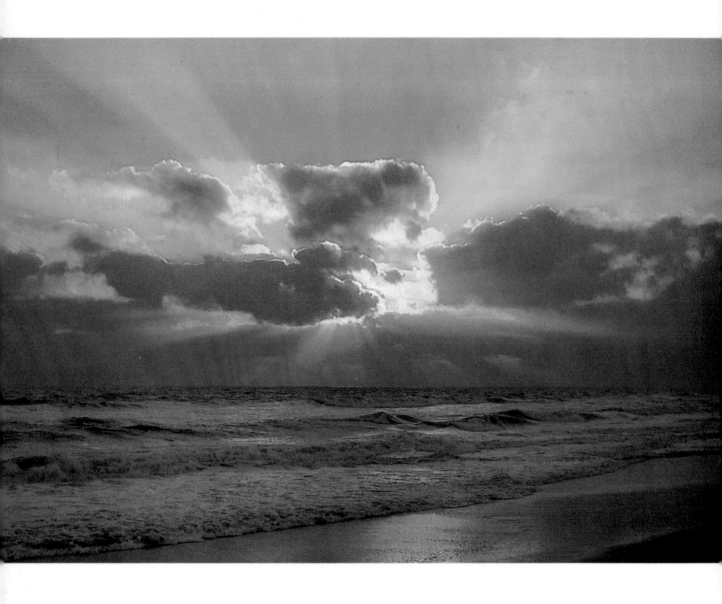

The dramatic light in the cloud reminds one of a biblical drama, possibly the story of creation. Here we see that light as such can be very beautiful.
[Photo by Dale Strouse]

Ancient Indian buildings mirrored in a pond. Because the sky was slightly hazy the sun came out as a soft white blob.
[Photo by Michael Flinn]

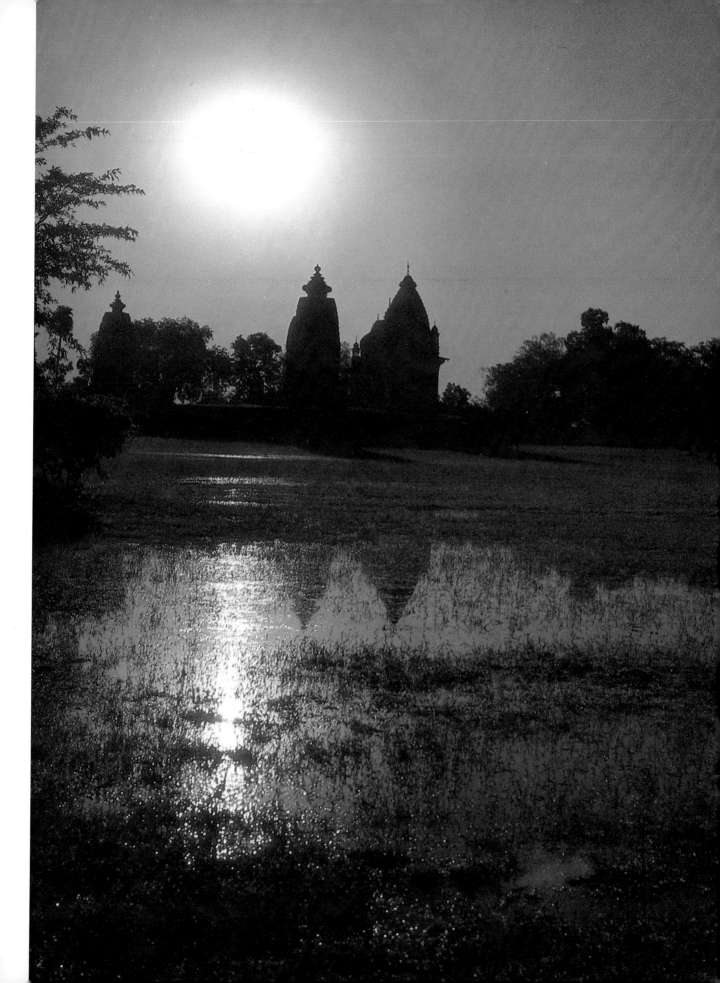

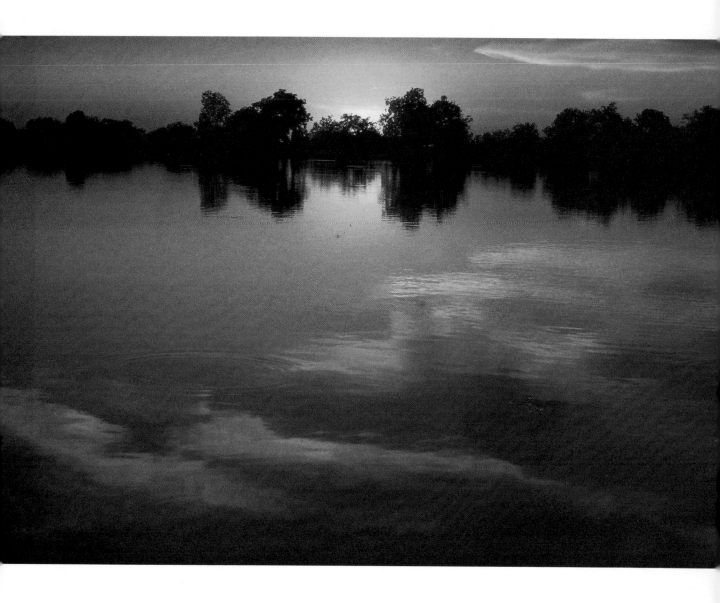

Though this picture is primarily about light, we see mainly
large dark areas, which emphasize the light. You can get
this effect by underexposing quite a bit.
[Photo by Benton Collins]

Unseen clouds in the sky are reflected in the water. They
come out soft, sensuous, and beautiful. The evening
color is unbelievably rich.
[Photo by Michael Flinn]

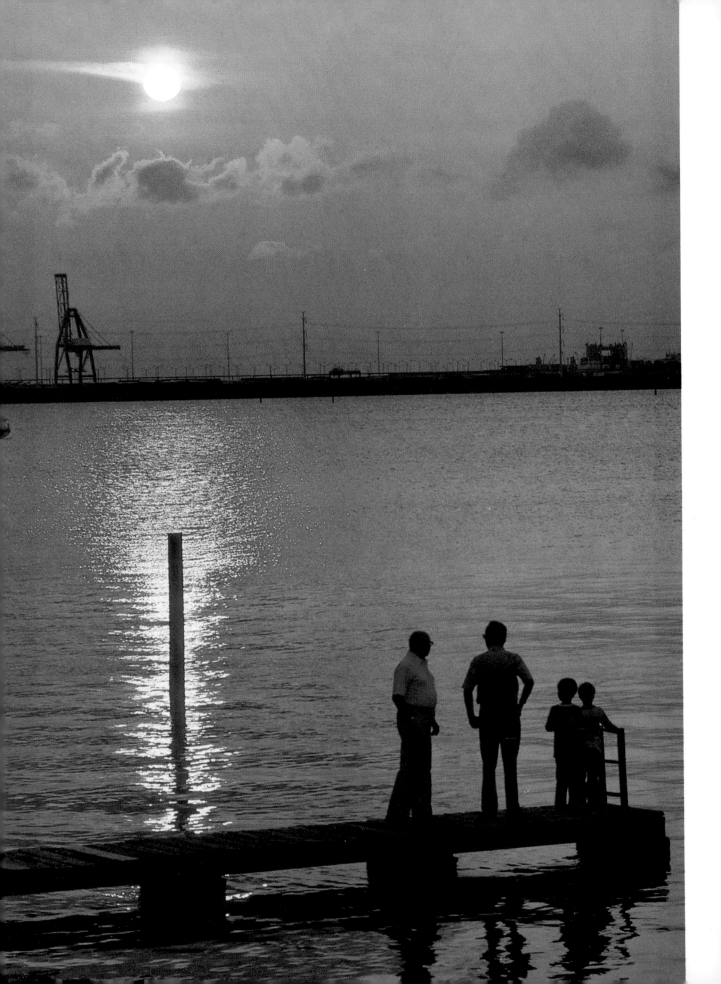

The long post silhouetted against the light path in the
water seems to point at the sun. The figures on the pier
seem almost secondary.
[Photo by David Howland]

● Color Temperature and Color Balance

Before getting to the color balance of color materials, we must investigate the notion of color temperature. Technically, this is a way of describing the color of light emitted by a material such as tungsten when heated to incandescence, as it is in a light bulb. According to their wattage, some bulbs burn hotter than others and have higher color temperatures, which are expressed in degrees Kelvin (K).

In photography, hot bulbs are favored because they produce intense light. Naturally, color films are balanced to these desirable bulbs, the two selected for this being rated at 3200K and 3400K respectively. Outdoor films are balanced for 5500K, which is considerably more bluish than light from tungsten bulbs.

When we speak of color temperature we are referring to light that ranges from very yellowish white (low-wattage tungsten bulbs) all the way up to very bluish white (daylight at noon, which is a combination of sunlight and skylight). There are higher color temperatures than daylight, but they needn't concern us here.

As we have seen, a color film, daylight or tungsten, is balanced for a specific color temperature. Shot at a higher color temperature than it is balanced for (more bluish), it will have a bluish cast. Shot at a lower color temperature (more yellowish), it will have a yellowish cast. Printing papers are balanced for enlarger light bulbs, which usually emit light that is moderately yellowish.

● Color Temperature Conversions

Offhand, it would seem that you should expose a given roll of film to only one color temperature of light source, which you can often do without any problem. There are times, however, when you may wish to use light sources of different color temperatures—for example, when you wish to expose part of a roll of tungsten film outdoors.

Fortunately, the color temperature of light can be changed before it reaches the film by the introduction of a color filter over the camera lens. Kodak filters are available for this purpose.

KODAK CONVERSION FILTERS

To Convert	Use Filter Number	Filter Color	Exposure Increase in Stops
3200K to Daylight (5500K)	80A	Blue	2
3400K to Daylight (5500K)	80B	Blue	1 2/3
3800K† to Daylight (5500K)	80C	Blue	1
4200‡ to Daylight (5500K)	80D	Blue	1/3
Daylight (5500K) to 3400 K	85	Amber	2/3
Daylight (5500K) to 3200K	85B	Amber	2/3

† Aluminum-filled clear flashbulbs such as M2, 5, and 25
‡ Zirconium-filled clear flashbulbs such as AG-1 and M3

Note that the use of a filter requires an exposure increase. However, if you take your exposure reading through the filter it will usually give you an exposure that is accurate enough. Increases for flash exposures can be made by opening the aperture the appropriate amount or by using a new flash guide number from the information sheet that comes with the film.

● Light Color Changes

As you have seen, the notion of color temperature—which is applied to a yellowish-to-bluish range of so-called white light—is used mainly in

shooting pictures. All the changes are either toward blue or toward yellow. However, the color of white light can be changed in any direction by the use of color filters. For example, it can be made yellow, red, magenta, blue, cyan, or green, which includes all the basic colors. The fact that this is true is critical in color printing, where you may need more than a simple color temperature shift. For example, you may wish to reduce the magenta from an image by using both cyan and yellow filters. This is indeed a color shift, but we don't think of it as especially involving color temperature, which concerns the yellow-to-blue spectrum. The term is rather strictly limited to describing light sources (usually "white") that are used for exposing pictures.

Perhaps the main reason for knowing about color temperature is that it helps you pick the light source for which your film is balanced or to pick the appropriate filter for changing the color of the light to make it usable with your film. This is not a negligible matter, but it is only a small part of the color filter story. The significant thing is that you can make white light any color you please by using color filtration. Chromatic colors can also be changed.

Reversal Color Film

In order to work effectively in color photography you need to know something about the materials you use. Though there is a great deal to know, you don't need all of it—but you definitely do need some. For example, you need to know roughly how a reversal film is constructed and what makes it work.

● Meaning of Reversal

Any film that will directly produce color slides or other transparencies for viewing or projection is of the "reversal" type. The name comes from the fact that tones and colors in the film are reversed during processing. In a typical Ektachrome-type film the image first produced in processing is not reversed but is negative. Indeed, it is a black-and-white negative much like any other. Projected, it would give you a black-and-white negative image, which is not what you want. This image is produced in the first developer. To make it right it has to be reversed to positive, which is done in the second developer.

First, there has to be a reversal exposure to light, though this can also be done chemically. Then the second (or color) developer will produce a positive image, this time colored, in conjunction with the silver negative image that already exists. This second image consists of both silver and dye. When the silver from both images

is bleached out, there remains only a positive dye image created by both the reversal and the chemicals. This is why films such as Ektachrome are called reversal types. Remember that this term applies to any film that produces a positive color image when used in the ordinary way.

● Three Emulsions

For a wide variety of reasons, modern color films are masterpieces of manufacturing science and technology. A typical film has a thin plastic base with numerous layers of stuff coated on it so evenly that manufacturing tolerances for thickness may be measured in a few millionths of an inch. Including the base itself, the average film has nine or more layers of stuff and is still very thin, as you have probably seen for yourself. Getting the layers this thin and at the same time extremely uniform is a triumph of technology.

The layers that concern us most are the emulsions, of which there are three, one on top of the other. Together they are sensitive to all colors of light, which are composed of combinations of the light primaries—blue, green, and red. Individually, each emulsion is sensitive to a particular light primary. The one that is sensitive to blue is

called the blue record. Similarly, we have a green and a red record.

The actual recording is done by silver halide particles in all three emulsions. No colored dye is involved when the film is exposed. Incorporated in the emulsions with these particles are compounds called color couplers, or color formers. They aren't colored either, but they produce color during processing.

● Color Formation

The color couplers (formers) react with chemicals in the color developer to produce the three subtractive primaries—yellow, magenta, and cyan. As we have seen, all other colorant colors can be made with these three. Yellow is formed in the blue record, magenta in the green record, and cyan in the red record. As you can see, each record emulsion forms its complementary hue.

This may seem a bit backward, but it's not. Remember that we are describing a reversal process. Tones are reversed, and so are colors. Complementary colors are the reverse of one another.

In a Kodachrome-type film the couplers are not embodied in the emulsion; they must be introduced into it in three separate color developers. The processing controls are so critical that it must be developed by Kodak or by one of the relatively few other labs that are set up to handle it.

It was a breakthrough in manufacturing technology to find color couplers that would stay where they were put instead of migrating to other emulsion layers through gelatin softened by processing. We didn't have this knowledge when Kodachrome was invented. However, it is such an excellent film that it remains popular to this day, despite the availability of more easily processed films.

● Color Balance and Color Shifts

As we saw earlier, tungsten films are balanced to either 3200K or 3400K; daylight films, to 5500K. If films stayed in balance after manufacture, this would be good; but they don't unless the conditions are right. Films out of balance will produce color shifts. For example, your pictures may have an overall magenta cast.

Getting three emulsions in balance with one another and with the light source is quite a tricky proposition, and keeping them there is too. However, fairly simple precautions will usually suffice to solve the latter problem.

A color film, like a living thing, is always changing. Among these changes is a slow but inexorable drift out of balance. Manufacturers anticipate this drift and give an expiration date with each roll of film. After that time you can expect your film to be too far out of balance for predictable results. When you buy film be sure that it is still in date.

Certain things will speed up this shift out of balance—for example, heat, humidity, and chemical fumes. A few hours in the hot glove compartment of a car will do it. So will too much moisture in the air, or exposure to solvents or mothballs or other substances.

It is best to store film in the refrigerator, even freeze it. Film and slide storage will be discussed at greater length in a later chapter. As you will see, there is quite a bit to it.

Improper processing will also shift film out of balance. You may have seen this in film you got back from the drugstore or in some you processed yourself. The thing is that processing must take place under very rigid control conditions. Sometimes drugstore photofinishers relax their controls somewhat, and it is easy enough to make a mistake if you are doing the job yourself.

● Over- and Underexposure

If a black-and-white negative is too dark it is overexposed. The reverse is true with a positive color transparency: too dark means underexposed. Conversely, too light means overexposed. It is easy enough to tell when an image is too

light or too dark, so we won't go into that. The important thing is to understand how they got that way.

● Black-and-white Negatives

As we have seen, the image on a color transparency is a black-and-white negative after the first developer. Sometimes people accidentally process color film in a black-and-white film developer, which leads to approximately the same results. Often the negatives can be printed on black-and-white papers. There is no reason to go through this process on purpose, but if you accidentally get negatives this way you may not be entirely lost.

● Exposing Color Reversal Films

With a typical black-and-white film the latitude for exposure error is fairly great. You can be two stops overexposed or one stop under and still get printable results. With a color reversal film the latitude is considerably less—about one-half stop over and one-half stop under. This indicates that your exposure readings should be very accurate.

People who do a lot of work in color often solve the short-latitude problem by doing a lot of bracketing. This means, they make intentional over- and underexposures in addition to using the exposure indicated by the meter. The idea is that if the indicated exposure happens to be wrong due to faulty metering, one of the other exposures will be correct. This notion usually works out well and is in very common use.

You could consider using a five-shot bracket, in which case your exposures might be: one stop over, one-half stop over, normal, one-half stop under, one stop under. Some people bracket even further than this, especially on important shots. However, a three-shot bracket is usually sufficient: one stop over, normal, and one stop under. A few people even bracket in two-stop jumps: two stops over, normal, and two stops under. Pete Turner, one of our best color photographers, recommends this.

Bracketing uses up a lot of film, of course, but it practically guarantees your getting the right exposure. Many professionals couldn't work without it. To get the best results they don't mind spending extra money on film, usually considering it to be the least of their expenses.

Metering itself is important, of course. Perhaps your best bet is to use a meter separate from your camera and take an incident reading. That is, you use the incident attachment and take a reading of the light source, not the subject. For most shots this works very well. The attachment is pointed halfway between the light source and the camera. Be sure that the light falling upon the meter is of the same intensity as that striking your subject. If you have any doubts, hold the meter very close to your subject.

The typical built-in meter is called a reflectance type and is used for reading subjects directly. That is, you point the meter at a subject, which gives you a reading of the light that it reflects. With average subjects, which includes most of what you shoot, this system works very well too. However, you should understand what happens when you use this method.

Anything that you read with a reflectance meter will come out average in tone in your color picture, no matter how dark or light it is in its original state. For example, a lump of coal and a light-yellow flower would yield medium tones when read separately for different pictures, one coming out lighter than normal, the other darker. However, this is ordinarily not what you want. You usually want dark things to come out dark and light things to come out light.

The secret is to take your reading from something in your subject that is medium in tone. Then things that are lighter than it is will come out lighter, and darker things will come out darker. Outdoors, light-green grass is a good medium tone to read. Indoors, you might select an article of clothing, a piece of furniture, etc.

Finding something that is average in tone is not quite as easy as it sounds. It is hard to pick the right tone. A way around the problem is to use a Kodak Gray Card to help you see what a medium tone actually is. It reflects 18 per cent of the light that falls upon it and is somewhat darker than you might expect a medium tone to be. However, it reflects a psychologically average amount of light and can be depended on to help you see what a medium tone is. Just hold the card in front of an object and you can tell if it is medium or not.

When you have identified your medium-tone object or area you can then take your reading from it, but this is not necessary. You can simply take your exposure reading from the card itself and not even bother to look for an object or area that matches it. The important thing is to read a medium tone; where it comes from is not important.

The main trick to using a gray card is to hold it in the same plane as your subject. For example, in photographing a standing person you would hold the card vertical, facing halfway between the camera position and the light source. Another approach is to simply angle the card in and out of the light until it looks about average for the scene confronting you, then take a reading from it.

Done according to these instructions, gray-card readings are usually very accurate and are popular among those who work in color. Understand, you simply read the card and use the exposure figures thus obtained. You can do this with either a built-in or separate meter. With either one you should make sure that you are reading the card and nothing else, because reading things behind it can throw the exposure off. Be sure not to read your shadow on the card, for this will lead to overexposure. Reading a dark background will cause overexposure; a light one, underexposure.

There is a still easier way to make an exposure reading. It works more often than not, though it is not as good as an incident-light or gray-card reading. You simply point your meter at your subject, reading the light, medium, and dark tones all at once—your meter will integrate them all. In terms of tones, most things reflect an average array of them, so you end up with what amounts to a reading from an average one. However, with subjects that have a preponderance of either light or dark tones you have to be more selective. For example, for a landscape with a lot of bright sky you should mostly read the ground, not the sky. If a subject is outlined against a dark area you should read it directly and exclude the area.

There are times when you can't quite make up your mind what you are doing when you set out to determine an exposure. In these cases bracketing is the most useful approach. You offer the film a variety of exposures and let it determine the best one. If you extend the bracketing far enough you can get the correct exposure without taking a reading at all, though this is a wasteful way to go about it. Better to get the best reading you can, then bracket from there.

There are people who have no meter at all who do quite well much of the time. They simply follow the little exposure charts that come with the film. For certain lighting conditions—namely bright sun, hazy sun, and bright overcast—they are amazingly accurate. Through a long process of experimentation the charts have been perfected to a high degree, despite their simplicity. As a matter of fact, you can use them to check your metering technique. If a metered exposure figure and a charted one differ too much, you should first suspect the way you are using your meter. Take some test shots. After the check you may find that your metering is correct, in which case you should depend on it. However, if you can't make up your mind what you are doing, it might be best to choose a charted exposure and bracket from there. It is hard to believe that a simple chart is sometimes more dependable than a meter reading, but this is often true.

There will be more about exposure determination elsewhere in this book.

● Colors from Light

We have seen that so-called white light can vary quite a bit in color without the eye being able to detect it, due to color adaptation. Since color film will detect most of these differences, it is good to know what some of them are. The objective is not to avoid certain light sources, which may give very handsome results, but to see what you might expect from them.

Just before sunrise or after sunset the light is quite blue, the color that we see coming from the sky. There can be red or yellow skies, but they are most likely to be blue. In the morning before 10 A.M. and in the afternoon after 2 P.M. the light is quite reddish, especially in the early morning or late afternoon. From 10 A.M. to 2 P.M. the light is quite neutral or white for daylight film.

Relative to daylight, tungsten light is quite yellowish, the yellowness increasing as we use bulbs of progressively lower wattage. For example, a 25-watt bulb is very yellow indeed, though its light may seem quite white to the eye. Candlelight is even yellower, as you might expect, yet it is fun to take pictures with it.

Electronic flash is approximately like daylight at noon, so it goes well with daylight films, which are balanced for 5500K. Blue flashbulbs are about the same. It is best to use either one or the other when you shoot daylight film indoors.

Reversal color films are very sensitive to the colors of so-called white light. Later we will return to this subject in greater detail.

Color Negative Film

Color negative films were created to improve color rendition in the positive color images that are made from them. The improvement is in comparison with the results you get from printing reversal-type films.

● Negative to Positive

The improvement comes largely through cutting down the number of times you must repeat the negative-to-positive process. In using reversal materials to make prints you go through it twice. For example, in processing a reversal film you initially get a negative, which is reversed to positive. It is then printed on a reversal paper (or film), with which you once again go from negative to positive by reversing the image.

Unfortunately, every time you go from negative to positive there is a loss of color quality. This is because the dyes and processes involved are not perfect. Indeed, they never will be, for such perfection is never an everyday reality but merely something that is striven for.

When you go through the process twice, as you do by making prints with reversal materials, the quality loss is substantial. If you start out with a color negative material, you go through the negative-to-positive process just once — there is no reversal processing involved. You go di-

rectly from the color negative to a positive print on film or paper.

● The Kodacolors

Since they are in most common use, we will describe the Kodak Kodacolor films. What is said here will refer to all of them. The objective is not to say that Eastman Kodak is the beginning and end of everything in photography, but to talk about excellent materials that are readily available when you need them.

● Color Balance

The Kodacolors are balanced at 5500K for use with daylight, electronic flash, or blue flashbulbs. However, you can also use them with clear flashbulbs or in tungsten light without filter correction, though the results won't be quite as good as they should be. Many people use them this way and never notice the difference. Even so, it is best to use filters to change the color of the light before it reaches the film, using the filter information given on page 26.

Notice that an exposure increase is required with each filter. When using a flashbulb use the guide number and distance to calculate the correct aperture setting (guide number divided by distance), then open up the aperture the appro-

priate amount to correct for the filter. For example, when using an M2, 5, or 25 bulb, you should open the aperture an additional stop. These things will be more fully explained in the chapter on flash.

When using a 3200K or a 3400K light bulb, simply take the exposure reading through the filter.

● Exposure Latitude

With Kodacolor negative films you get a lot more exposure latitude than with reversal films. If your exposure error is as much as two stops over or one stop under, you will still get printable results, though not the best. If there must be an element of guesswork in your exposure determination, as is sometimes the case, it is better to risk overexposure than under. However, exposure bracketing will take care of a problem like this.

Though the rather long exposure latitude is indeed there, it is best not to count on it too much, because deviations from the normal exposure don't give the best results in the prints that you make. The extended latitude is mainly for people who have little idea of what they are doing when they expose their film.

● The Film

A color negative film has three emulsion layers that record the three light primaries—blue, green, and red. These layers contain silver halides (the light-sensitive elements) and dye couplers that form the image. In development a silver negative image is formed. At the same time a negative image is formed in dye—yellow in the blue record, magenta in the green record, and cyan in the red record. That is, the colors are all complementary to the colors of the things photographed. They are also the subtractive primaries. In addition to the colors just mentioned, the color negative has a rather strong overall reddish-tan cast due to a coupler introduced into the emulsion for the specific purpose of forming it. This is sometimes called the masking layer. Its purpose is to introduce color corrections during printing.

In processing the film is treated with only one developer (as opposed to two with reversal films), after which the silver image is bleached out, leaving only a negative dye image. Except for the reddish-tan color, it looks quite a bit like a black-and-white negative.

● The Negative

Except for the orange mask, the negative doesn't look very colorful, though the image is made entirely of dyes. However, highly saturated colors in a photographic subject will leave discernible colors. For example, yellow leaves a perceptible purple; red, a green, and so on. Less saturated dye colors are not visible to the eye, due to the reddish tan.

Like a black-and-white negative, a color negative should not be blocked up in the highlights (dark areas), and it should have ample detail in the shadows (light areas). That is, dark areas record the subject's highlights and shouldn't be too dense. And light areas record the subject's shadows and shouldn't be too clear.

Though you can generally tell how a black-and-white negative will print just by looking at it, this is not true of a color negative—the mask is too confusing. Here you must either print by trial and error or use some indirect method of assessing the color-printing characteristics. Such methods are best covered in a discussion on printing from color negatives and need not concern us here.

The main objective of this chapter was to give you a moderate amount of information on color negatives and to let you know that they lead to improvements in color printing. The majority of people who make color prints are now using them.

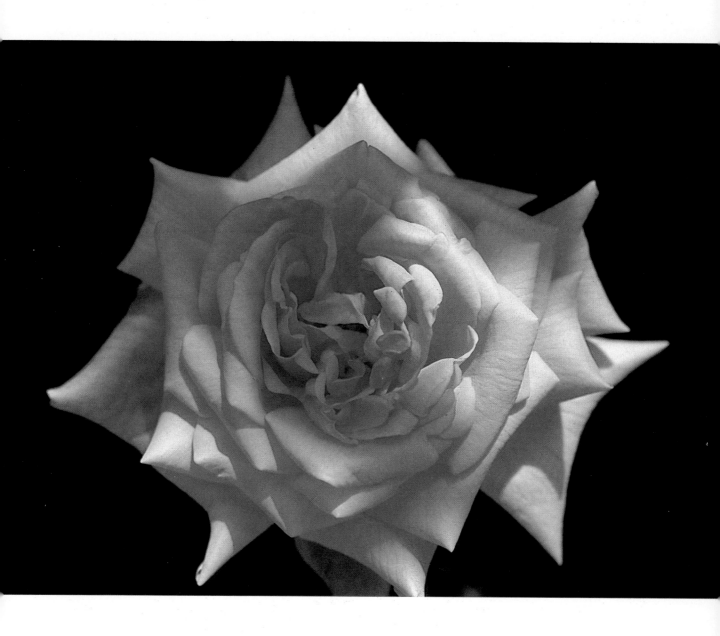

A beautiful specimen of a rose combined with a very
subtle and handsome light pattern. The dark background
makes the rose seem to shine in the light.
[Photo by David Howland]

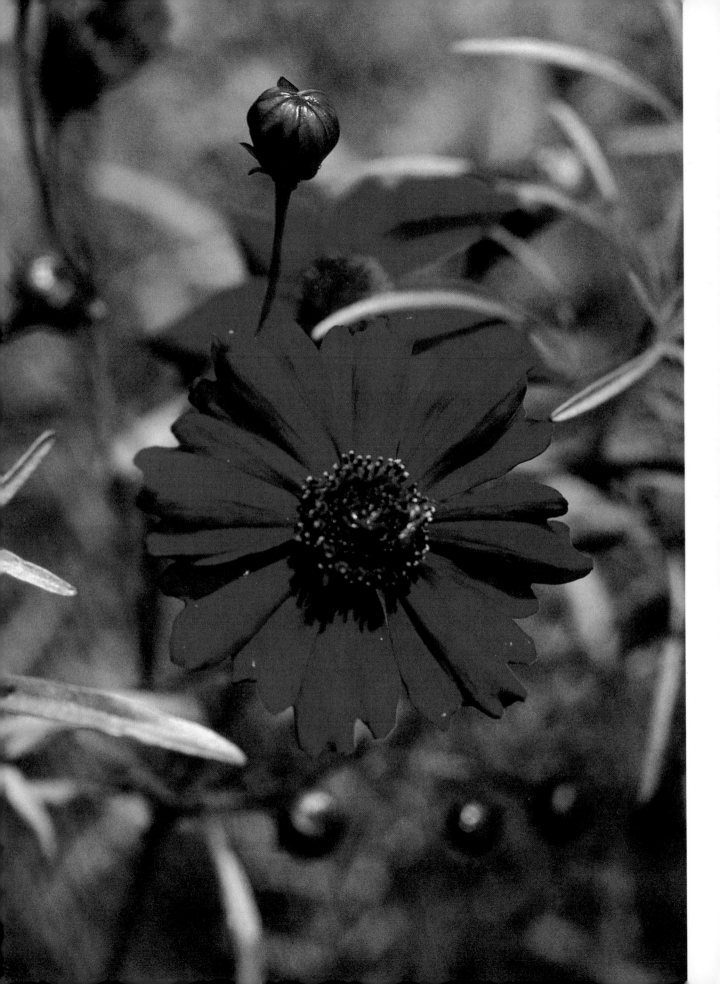

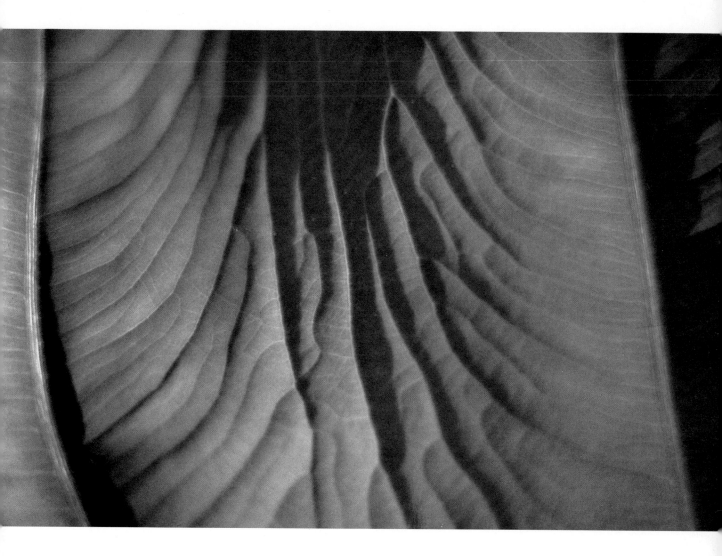

Slight underexposure has made the red in this flower
much richer than one would expect. Displayed against
the cool green, it seems to almost vibrate.
[Photo by David Howland]

The shadow pattern on the leaf looks like a mysterious
tree or a river estuary seen from the air.
[Photo by David Howland]

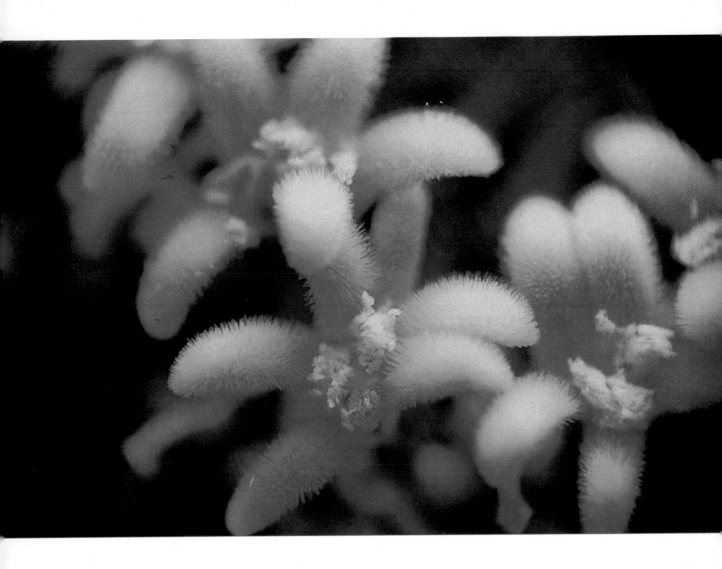

These flowers aren't very sharp, but it doesn't really matter. The very softness makes them look like furry little animals reaching out for the light.
[Photo by David Howland]

Though yellows and browns don't usually stand out strongly in pictures, those in this picture do. The dark tones behind them dramatize them very nicely.
[Photo by Rod Mann]

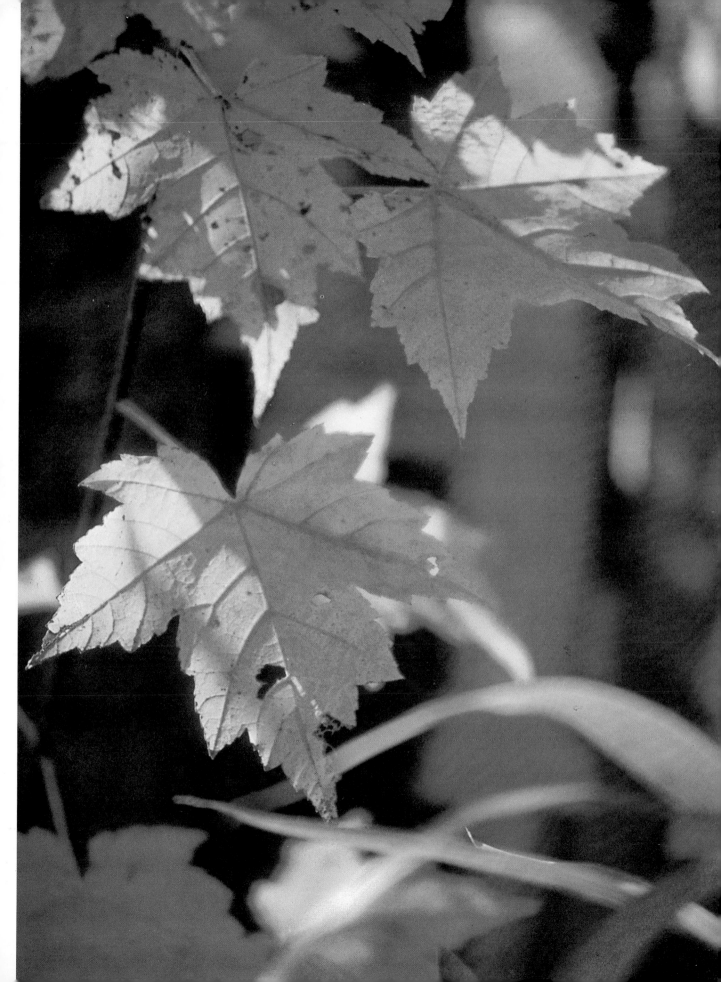

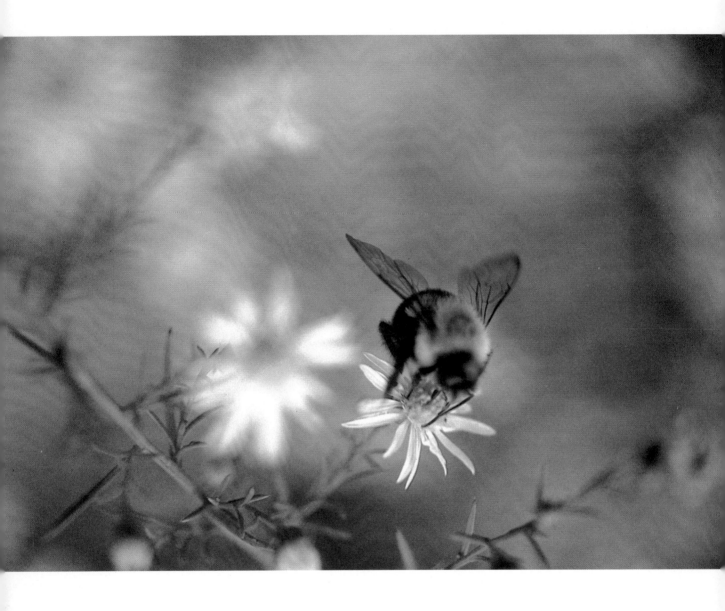

The shallow depth of field in this close-up picture makes most of the things in it very soft and fuzzy, as in a dream sequence. And the effect is charming.
[Photo by Benton Collins]

The very dark tones behind these flowers make them look bright. Warm colors in general are helped by dark areas.
[Photo by Robin C. Barringer]

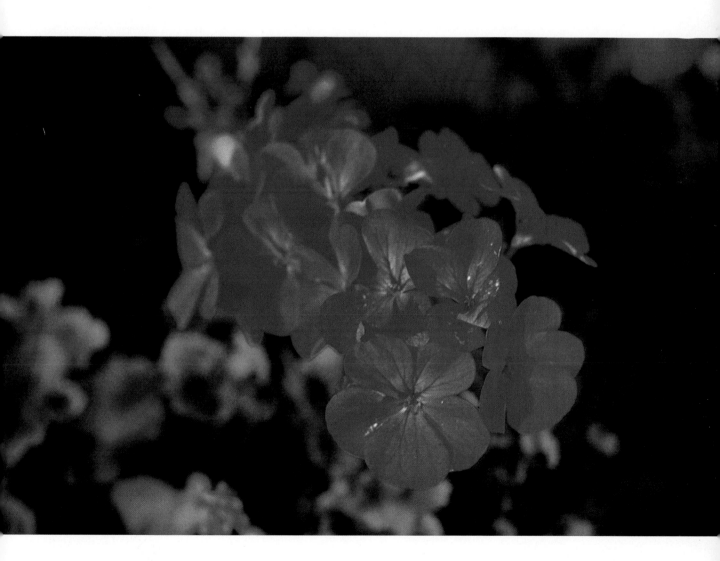

These delicate flowers seem to be blowing in the wind.
The rich blues and greens behind them seem to make
them sparkle in the sun.
[Photo by Ken Salzmann]

● Choices

Now that color film has been discussed in brief, you may be wondering which film you should choose for yourself. A simple but hardly satisfactory answer is that it doesn't really matter very much, one modern color film being about as good as another. There are certain subtle differences, to be sure, but you probably wouldn't recognize them if you saw them. Indeed, we can't even illustrate them in this book, because such subtleties are lost in reproduction.

One reasonable basis for choice is availability—in order to use a certain film you first have to find a source for it. In this area Kodak films win hands down, for they may be obtained nearly everywhere. Since they are as good as any on the market, you wouldn't penalize yourself by using them.

How about the difference between reversal and negative films? Which one should you buy? Again, it doesn't really matter that much, though one may be more convenient than the other. You can get prints from both reversal and negative films, and you can get slides from negative films. However, if you are into slide viewing and projection, it might be better to start out with a reversal film, which gives you the slides directly. If you want prints you can have them too, though individual prints cost a little more this way.

If you use Kodak printing processes, the print made from a color negative is slightly better than one made from a slide. However, if you print a slide on Ilford's Cibachrome you get a topnotch result, so it is safe to say that you can get the best of prints from a slide.

If you know how to judge color negatives you can save quite a bit of money by having your film developed without prints. Then you can pick the good negatives and have prints made from them, thus saving money by not paying for bad prints. However, judging color negatives is pretty tricky, and it's not likely that you would know how to do it at this point in your career.

There are considerable differences between Ektachromes and Kodachromes. The Kodachromes are quite a bit more natural in color, while the Ektachromes are more colorful and ring slightly false. The Kodachromes are also a lot sharper and have much finer grain. However, the grain from an Ektachrome will not be very apparent in an 8 x 10 print, so you have little to worry about. Again, the relative sharpness won't make that much difference in a fairly small print, though it would in a larger one.

There is a grain difference between Kodacolor II and Kodacolor 400, the latter being quite a bit grainier. However, when you need the high speed of Kodacolor 400, as in available-light photography, you have to be prepared to compromise somewhat on grain. The color differences between the two films are negligible, though Kodacolor II is somewhat better.

As a general rule, slower films, both reversal and negative, yield better quality than faster ones. However, the difference is so small that you may not notice it. And the advantages of having greater speed are very enticing. For example, you can shoot in many more situations without the use of flash or photofloods.

In my personal choices of film I go for speed, figuring that the color quality will be more than adequate for my purposes. Thus I favor Kodacolor 400, Ektachrome 400, and Ektachrome 160.

Others don't agree with my choices—for example, Pete Turner and Norman Rothschild, two of the world's finest color photographers. As far as Turner is concerned, there is only one color film really worth bothering with: Kodachrome 25. He likes its great sharpness, high fidelity, good contrast, and extremely fine grain. Though they are also good, he says that Kodachrome 40 and Kodachrome 64 don't quite measure up in these respects, so he doesn't use them.

Rothschild is also a Kodachrome nut. He says, "If it isn't Kodachrome, it isn't color film." However, he sees the differences among the Kodachromes as negligible, except for speed,

though Kodachrome 25 is the sharpest of the three. He says that many photographers have chosen Kodachrome 64 as their standard. In his capacity as Senior Editor at *Popular Photography* he has for many years been systematically comparing various color films, so I will paraphrase some of his comments in the material which follows.

Ektachrome 64. Doesn't have the tendency toward bluishness found in Ektachrome X. Colors are clean, rich, and a mite cooler than Kodachrome 64. Pictures made in the shade will not be overly blue. Grain is not quite as fine as Kodachrome, though very good.

Agfachrome 64. Notably warmer than American color films. Flesh tones are less toward the idealized orange than we are accustomed to. Some call this better fidelity. Blues tend more to blue-violet, yellows are clean, oranges and reds are brilliant, greens a bit on the cold side. Neutral colors and browns are exceptionally well rendered. Sharpness and grain are good.

Agfachrome 100. Slightly warmer than Agfachrome 64, though the grain and sharpness are still good.

Fujichrome R 100. The color is bright but delicate, having a typical Japanese liquidity. It is somewhat on the warm side. Yellows are good, reds and oranges brilliant. Blues and violets are natural-looking.

3M Color Slide Film. All in all, this film gives rich but delicate colors. It is definitely on the warm side. Blues are a bit cyan but pleasing. Yellows are clean, reds and oranges rich but not overly brilliant. Greens and violets are good.

Ektachrome 200. Somewhat lower in contrast than the Kodachromes or Ektachrome 64. The colors are not quite as saturated as in the slower films—there is never a harsh feeling. It should be used for delicate pictures. In graininess, sharpness, and general rendition of colors it is very similar to Ektachrome 64.

Ektachrome 400. Much like Ektachrome 200, but you can expect slightly more graininess and a little less saturation.

Ektachrome 160. This is a tungsten-type film designed for use with 3200K light sources. It renders flesh tones very well. Other colors come out much as they do in daylight films, with clean yellows, brilliant reds and oranges, clean blues, and good violets. This film is a logical choice for indoor work when a high ASA rating is called for.

Kodachrome 40. A tungsten film for 3400K light sources. It typically exhibits the fine grain and sharpness characteristics of all the Kodachromes and a very high degree of color accuracy. It has a high degree of color saturation. This product is worth looking into as a fine studio film for professional portraits, still lifes, etc.

Kodacolor II, Vericolor II, Fujicolor II, 3M Color Print Film, Agfacolor CNS-2. When correctly printed, all of these films will produce highly pleasing results. Grain is quite fine, and sharpness is much better than with earlier films.

ASA 400 color negative films—Kodak, Fuji, 3M, and Sakura. Besides their speed, what makes all these films especially interesting is that you can expose them under light sources of many different Kelvin ratings, though they are best at 5400K. With appropriate filtration in printing you can get handsome prints. Even fluorescent lighting can be used.

The foregoing are some of Norman Rothschild's comments—I hope you find them useful. However, you may find that you have been afflicted with too much information. In that case, I suggest that you go for either quality (the Kodachromes) or for film speed (the faster Ektachromes or Kodacolor 400). The main problem with slower films is that you frequently have to use a tripod, but you can get used to that.

Matching Film
to Colors of Light

Earlier, you read that color films are balanced for specific color temperatures and that you should expose a given film with the color of white light for which it is balanced. You were also given a chart showing you how to use a filter to change the wrong color of light for a film to the right color. This information is very useful, but it is not the whole story. The most effective color of light for a given film and situation does not always conform to the rules. For example, you may wish to make an outdoor snow scene very bluish by using a tungsten film. The thing to understand is that your personal likes and dislikes concerning the appearance of pictures are sufficient reason to abandon the rules. Even so, it is good to know what some of them are, since rules can be useful tools.

● Neutrals and Caucasian Skin

Before giving up on the rules (which many people do without even knowing it), it is good to know what they are based on. One rule is: Neutral tones in color pictures should be truly neutral. If a film and a light source are properly matched, the neutral blacks, grays, and near whites shouldn't be tinged with red, blue, green, etc. The rule goes further: If the neutrals are really neutral, the chromatic colors will also be all right, so this neutrality is a good standard to go by.

Even if the light source and film are properly matched, however, the neutrals aren't usually all that neutral—they usually have a touch of chromatic color in them. This may be due to color shifts in processing or in the film itself. The question is, How should one feel about this? Well, perfectionists find it very disturbing, but most people do not. To the average eye it doesn't make the slightest bit of difference if the neutrals are a little bit off-center. Furthermore, people are thoroughly used to seeing this—in color TV, for example—and are not much disturbed by what they are accustomed to. It also seems likely that many people aren't very aware of neutrals, to begin with, so that color shifts don't tend to disturb them.

The way it works out is that you seldom get pure neutrals in a color slide—you can be disturbed by this or not, according to your inclination. Even so, getting neutral neutrals is a reasonable standard to shoot for, though you shouldn't let this restrict you. There is a small chance that you might get neutral neutrals if film and light source are properly matched, but no chance at all if there is a mismatch.

Off-color neutrals are actually very pretty. For example, bluish or greenish grays may be very nice indeed—and it may not matter much that they started out as neutral grays. This suggests that you should judge a slide by what it looks like rather than by what it might have looked like. At any rate, neutral neutrals are not something to

get uptight about. Sometimes you get them, most often you don't. We can use neutrals for judging the color balance of film, but we should be somewhat leery of judging our pictures by them.

Another popular standard for judging both images and the color balance of positive color transparencies is idealized Caucasian skin color. The rule is: The color in a slide is right if untanned white skin conforms to the ideal. Untanned Caucasian skin is almost always gray with a very small touch of color in it, but this is not what we want. The idealized verison of it, by which we measure our pictures, has less gray and more chromatic color. We might call it pinkish-yellowish-gray, though the grayness is not very apparent. If a person in a picture comes out with this rather handsome color, we say that the slide is properly color-balanced—for portraiture, at any rate.

Since most pictures are of people, this skin-color standard makes good sense. It just happens to be a color that people like in pictures of skin. Film manufacturers take it into account when they make their films, and processing is often judged in terms of it—if skin looks right, everything is O.K. However, it has to be untanned Caucasian skin.

The thing is that the color of such skin is very fragile—it is always on the verge of looking bad on account of its inherent grayness. Thus if the color balance of a picture is seriously off, it may look awful, and the skin would be a good indicator that something is wrong. However, skin as an indicator has its limitations, for some off-colors of skin may look pretty good—for example, reddish and yellowish. Even skin with blue or cyan in it may look pretty good. The colors that make skin look most awful are magenta and green. If a color transparency is off balance into either of these colors, you are fairly sure to get skin that looks terrible. However, it may be off balance in other directions without causing any particular harm. Thus using skin alone as a color-balance indicator has its limitations. The thing to do is to use skin and everything else in the picture too.

Black skin and well-tanned Caucasian skin aren't very good indicators, mainly because they are so rich in color. A moderate color shift in any direction will leave them looking just fine, and even heavy shifts may not matter. As we have seen, it is the color fragility of white skin—which dark skin lacks—that makes it such a good indicator. Remember that white skin is actually gray and that you have to get the right kind of gray in a color slide in order for it to look right.

● What Colors Can You Get?

Though some people stick as close as they can to the neutral and skin-color standards, a good many people couldn't care less. With some it is because they aren't very aware of color, and one color looks as good to them as another. Others may be aware of color differences and have definite preferences, but they don't like to read the technical literature that tells them how to control such things. Still others may be moved by sheer curiosity and simply want to know what effects can be gotten with color films, whatever they happen to look like. Since this last point of view has many adherents, we will discuss it.

If you just want to know what happens, you don't have to worry much about matching films and light sources. Sometimes you can do it, sometimes not. Anything that happens should satisfy you, since that is what you are looking for. If you don't like a particular effect, you don't have to repeat it. Some people apparently tune their color TV sets this way—they don't seem to care what color they get as long as it is color. This could mean that they have poor taste in color, but it is just as likely to mean that they are venturesome—they simply want to see what happens.

If you are an experimental person who wants to see what will happen, it's a good idea to take notes on the things you do, so that you can repeat the effects you like. Otherwise, you might forget

the things you try. Since a lot of things can happen in color photography, it is wise to keep a notebook anyway.

● Ultraviolet (UV) Filters

Some people are disturbed by the amount of blue they get in their outdoor pictures. Part of it comes from blue in the sky, but some of it also comes from ultraviolet radiation, which can be shut out of the camera with a UV filter. Though the eye can't see this radiation, the film sees it very well and records it as blue. Indeed, there are films that are more sensitive to UV than to anything else.

The remedy is to use a UV filter. It is practically colorless and doesn't affect the exposure, yet it does absorb UV and make pictures tangibly less blue. You can get one at almost any camera store—I recommend the type that screws into your lens. Those who have such filters often leave them on their lenses all the time, indoors and out, claiming that it is a good way to protect the lenses from fingerprints, dust, and scratches. This makes good sense. Since exposures aren't affected, you can simply screw on a filter and forget about it. However, for the best sky color you should probably remove the filter.

● A Personal Daylight Color

There are a few professional photographers who like to tamper with the color of daylight, saying that it doesn't suit them as is. I have a friend, for example, who says it isn't warm enough for him, so he warms it up by always using a light-yellow or light-red filter when he is outdoors. Naturally, his pictures come out warmer too.

If you would like to establish your own personal daylight color you might consider getting a gelatin filter holder for two-inch Kodak color compensating (CC) filters, which come in different strengths in red, green, blue, cyan, magenta, and yellow. With all these colors to select from, you can get almost any color of daylight you like. To warm up the light, for example, you might try a CC1OR, which is a very light red filter with a density of .10. Or you might wish to cool it down with a CC10B (blue). Since it is great fun to play with CC filters, you might at least keep them in mind. I will say more about them in the chapter on Cibachrome printing.

Perhaps the best route to follow when using filters in this context is to match your daylight color to your mood and to the nature of the things that you are photographing. This surely gives you many options to play with. As to the validity of tampering with daylight, that is strictly up to you. Probably the best way to look at it is that anything that works is good. Though manufacturers balance film for daylight at noon, you don't have to stick to their color balance unless you want to.

● Monochrome Color Pictures

Some people get tired of color as they normally see it around them—mostly gray with just a touch of bright color here and there. They want bright color all over their slides and can get it by making monochromes, which are pictures that are all in one color. You can get them by using color filters normally used only in black-and-white photography—for example, deep yellow, deep blue, deep green, and deep red.

You can also use the heavier CC (color compensating) filters, which aren't as dark as the filters for black-and-white work. This means that a filter will transmit some light other than its own color. For example, a CC50G (green) will transmit some red and blue light as well as green. For many monochrome pictures this looks perfectly all right, but others will look somewhat degraded—so it is best to stick with filters in really dark colors—for example, those made for black-and-white photography.

Since dark filters substantially decrease the amount of light that reaches the film, you must increase the exposure quite a bit. Working out the increase with a built-in meter is very easy — you simply take the exposure reading while the filter is on your camera. With a separate meter, take your reading while holding the filter over the light cell.

Because a monochrome rendition changes a scene considerably, you can't be sure whether you would like it light, medium, or dark in tone. For this reason it is a good idea to bracket your exposures. The bracketing might be used for still another reason: light meters and film don't react to the colors of light in quite the same way. Thus metered exposures through color filters are likely to be a little off. However, you will probably find that you can make gross exposure errors and still get very pleasant pictures. For example, an all-blue picture will probably look good to you no matter how light or dark it is, because blue is such a pretty color.

● Daylight Colors

Daylight films are balanced for a kind of idealized daylight, which is 5500K — rather bluish, but with quite a bit of yellow in it. When daylight actually approaches this color, all the colors in your pictures will tend to come out just as you would expect them to. In other words, they look right. However, daylight often misses 5500K, especially in urban areas where there is a lot of smog, which makes the light appear as yellowish red.

One way to get around this is to use the very expensive type of color temperature meter that reads three colors and use it to select special filters, also expensive, to fit on your camera. If it is absolutely necessary that you get neutral neutral colors and standardized ideal flesh colors, there is not much else you can do. However, such

things are for specialists; the average person doesn't have to go that far. You can shoot in smog without any filtration at all — and your pictures will look very much like what you saw when you shot them.

Now, *heavy* smog is something else. We see it as gray, but the film sees it as bluish. It also sees ordinary overcast as bluish, and everything in your pictures comes out with a bluish tinge. This can be very handsome, so there is ordinarily no point in trying to avoid it. The important thing is to know how the film sees the overcast and to try to guess what it will do. Or you can just wait and see.

When you photograph in shade the film sees the light as definitely blue. When you realize that the light in shade is reflected from the blue sky, this isn't surprising. You can even learn to see the blueness of the light yourself, but this takes time because the eye tends to adapt to it and cancel it out. Even so, you can overcome the adaptation to some degree if you try. If you can't learn to see the blueness, however, your pictures will show it to you.

This blueness wreaks havoc with standard idealized Caucasian skin color, but nobody really cares any more. We are so used to seeing bluish skin in pictures and on TV that we totally accept it nowadays. Actually, a given person's skin seldom looks the same way twice, due to differences in the light that falls upon it. Our experience with photography (including TV) seems to have prepared us to accept this truth, though artists accepted it long ago. For example, Van Gogh never hesitated to paint skin green, blue, or yellow. He saw such colors in skin and simply painted them.

Van Gogh and others long ago realized that the color of daylight is never the same two days running — it may be delicately tinted with any color of the rainbow. You can learn to see these differences if you work at it. The best way is to take up landscape painting, which forces you to match what you see with pigment colors. Since you probably don't paint landscapes, the next

best thing is to turn to your color slides, where subtle differences in daylight color are often revealed.

Some daylight colors are pretty, some a bit ugly. For example, daylight tinged with smog or aerial dust is usually not very pretty. On the other hand, when the sky is a deep blue the daylight color is invariably beautiful. You can learn to distinguish the relative beauty of various kinds of daylight and know when you will get your best color pictures. It is mainly a matter of feeling — when the day *feels* beautiful you can be pretty sure it is, because people are a very accurate instrument for measuring such things. Relying at first on feeling, you can eventually learn to handle day color intellectually and actually see the particular tint of color prevalent on a given day. As I said, painting landscapes helps, but so does color photography.

In the early morning after sunrise and in the hours just before sunset the day color is often quite reddish — and you can learn to see this too. You may subtly feel it as a kind of warmth, because redness as such makes you feel warmer — which is why red is called a warm color. Your color film will see the redness in an even more positive way. Again, this wrecks standard idealized Caucasian skin color — and again, nobody gives a hoot. White skins usually look good with a little extra red in them, and black skins look positively gorgeous. So early morning and late afternoon are not times to avoid. Indeed, many photographers prefer them for their color work.

On days with a light white overcast, the sky color looks definitely white. However, the film sees it as bluish. Even so, you can make swell pictures on such a day, the colors often coming out rich and beautiful.

My main purpose in this section has been to point out that there are many day colors and that most of them can be used to create beautiful pictures. The thing to do is to try them all to see what results you get. Film doesn't see things in quite the same way you do, but it comes close enough most of the time.

● Dramatic Sunrises and Sunsets

Many people adore shooting sunrises and sunsets, possibly because color as such rivets their attention at such times. Though the daytime world is full of color, it usually stays pretty much the same, so we get used to it. Being used to it, we soon fail to notice it at all. But sunrises and sunsets can confront us with dramatic color differences. What was once an ordinary blue sky now flashes with brilliant warm colors. They catch our attention, and we instinctively reach for our cameras.

We see these colors as very warm, while daylight film sees them as positively hot. This is because the day color is often very red at sunrise and sunset, and the film is balanced for something much cooler (5500K). So color slides may come out very warm indeed. If this bothers you, shoot your pictures on tungsten film, which is balanced for a warmer light. It will make your pictures seem more accurate as to color, calming the reds down quite a bit.

But how important is accuracy? Couldn't flaming color slides be even better? What does it matter if your colors come out a bit more brilliant than they actually were? Most people simply don't care, so they wouldn't think of photographing sunrises and sunsets on tungsten film. Why bother? may be their attitude. If you are going to shoot something brilliant, why try to make it less so?

● Cityscapes After Dark

As you well know, cities after dark can be very beautiful — you have experienced this often and have seen many night pictures. Since city lights are quite warm on the color temperature scale, it would make sense to photograph them on tungsten film. Indeed, this would give you the most accurate color rendition. However, accuracy in pictures has its limits, and inaccuracy may be

more beautiful. For this reason you will probably like your nighttime cityscapes better if you photograph them on daylight film and let the colors warm up.

Since you may have trouble deciding how to take exposure readings at night, I will suggest some starting exposures for Ektachrome 160 (tungsten), Ektachrome 200 and Ektachrome 400 (daylight), and other films of similar ASA speeds. From a given starting exposure you should bracket one stop on each side, which should take care of the exposure problem without difficulty.

If you are nervous about missing a good shot, you might bracket twice on each side of the suggested exposure.

	Shutter Speed (Sec)	Starting Aperture for ASA 160/ 200	Starting Aperture for ASA 400
Fairs, amusement parks	1/30	f/2.0	f/2.8
Brightly lighted street scenes	1/30	2.8	4.0
Illuminated store windows	1/30	4.0	5.6
Floodlighted monuments and fountains	1/2	4.0	5.6
City skyline after sunset	1	2.0	2.8
Distant brightly lighted streets	1/30	2.8	4.0

● How Green Was My Valley

You sometimes see color shots in which green foliage is outrageously green—they are usually very beautiful. It happens that greenery reflects a lot of red, so such brilliance is not the usual thing. Red tones down green, making it dull. So where do those brilliant pictures come from?

Well, you can make them in the spring when there is a lot of new foliage around. At that time it isn't reflecting as much red. Or you can make them right after a rain, when sheer greenness is emphasized. Perhaps the most dependable trick is to use a light-green filter such as a CC20G, which will absorb most of the red and let the green shine through. For a more saturated effect you can use a higher-density filter such as a CC50G, but this will knock out many of the subtleties in the greenery itself and come close to giving you a monochrome picture.

Similarly, you can use a red filter to emphasize the redness of things, a blue filter to emphasize the blueness of things, and so on. If you go in for such things, as many professionals do, you should surely have a gelatin filter holder and the whole range of Kodak CC (color compensating) filters. Here the objective is not to make monochromes but to brighten up certain specific colors.

● Fluorescent Lighting

Color shots made by fluorescent light usually don't look very good, mainly because such lighting is deficient in reds. Fortunately, this can be corrected to a considerable degree with filters. Ideally, you should have a special filter combination (usually two filters at a time) for each of the six most popular kinds of fluorescent tubes. This can be quite a hassle, because you have to identify the type of tube in each area you work in and you must have a substantial assortment of filters. However, there is an easy way out that works most of the time.

You can use single filters—one kind for daylight film (which is your best bet) and another kind for tungsten. For daylight film, try a CC30M (magenta) filter and a 2/3-stop-larger aperture. For tungsten film, use a CC50R (red) filter and a one-stop-wider lens opening.

If you have a built-in meter you don't have to worry about the exposure increase. Simply read the exposure through the meter. As I have suggested before, this isn't the most accurate way to do it, but it is quite satisfactory. With a separate meter, hold the filter over the light cell while you take your reading. It is somewhat more accurate to open up two thirds of a stop for daylight film and one stop for tungsten.

The one-filter recommendations for fluorescent light are only approximate, but they will produce acceptable results in most cases.

● Filters or Not

As you have seen, this chapter on matching films to light colors has dealt mainly with filters, which change the color of light. You probably wonder if you should go to the trouble—the majority of people do not. It all depends on how finicky you are about such things as standard idealized Caucasian skin color and neutral neutral tones. If you don't really care what happens to them, it would be foolish to invest in filters. Furthermore, if you are merely curious to see what a given film will do under various lighting conditions, this factor would also rule out filters.

Filtration is mainly used to make things on color film look the way you expect them to. However, in this age of color TV you may have gotten beyond expecting any particular color in an image. Looking at instant-color pictures has about the same effect. In the main, you simply learn to take what you get. If this fully satisfies you, as it apparently does for many people, it wouldn't make sense to investigate the art of modifying light color by means of filtration.

● Daylight Film in Tungsten Light

Daylight film is balanced for light much bluer than tungsten. Consequently, it will produce pictures that are an obvious reddish-yellow when exposed by tungsten light—the lower the wattage

of the bulb, the stronger the reddish-yellow. In many cases this doesn't matter, for the color can look very good. It often has a comfortable warm feeling that is welcome in many types of pictures. Candlelight pictures have this feeling, and they come out looking like real candlelight. Pictures shot in restaurants and nightclubs look pretty much the same way.

The thing to do is to try daylight film indoors just to see what you get. If you don't like the reddish-yellow, you can always switch to tungsten film for subsequent shooting sessions.

● Tungsten Film in Daylight

Most tungsten film is balanced for 3200K, a color of light much warmer than daylight (5500K). Consequently, it will produce pictures that are very obviously bluish when used outdoors, which you may or may not want. Standard Caucasian skin color comes out definitely bluish, and so does the rich color of black skin.

Many people feel that it is better to use outdoor film indoors than indoor film outdoors. Of course, you can use the conversion filters that will be discussed in a moment, but I am referring to the use of film without filtration. The only use commonly recommended for tungsten film outdoors is for snow scenes—the extra bluishness makes them look very cold. However, I have seen fashion pictures that were shot this way—fashion photographers sometimes like to twist color around for an unusual effect.

The main reason that tungsten film is not very popular outdoors is probably blue skin—most people don't like it. If you want just a touch of blue in it, which can be very handsome, it is sufficient to use daylight film in the shade or on an overcast day.

● Theatrical Gels

It is sometimes fun to play with theatrical gels, taping them over light reflectors to get any color of light that you please. The most dramatic ef-

fects come from using two light sources, each with a different gel. For example, magenta and cyan are a good combination. These gels come in different strengths (they look like cellophane), but the stronger ones are most fun to use. They make colors come out bright and clear, so that you really know what you are looking at.

These inexpensive gels are rather fragile, so that hot lights tend to buckle them. One way around this is to use 100-watt bulbs instead of photofloods in your reflectors. However, the buckling doesn't really matter very much, so you shouldn't worry about it. A gel will still change the color of a light, no matter how wrinkled it gets.

You can also shoot through pieces of gel, using them as if they were filters, which they are in a sense. Since they are not optically flat, they will distort the image somewhat, but you probably won't even notice it. Taking this approach, you can get quite an assortment of filters for very low cost per filter. Perhaps it is best to use them for shooting monochrome pictures. The gels are available from theatrical supply houses, where the clerks will generally let you look through the entire stock (or a sample book), so that you can be sure of getting the colors you want.

● **Conversion Filters**

I have suggested that you freely pair up films with various colors of light sources just to see what happens—this is one valid way to approach photography. However, you may want the colors in your pictures to match as closely as possible the original colors as you think they looked. If this is the case, you may want to use conversion filters, which will change the color temperatures of different kinds of light to match the color balance of the specific type of film you are using. Then the neutral colors will tend to be neutral, the chromatic colors in the right strength, and the flesh tones acceptable in terms of the idealized standard.

As you will see in a moment, a selection of twelve filters will do a very substantial job of changing different kinds of light to the right colors, and I imagine there are some people who have that many. Most people settle for two, however—one to adapt daylight for tungsten film, the other to adapt tungsten light (specifically, 3200K light) for daylight film. You need such a simple conversion kit if you should decide to shoot outdoor pictures when you still have half a roll of tungsten film in your camera, or when you have a half-used roll of daylight film in your camera and decide to shoot indoors.

But there may be special times when you need one or two of the other filters, which can be bought in most camera stores. For example, you may decide that you wish to expose tungsten color film with ordinary 100-watt light bulbs instead of using 3200K bulbs. Ordinarily, this would give you pictures that are too reddish-yellow, but an 82B filter would bring them back into line. But why would you want to use 100-watt bulbs instead of 3200K?

Well, 100-watt bulbs are much cheaper, they hold up much longer, they are easier on the eyes, they are more readily available in stores, and they are not nearly as hot as 3200K bulbs, which are very hot indeed. Furthermore, if you are doing available-light photography, the bulbs in most homes tend to average out around 100 watts. Such factors may influence your decision to use 100-watt lamps, though it is generally easier to use 3200K lamps on account of their brightness. On the other hand, you might try them just to see if the recommended filter will bring their color temperature up to 3200K. It will.

Another factor in your decision to buy an 82B filter may be that you might run into situations where you don't have the option to use brighter bulbs—it could be disturbing to people. Or you might not have any with you, for they are not generally carried in gadget bags. Thus the filter could be considered as emergency equipment. Surely, it doesn't hurt to have one—who can tell what might happen?

The filters on the list require exposure changes ranging from slight to fairly substantial. Once again you can solve the increase problem by taking your light reading through the filter. This exposure increase is sufficient to suggest that you should ordinarily use conversion filters with faster films such as Ektachrome 160, Ektachrome 200, Ektachrome 400, and Kodacolor 400. Though you can also use slower films, you would also find yourself using very slow shutter speeds and large apertures and having a problem with the reciprocity effect, which I will tell you about later.

I do not suggest that you buy twelve conversion filters, for that would really be gilding the lily. The important thing is to know that they exist and that you can get one or two if you need them.

Some of the filters don't change the color of the light source they are paired with to exactly 3200K or 5500K. However, they come close enough for all practical purposes. This information was taken from a light-conversion nomograph in one of the Kodak publications, and when Kodak says you can do something with a light or a film, they are always right—they have to be.

Remember that these filters are strictly for making the colors on your film come out the way you think they should. They do this by adjusting the color temperatures of light sources to agree with the color temperatures for which films are balanced. All this is done with filters that are either yellowish or bluish. There is hardly any magic to it at all, so don't be unduly impressed.

In this chapter you should have gotten the idea that the color of light by which you photograph has something to do with how your pictures come out. We have dealt mainly with so-called white light, which can be any color of the rainbow without your being aware of it. The point is that your film does notice such differences, so you ought to know a little bit about matching films to light sources. You can strictly wing it, of course, but that is another story.

FILTERS FOR CONVERTING VARIOUS LIGHT SOURCES TO 3200K OR 5500K

	Filter for Tungsten Film (3200K)	Filter for Daylight Film (5500K)
Clear skylight (open shade) (10,000K)	86	85
Overcast sky (7000K)	85B	81C
Photographic daylight (5500K)	85B	none
Carbon arc (5500K)	85B	none
Flashcube (5000K)	85	82A
Blue photolamp (4900K)	85	82A
Clear flash (zirconium) (4100K)	85C	80D
Two hours after sunrise (3900K)	81EF	80C
Two hours before sunrise (3900K)	81EF	80C
Clear flash (aluminum) (3800K)	81EF	80C
One hour before sunset (3600K)	81C	80B
One hour after sunrise (3600K)	81C	80B
500-watt 3400K photolamp	81A	80B
500-watt 3200K photolamp	none	80A
Sunrise/Sunset (3100K)	82A	80A
100-watt general service bulb (2900K)	82B	
75-watt general service bulb (2800K)	80D	
40-watt general service bulb (2650K)	80C	

The bluish overcast sky softens all the color in this picture, which is good. The muted color forms a good pictorial environment for a man hard at work.
[Photo by Ronn Kilby]

This man and the sawmill seem lost in the forest, the source of thousands of trees that will be turned into lumber. The action seems to be taking place in a bygone day.
[Photo by Douglas E. Throp]

This girl is also in the woods, though the trees are at some distance. They shade her face so that it is lit by open sky, which gives a slightly bluish effect.
[Photo by Ralph Hattersley]

Except for the fact that it hasn't been retouched, this looks like a formal studio portrait. The lighting is very bold, the face rugged. We see a man who knows what he wants and gets it.
[Photo by Ronn Kilby]

This girl is hard at work — in a beauty contest in Jamaica.
[Photo by Ralph Hattersley]

The color here is all soft and warm — no bright or cold colors at all. In portraits you can often get along without them.
[Photo by Ronn Kilby]

This picture was shot on daylight film by the light that was streaming through the windows.
[Photo by Ralph Hattersley]

This picture was shot on tungsten film under a light source
for which the film was balanced. Note that the colors
are very natural.
[Photo by Ralph Hattersley]

Using Flash

Nearly everyone has used flash at one time or another, and it is a favorite tool among those who know hardly anything at all about photography. Though it won't do everything, it is extremely useful because it gives you lots of light in situations where the available light may not be strong enough. It is especially good for indoor work, though it can also be used outdoors. There is even enough light for films that are very slow — for example, Kodachrome 25 (ASA 25).

● **Guide Numbers**

A guide number is a special number that you use to determine the proper f/stop to use when you shoot a picture. The f/stop and the flash itself control how much exposure you will get. To find the proper f/stop you divide the guide number by the subject-to-light distance in feet. Say your guide number is 28 and your subject is ten feet from the light — that would give you 28 divided by 10, or 2.8. Use f/2.8 as your aperture setting. If you get a result like 3.0, which your camera doesn't have, you simply estimate the aperture setting.

As you see, the guide number system is very simple. It can be made even simpler by working out some of your f/stops in advance — say, for three, five, seven, and ten feet, all common working distances. Then print them on a card and tape it to the back of your camera for ready reference.

There is a guide number for each combination of film speed and flashbulb or electronic flash unit. For example, the guide number of 28, used above, may be just right for Kodachrome 25 and a particular make of electronic flash unit. With film of another speed, or with a unit that has a different light output, you would need another guide number. Similarly, each combination of film speed with a particular kind of flashbulb or cube has its own guide number. Naturally, there are a good many guide numbers, but this needn't concern you. You need only one — for a particular film (you should standardize on one type) and for the particular type of flash equipment you intend to use. Once you have this single guide number, you are in business and can use it all the time.

Information sheets that come with films frequently give trial guide numbers. They are usually correct but may have to be changed to fit the equipment you are using, which is easy enough to do. What you may need is a personalized guide number.

To find your personal guide number, make some photographs of an average subject (say, a small group of people) at a distance of exactly ten feet. Use a series of f/stops, preferably all that you have on your camera. Then work backwards from the picture with the best exposure — the f/ number used for that picture x 10 = the guide number. For example, if f/8 gives the best exposure, the guide number would be 80.

77

If the correct exposure falls between two stops, you can estimate the guide number. Say it falls between $f/8$ and $f/11$. The $f/8$ would give you a guide number of 80, while $f/11$ would be 110. The average would be 95 — your personalized guide number.

This test works for both regular flash amd electronic flash. If you intend to use a filter to change the light color, have it on your camera during the exposures.

Your guide number will work very well in most indoor situations where rooms are of average size. The light reflected from walls will help illuminate your subjects. However, if you go into a very small room with light-colored walls (say, a bathroom), stop down one stop. If you photograph outdoors at night or in a very large room (say, a gymnasium), open up one stop. Because the figures in this paragraph are only approximate, it would be advisable to bracket.

● Kodachrome 25 Guide Numbers

When you go shopping for electronic flash you will see that the output of many units is measured in terms of their guide numbers for Kodachrome 25, which has an ASA speed of 25, as the name implies. Why manufacturers do this I'm not quite sure, but it has gotten to be an industry-wide habit. At any rate, we are stuck with it, so we might as well make the best of it.

The problem is to get from the guide number for ASA 25 to the number for the ASA of film you are actually using. There is a simple way to do this for ASA speeds that increase by multiples of 2 from 25 — i.e., ASA 50, 100, 200, 400, etc. Simply cut the given ASA 25 guide number in half and multiply the result by each of the $f/$ numbers, starting with $f/2.8$ — 2.8, 4, 5.6, 8, 11, and 16.

Say you have a unit that is rated at a guide number of 60 for Kodachrome 25. Halving the 60 gives us 30, which we multiply by the $f/$ numbers. The results of the multiplications give us the following new guide numbers: 84 (for an ASA 50 film), 120 (for ASA 100), 168 (for ASA 200), 240 (for ASA 400), 330 (for ASA 800), and 480 (for ASA 1600).

If the ASA of the film you wish to use falls between two of the foregoing speeds, it is safe to estimate the new guide number. Say your film is rated at ASA 160 (about halfway between ASA 100 and 200), you would determine the number that falls halfway between the guide numbers for these speeds (120 and 168), which would give you an ASA 160 guide number of about 144. Mathematically, this isn't quite kosher, but it works very well.

The system doesn't have to be perfect, because you should run an exposure check to get a personalized guide number anyway. This check is made necessary by the fact that manufacturers sometimes overrate their flash units, giving them ASA 25 guide numbers that are too high. This makes the units seem more powerful than they actually are.

● Electronic Flash Guide Numbers Based on BCPS

Though manufacturers often express unit output in terms of Kodachrome 25 guide numbers, they may also express it in terms of beam candlepower seconds (BCPS). Below we have some trial guide numbers for different ASA-speed and BCPS ratings. Remember that you should run a check on any guide number you come up with.

This chart will help you rate the outputs of electronic flash units in terms of what you really want to know about them — their guide numbers with films of various speeds. As you can see, even the smaller units have ample outputs. For example, a 350 BCPS unit gives you a Kodachrome 25 guide number of 20, which means

that you can expose this slow film at $f/2.0$ at ten feet. On the other hand, you can expose Ektachrome 160 (ASA 160) at $f/5.5$ at that distance. This is not bad for a small unit.

There are lots of numbers on this chart, but don't let that bother you. For a particular flash unit and film combination you need only one of them—the guide number.

● Computer Dials and Charts

Many flash units have charts or computer dials on them to help you choose the right f/stop for a given shooting distance and a film with a given ASA rating. This is very good, of course, but they give a lot more information than you need, which can be confusing. The thing to do, as I mentioned before, is work out in advance the f/stops for various shooting distances and a particular ASA speed and write them on a card. Then tape the card to the back of your camera for quick reference.

● No Information

Because information confuses many people, a lot of flashcubes, flash bars, flipflash units, and other items are sold without it. In other words, you aren't given the slightest clue concerning how to use the materials, which would seem to be a serious oversight on the part of the manufacturers. The oversight is intentional, however, for these flashbulbs are designed mainly for use on cheap little flash cameras with fixed focus, fixed apertures, and one or two shutter speeds—cameras that are really very crude, all working in the same way. The manufacturers assume that you will use a film rated at about ASA 80 and that you will stand five to seven feet away from your subjects, which is about average.

They further assume that you will use a direct-print (color negative) film such as Kodacolor II, which now has an ASA of 100. For cheap cameras this is even better than ASA 80. This film has a lot of exposure latitude, so that anything shot in the five-to-seven-foot range will be fully

Film Speed BCPS	350	500	700	1000	1400	2000	2800	4000	5600	8000
ASA 25 guide no.	20	24	28	35	42	50	60	70	85	100
ASA 50 guide no.	30	35	40	50	60	70	85	100	120	140
ASA 64 guide no.	32	40	45	55	65	80	95	110	130	160
ASA 80 guide no.	35	45	55	65	75	90	110	130	150	180
ASA 160 guide no.	55	65	75	90	110	130	150	180	210	250
ASA 200 guide no.	60	70	85	100	120	140	170	200	240	280
ASA 250 guide no.	65	80	95	110	130	160	190	220	260	320
ASA 400 guide no.	85	95	115	140	170	200	240	285	340	400

printable, as will many things that are slightly out of this range. Since this system works pretty well for people who are not choosy about color pictures, the manufacturers abstain from confusing them with information they really don't want. From the user's point of view, the chief trick is to stick with Kodacolor II, which is easy enough to do. Films much faster or slower than ASA 80 or 100 would be badly exposed, and the system is not really safe with color positive (reversal) films because of their very short latitudes.

● Flash Modes

There are several modes in which flash is generally used. To make the rest of the chapter coherent, I will describe them at this point.

On-camera flash: also called *direct flash* or *straight flash.* The flash unit, regular or electronic, is mounted on the camera and pointed directly at the subject. Being on the camera, it is usually very close to the lens axis, which mainly accounts for on-camera flash pictures looking the way they do.

Off-camera flash: the flash unit is taken off the camera and held at a distance ranging from a foot or two to many feet. It is connected to the camera with an extension cord, though this is not necessary with open flash. It is generally pointed directly at the subject. The objective in having the flash off the camera is to create interesting light and shadow patterns on the subject.

Open flash: in a darkened room or area the camera shutter is held open on the "B" (bulb) setting, which is a way of opening the shutter for a long period of time. While it is open the flash is fired one or more times. This is a crude but effective way of synchronizing the flash with the shutter. Where the flash is fired more than once from different positions, it is a way to achieve the effect of more than one light source. It is also a way to illuminate an area too large to be covered

by a single flash. When the light is flashed more than once, the camera should be on a tripod.

Bounce light: during the flash exposure the flash unit is pointed at a reflecting surface – e.g., wall, ceiling, sheet of white paper – instead of at the subject. Light reflecting from the surface illuminates the subject. The objective is to get the feeling of natural, or available, light and to overcome certain shortcomings of on-camera flash, mainly its unnatural quality.

Bare-bulb flash: a flashbulb is fired from a unit from which the reflector has been removed, usually from an off-camera position. The light from the bare bulb bounces off surrounding walls and ceiling, helping to create a natural light effect.

Multiple flash: more than one bulb or electronic flash unit is fired at the same time. In electronic flash photography the secondary units are often slaves which are triggered by the flash from the main unit.

Flash fill: to lighten (fill) the shadows of a sunlit outdoor picture with flash, which adds to the ambient light, especially in the shadows.

● Problems with On-camera Flash

Most of the flash modes just described originated as ways to get around the shortcomings of on-camera flash. When the flash unit is mounted on the camera the effects are considered undesirable by some people, though this is open to question. Except for the red-eye effect and the differential exposure problem, most people aren't bothered by on-camera flash pictures. Furthermore, it is by far the most popular mode for making flash pictures.

Flat-lighted faces: direct flash is flat light in that it fills in all the shadows on faces and makes them look flatter than they are. The people most disturbed by this are certain advanced amateurs and professional photographers, who believe that a face doesn't really look right unless it has shad-

ows on it, as it nearly always does in everyday life. However, Mr. Brown's shadowless face still looks exactly like Mr. Brown, which is the important thing.

The other flash modes just described can all contribute shadows to faces, if that's what you desire. However, you should ask yourself if it really makes that much difference to you. If not, it is simpler to make on-camera flash pictures.

Dark shadow: in an on-camera flash picture there is usually a very dark shadow behind one side of your subject. It may or may not be intrusive, but it is not considered cool. Bounce or bare-bulb flash will lighten or eliminate this shadow, if you think it is that important. We could get along very well without such shadows, but they don't really do much harm. Furthermore, we have seen them so often that we are quite used to them, aren't we?

Dark backgrounds: in on-camera flash pictures things are progressively darker the further away they are from the camera. Thus in a large room the background behind someone might be nearly black. Pictorially, this doesn't always matter, but sometimes it does—dark areas may simply look bad in your pictures. One answer to the problem is to keep subjects fairly close to their backgrounds. Another is to use bounce flash, which levels out the subject-background tonal difference. And a third is to ignore the problem altogether and accept whatever tone of background you get.

I personally think that the dark background is the most serious defect in on-camera flash pictures. They often look dull and dingy, turning nice homes into slave-labor camps and dungeons. And as I said, bounce flash solves the problem very handily.

The red-eye effect: occasionally a person in a picture will come out with red or amber eyes—a very startling appearance. This is caused by light reflected from the blood-rich choroid layer behind the retina of the subject's eyes. It happens when the flash is very close to the camera lens,

and it is more prevalent in children than adults. The solution to the problem is to move the flash unit further from the lens with a flash extender or extension cord, or to use bounce flash.

Differential exposure: objects at different distances from the flash unit receive different amounts of exposure, which shows up very strongly in color films. For example, a subject at five feet will get twice as much exposure as one at seven feet, while one at three and a half feet will receive four times as much. Thus within a distance of only three and a half feet we have an exposure range of two full stops, which is a lot in color photography. Remember that a half-stop exposure error is all that is permissible for reversal color films.

The exposure differential problem can be most easily solved by lining up your subjects equidistant from the camera. If you can't do this, try bounce flash—though there will still be a differential, it won't be as great. If you have to line up your subjects at an angle to the camera, try off-camera flash with the light-to-subject axis at a 90-degree angle to your line-up.

Hot spots: if you are positioned directly in front of a mirror, a window, or some other shiny surface, it will reflect the flash back to the camera, making an objectionable hot spot. The simple way around this problem is to position yourself at an angle to such surfaces. I personally don't mind hot spots, but most photographers seem to.

● Bounce Flash

You have seen that flash is bounced by pointing the unit at a reflecting surface, letting the light reflected from the surface illuminate your subject. Such light is very diffuse and soft, making it especially good for pictures of people, for which it is most often used.

Though bounce flash is very popular among photographers, it has certain drawbacks, most of which can be overcome. Your guide numbers won't do you any good, for example; but you can learn to get along without them. A lot of light intensity is lost when light is bounced, so you may have to use larger *f*/stops than you prefer. Except with certain kinds of automatic electronic flash units, exposures are seldom as predictable as one would like.

Most bounce flash is done in homes, which generally have eight-to-nine-foot white ceilings. This gives you a starting point for solving the exposure problem, for you can almost always bounce light from the ceiling from a distance you can assume to be a constant. The thing to do is to make a series of trial exposures at different *f*/ stops, starting with an opening two stops larger than you would ordinarily use for a subject five feet away as determined from your guide number. The *f*/stop used for the exposure that turns out best should be the one you use thereafter for bounce flash in rooms with eight-to-nine-foot white ceilings.

Make your test in the position you intend to hold—standing or seated—when shooting most of your pictures. There is roughly a one-stop exposure difference between the two. Thus if you run your test while standing, you should open up a stop for sitting down. Though this figure is approximate, it usually works pretty well. However, on important pictures you should consider bracketing—just to make sure.

In ordinary rooms—living room, dining room, den, etc.—you should open up one stop if your subject is more than seven feet away. In a small, bright room, like a bathroom, you should close down a stop. For rooms with ceilings higher than nine feet, you should run separate tests, recording the results in a notebook so that you won't forget the figures. In time, you will find that you can estimate both the height of the ceiling and the exposure.

If you have an automatic electronic flash unit that has bounce-flash capability, you probably won't have to do any testing. We will say more about this in a moment.

The problem of having to use larger *f*/stops can be solved simply by using a faster film, which permits smaller openings. For example, with electronic flash or blue flashbulbs you could use Ektachrome 400 (ASA 400) or Kodacolor 400 (ASA 400). With ordinary flashbulbs use Ektachrome 160 (ASA 160). If necessary, these films can be push-processed to increase their effective speed, thus permitting even smaller lens openings.

Colored walls may give you a problem with bounce flash, because they will reflect light onto your subjects, thus changing their color. For example, a red wall will make a face appear reddish. However, most walls are muted in color, so that they don't make that much difference, though they will affect your subjects somewhat.

The main attraction of bounce light is that it helps to make things look as they usually do in available light. You might say that it gives them a kind of natural appearance. The exposure differential that gives you a problem with on-camera flash is no longer an important factor. Faces are no longer flat but have a delicate pattern of light and shadow. Backgrounds don't turn black or some other dingy color. There are no longer dark shadows behind subjects, nor is there any problem with the red-eye effect or hot spots.

The only difficulty is in learning to estimate your exposures correctly, but testing and experience will help in this. You get to a point where you can glance at a ceiling and pretty well know what to do. Though this might seem a haphazard way to go about things, thousands of photographers do it successfully.

● **Bare-bulb Flash**

Some flash holders are designed so that you can remove the reflectors. Shooting without a reflec-

tor, you get a result somewhat similar to bounce flash, because the bulb bounces light from all the surrounding walls. This is usually done with the flash unit at some distance from the camera. The best place to use it is in a small white or light-colored room. Stronger wall colors would be reflected onto your subject, not always a pleasing effect.

Since there is no reflector to concentrate the light on the subject, the exposure should be about two stops more than you would use for on-camera flash. To be sure of getting the correct exposure, bracket one stop over and one stop under the estimated exposure. The correct exposure is considerably influenced by the distance of the flash from surrounding walls.

Flash holders that fold will work for bare-bulb flash—simply use them in the folded position. However, you can't use flashcubes, flipflash, and most electronic flash units, because you can't eliminate the reflectors. Thus bare-bulb flash is mainly for use with flashbulbs.

● Electronic Flash

Electronic flash is touted as the surefire way to success in photography, and there is a great deal of truth in the assertion. Thousands of people who know virtually nothing about photography except how far to back up and what button to push are making effective pictures, often for money. Often the pictures are technically perfect, with correct exposures, good color balance, and maximum sharpness.

Seasoned professionals often depend heavily on electronic flash, and their studios are filled with heavy-duty units, though they also use the little portables that appeal to amateurs. They use every kind of lighting imaginable. However, many pros use on-camera flash for nearly everything. This includes press, nightclub, wedding, industrial-plant, and military photographers. Though on-camera flash has its deficiencies, it is still exceptionally good for many uses.

The flashing part of an electronic unit is a transparent tube filled with an inert gas under pressure. A concentrated charge of electricity is discharged through the gas, making a bright flash of very brief duration. All units have such a tube, a means of concentrating the electrical charge, and a means for triggering the flash when the camera shutter opens.

Most of the electronic flash units that interest amateurs (and many pros) are battery-operated, although many of them can also be operated from house current by means of an A.C. (alternating current) cord. This A.C. mode is very convenient, even if you don't intend to use it for making pictures. If a unit hasn't been in daily use it gets sluggish—the capacitor becomes "deformed." You can put it back in shape with a few warm-up flashes before you load film into your camera. These warm-ups require a lot more energy than normal flashes, so draw it from your house A.C. line and save your batteries from depletion.

Most electronic flash units are of the low-voltage type, though they aren't called that, and can be equipped with different types of batteries, each with its special virtues. Most popular are ordinary flashlight or penlight batteries, which can be discarded when spent. Next in line are nicads (nickel-cadmium cells), which can be recharged. Some nicads require overnight charging (on a household A.C. line), but others will quick-charge in less than an hour. Since recharging takes so much time, you are out of operation for an extended period of time while it is going on. This makes flashlight batteries especially attractive, because you can simply flip in a new set when the old ones are spent.

As batteries are progressively used up, the recycle time (the time it takes to recharge the unit for the next flash) gets longer and longer, until it may take ten seconds or more. However, if you are not in a hurry, this doesn't make any

A Vivitar automatic thyristor electronic flash unit in the bounce flash position. The white circle at the base of the unit is a sensor that measures the amount of light reflected by the subject. When enough light has been received, the thyristor circuit turns off the light.

difference. People who need a very short recycle time (such as news photographers) often use high-voltage battery flash units. Unfortunately, there are no rechargeable high-voltage battery packs; the batteries are expensive, and they wear out even when not being used. However, there is a simple way to get a quick recycle time with an ordinary low-voltage unit—switch to the A.C. mode of operation.

● Automatic Thyristor Units

Occasionally, even experienced photographers get bad exposures with electronic flash. This may be due to impatience and not waiting long enough between shots for the capacitor to become fully charged. Or it may be due to unusual reflectances. For example, there is quite a difference between shooting outdoors at night and shooting in a small room. Most often, however, the problem is the distance between the flash and the subject. If you make a wrong guess on the distance, your exposure may be way off. Problems of this sort are alleviated almost entirely by using automatic units.

Though there are several kinds of automatic units, the thyristor type is now the most popular, mainly due to its economy, dependability, and excellence. It embodies both a sensor and a thyristor circuit. The sensor measures the amount of light reflected by a photographic subject during a flash exposure. When it reaches the amount deemed appropriate for exposing the film, the thyristor circuit simply turns off the light. That is, the exposure is determined by light intensity and duration, and the thyristor unit controls it by controlling the duration. In a typical unit the duration may range from, say, 1/1000 second to 1/30,000 second. The closer the light is to the subject, the shorter the duration. As you can imagine, the sensor and the thyristor circuit work with incredible speed in limiting an exposure to as little as 1/30,000 second.

Since most flashes are interrupted in this manner there is a considerable saving of energy, and batteries last much longer than usual. Recycling time is cut way down too—for close-up subjects it may be less than one second. These are both factors that help to attract photographers to thyristor units.

Many units have a provision for bounce flash. The flash head swivels (on one or two axes), while the sensor remains pointed at the subject. Thus the sensor measures light that has been reflected twice—once from a wall, and once from the subject. However, it doesn't matter where the light on a subject comes from; the amount is all that counts. This the sensor measures with great accuracy. It is a special kind of exposure meter, you see.

Units of this sort take all the guesswork out of bounce flash, which is a great relief for many photographers. Though bounce units generally cost somewhat more than others, you should surely consider getting one if you intend to do much flash photography.

With thyristor units you are usually limited to using only two or three f/stops. The computerized units are programed for these stops, so that the sensors know how much exposure you will get with each one with different amounts of light. Though it is probably possible to program all the f/stops, two or three will do very well, and they make units less complicated. The stops chosen for programing work very well with 35mm cameras, but they are a little too large for larger cameras—for example, f/2.8 and f/5.6.

Though I have no data on the subject, I think you should expect a problem with the reciprocity effect at flash durations approaching 1/30,000 of a second. The reciprocity effect is an exposure phenomenon whereby film tends to lose effective speed during exposures of very short duration. Since the sensor doesn't know about this loss, it doesn't compensate for it. Thus you might expect underexposure when photographing close-

up subjects at extremely brief flash durations. Once you know the degree of underexposure, you can compensate by opening up a bit without telling the sensor you are using a larger *f*/stop.

Another aspect of the reciprocity effect in color films is a color shift, for which you can compensate with appropriate filtration. To move away from a color you use a filter, usually very weak, of the complementary hue. For example, you move away from a blue color shift with yellow filtration. If the filter requires an exposure increase, as some do, you can open up a bit without telling the sensor. For instance, a CC10Y (yellow) filter requires an additional one-third stop exposure, so you can open up one third of a stop.

● **Color Temperature**

Theoretically, all types of electronic flash units, thyristor as well, produce light that is very close to 5500K and are thus ideal for daylight color films without the use of filters. In practice, however, many units give somewhat bluish effects. Some manufacturers compensate for this by installing gold-colored reflectors in the flash heads, while others use built-in flash filters. For an uncorrected unit that gives you too much blue, a CC05Y (yellow) filter will probably solve the problem—it requires no additional exposure.

In recent times there have been complaints about reddish, or "beefy," faces, accompanied by bluishness in the very light and white colors and in facial highlights. Now, a beefy color is essentially a magenta, which has quite a bit of blue in it. The correct filtration would thus seem to be yellow, which would subtract much of the blue from the beef, leaving the face its normal color. A CC05Y or CC10Y filter should do the job.

With the whole gamut of Kodak color correction (CC) filters, the possibilities of modifying the light from flash units are extensive. For-

tunately, many electronic units require no correction at all, and the rest can usually be satisfied with yellow filtration. However, the bluishness tends to get progressively stronger with flashes of increasingly short duration, so you may need filters in different strengths of yellow in order to compensate. This applies only to thyristor units, of course.

Many photographers don't bother with filters —they just take whatever pictures they get. But if you are reaching for perfection you ought to know the general procedures to follow.

● **Angle of Coverage**

Most flash units, regular and electronic, have an angle of coverage similar to that of a normal lens —for example, a 50mm lens on a 35mm camera. With a wide-angle lens there is a definite darkening or lighting fall-off toward the edge of the picture. Though bounce flash will even out the fall-off, it may not be convenient to use it. Thus it would seem as if you were stuck with a normal lens. However, a few electronic flash units have provision for wide-angle, normal, and telephoto coverage, all with a single unit. This is sometimes done with fresnel lenses over the flash head; they can either broaden or narrow the light beam.

It is convenient, of course, to have a flash unit with a variable angle of coverage, though most flash pictures are taken with normal lenses, which don't call for such a unit. Even so, it is nice to know that you can use wide-angle lenses if you want to, since they are very convenient for indoor work in cramped spaces.

In the telephoto mode a variable-coverage unit gives you quite a bit higher guide number, because the light beam is more concentrated. This in turn may extend the distance at which a thyristor-type unit will work on automatic. It also means that you can take pictures at a considerable distance—say, with a 135mm lens.

● Synchronization

For shooting flash pictures the flash has to be synchronized with the shutter. That is, there has to be a timing arrangement so that the light of the flash reaches its peak when the shutter is wide open. With cheap so-called flash cameras the synchronization is built-in and automatic. You just use the kind of flash, regular or electronic, for which the camera was designed, and everything will be all right. For example, if a camera is designed for flipflash, it will automatically synchronize flipflash exposures.

Most modern 35mm cameras have focal-plane shutters which are fully open only at speeds of 1/60 second or less. The built-in synchronization—the "X" setting—times an electronic flash to fire at the precise moment the shutter is open at its fastest full-open speed. Not being able to sync at higher speeds is a definite disadvantage, but one that photographers learn to live with. The main problem is that it makes it difficult to use the flash outdoors for fill-in flash pictures. With the camera of necessity set on, say, 1/30 second, it simply gives you too much exposure in many situations.

Ghost images are another problem with cameras that sync at slow speeds. At a speed of 1/30 second the ambient light may be intense enough to form a secondary image while the shutter is open, before or after the flash goes off. If the subject or camera is moving, you would get a "ghost." Two exposures would be superimposed on each other. To get a ghost you need a rather bright light in the room and/or a rather fast film. With lower light levels and the slower types of color film, ghosts are no problem. The fact that you may never have seen one indicates that you shouldn't worry about them very much.

The cameras that sync at slow speeds have focal-plane shutters, which aren't ideal for flash work. However, leaf-type between-the-lens shutters are very good, because they will synchronize at the higher shutter speeds. With them there should be no ghosting problem, and they are very good for outdoor fill-in flash.

● Freezing Action

One of the irritants of indoor available-light photography is that subjects often move just as you shoot their pictures—or you yourself move, which has approximately the same effect. The pictures are fuzzy. This is because of the slow shutter speeds involved—they can't freeze movement.

With electronic flash this is no problem at all. The light is turned on for such a short interval that it will freeze all ordinary action, your subject's and your own. You can even have your subjects running around. Ordinary flash also tends to freeze action, but only up to a point. You still have to consciously hold the camera steady and try to catch your subjects when they are not moving. It is like using a shutter speed that is quite a bit faster—it will help, but not go all the way.

For freezing very fast action such as the moving parts of a machine, a thyristor unit very close to the subject is the best bet. Remember, you get flash durations approaching 1/30,000 second. There are even units as fast as 1/50,000 second. Naturally, these will freeze very fast action.

Some people get so steamed up about freezing action that they take most of their pictures for this purpose alone. It was a very big thing in the early days of electronic flash. Well, if this is what you want to do, hop to it—it is as good a hobby as any. For most photographers, however, the action-freezing capability is just a boon to help them do a better job of taking the kinds of pictures they would ordinarily take. It also frees them to let their subjects move a bit and to move themselves when so inclined. No panacea, action freezing is just another photographic tool.

The gleaming whiteness of the dog against the green
makes for a beautiful and improbable combination.
Bowser is probably looking for frogs or water bugs.
[Photo by Dale Strouse]

A burst of birds flashing in front of the camera. The blurring is caused by their own movement and a bit of camera movement as well. It causes a kind of fantasy effect, appropriate for wild things in flight.
[Photo by Terence Knight]

Shooting at a rather slow shutter speed, the camera was panned to the left to keep the horses fairly sharp while turning the racetrack into a blur. This is a photographic way of suggesting speed.
[Photo by Terence Knight]

The whiteness of this kitten is emphasized by the dark background. The pictorial rule is that darks make whites look even whiter.
[Photo by Benton Collins]

Like a framed painting, this rooster resembles a work of art. Actually, he is basking in the light, for the henhouse is quite dark.
[Photo by J. Bailey]

Like a dark priest standing in his pulpit, this grasshopper surveys his green world. Except for his knees he isn't quite sharp, but it doesn't really matter.
[Photo by Dale Strouse]

A unique double web made by an extremely industrious spider. The dew sparkling in its threads makes it look like a jewel.
[Photo by Douglas E. Throp]

This young fellow doesn't think that we see him, for his
protective coloration disguises him well. Like a green
ghost he glides unseen through the foliage.
[Photo by Dale Strouse]

The picture with the darker face was a straight shot. The other one had fill-in flash. As you can see, flash is used outdoors to lighten shadows, or "fill" them.

● Fill-in Flash

Fill-in flash is used mainly on bright sunny days with backlighted subjects, usually people. Since they are backlighted, their faces and bodies would normally come out too dark if the exposure is made for the overall scene. They are in the shadows, so to speak. The trick is to use flash to fill in the shadows. Thus you get a flash exposure superimposed on a daylight exposure, both happening at once. The daylight exposure is mainly for the overall scene, the flash exposure for your subject.

Getting the daylight exposure right is no problem at all—a simple reading with an exposure meter will do the job. However, getting the flash exposure correct is a little tricky—the problem is to get just the right amount of flash, neither too little nor too much. The amount of flash that falls on your subject is dependent on the flash unit-to-subject distance, which may not be the same as the camera-to-subject distance. That is, you may have to operate the flash from an extension cord so that it can be positioned in front of or behind the camera. This means that either someone must hold the flash unit for you, or you must attach the unit to a light stand.

Since the shadowed portion of your subject is already reflecting quite a bit of daylight into the camera, you don't want a full flash exposure. This would give you overexposure when the flash and daylight exposures are superimposed. Instead, you should choose a flash unit-to-subject distance that would give you about one stop underexposure. This underexposure plus the daylight exposure should come out about right.

Let us assume you are using Ektachrome 64 (ASA 64) and a flash unit with a guide number of 65 for that film. This would give you a sunlight exposure of 1/125 at $f/11$. Set your camera at $f/11$ and leave it that way. You can then use the guide number to tell you the flash-to-subject distance for a full flash exposure: the guide number

divided by the *f*/number (*f*/11) will give you the distance, which is about six feet. However, you want the flash exposure to be one stop under, so you would want the light further back. Use the next smallest *f*/stop (*f*/8) for your figuring, but leave your camera set on *f*/11.

Divide the guide number by *f*/8 and come up with the correct flash-to-subject distance, which is eight feet this time. For fill-in flash your flash unit should be eight feet from the subject. Once you know the distance with a particular flash unit, film, and *f*/number, you can use it again and again without going through these calculations.

If such calculations distress you, as they do many people, there is a simple way to arrive at the subject-to-flash distance. Shoot a series of flash pictures of the same subject with your flash at different distances. The one that comes out best will tell you the distance you should always use with that particular film and flash unit.

Fortunately, there is even an easier way to get the distance—if you know the BCPS rating of your flash unit. Just use the following chart (courtesy of Eastman Kodak), which works on any film. (The camera settings are based on the ratio of flash to sunlight, not on the film speed.)

This chart is for interchangeable-lens cameras with focal-plane shutters. Since some shutters will not synchronize at speeds faster than 1/60 second, you had better check your camera's instruction book. At shutter speeds as slow as 1/30 second you should use a slow film such as Kodachrome 25 (ASA 25), which will give you a daylight exposure of 1/30 at *f*/16. With faster

Subject-to-flash Distances for Fill-in Flash with Electronic Flash
(Distance in Feet)

Output of Unit BCPS	Shutter Speed with X Synchronization		
	1/30	1/60	1/125
350	$1\frac{1}{2} - 2 - 3\frac{1}{2}$ feet	$2 - 3 - 4\frac{1}{2}$ feet	$3 - 4 - 7$ feet
500	$2 - 3 - 4$	$2\frac{1}{2} - 3\frac{1}{2} - 5\frac{1}{2}$	$3\frac{1}{2} - 5 - 8$
700	$2 - 3\ \frac{1}{2}$	$2\frac{1}{2} - 3\frac{1}{2} - 6$	$4 - 5\frac{1}{2} - 9$
1000	$2\frac{1}{2} - 3\frac{1}{2} - 5\frac{1}{2}$	$3\frac{1}{2} - 5 - 8$	$5 - 7 - 11$
1400	$3 - 4 - 7$	$4 - 5\frac{1}{2} - 9$	$6 - 8 - 13$
2000	$3\frac{1}{2} - 5 - 8$	$5 - 7 - 11$	$7 - 10 - 15$
2800	$4 - 5\frac{1}{2} - 10$	$6 - 8 - 13$	$8 - 11 - 18$
4000	$5 - 7 - 11$	$7 - 10 - 15$	$10 - 14 - 20$
5600	$6 - 8 - 13$	$8 - 11 - 18$	$12 - 17 - 25$
800	$7 - 10 - 15$	$10 - 14 - 20$	$15 - 21 - 30$

films you would overexpose at that speed and f/stop.

To use the table, just locate the output of your flash unit and read to the right to find the subject-to-flash distance for a good fill-in flash shot. You will get full fill when your subject is at the near distance, average fill at the middle distance, and slight fill at the far distance. You should generally use the middle distance.

An example might be useful. With a film rated at ASA 100 (such as Kodacolor II), your basic exposure for a normal sunlit subject would be 1/125 at f/16. Let us say you have a 2000 BCPS unit and want a moderate amount of fill. According to the chart your light should be ten feet away from the subject, but you want your camera to be within five feet. You should then use the flash on an extension cord at ten feet. An alternative would be to use the flash on the camera and cover it with a single thickness of handkerchief, which will cut the amount of illumination approximately in half.

The problem with most electronic flash units is that they provide too much light to be used conveniently for fill-in flash outdoors. One answer is to have a second, small unit with a minimum of output for fill-in work.

With an automatic flash unit you don't need the chart for fill-in flash. However, when you are setting the film speed on the unit you should increase it, so that less light will be produced. Remember that you want less than a full flash exposure for fill-in. Doubling the film speed will give you half the light, which is about right.

● **Electronic Flash Meters**

There are special rather expensive meters for reading electronic flash, but they will generally read flashbulbs and available light too. They give very accurate readings and are very dependable. They are mostly used by professionals in studio photography, who often use very complicated lighting setups for which guide numbers for the lights would be of little use. Most meters read directly to give you the f/stop you should use for a particular lighting situation. They are especially useful for bounce flash or for work with umbrellas, which is a kind of bounce flash.

● **Umbrellas**

Made especially for photography, there is a special type of umbrella that is used in conjunction with flash units. These umbrellas are coated with various reflective substances, but silver Mylar is probably the best. To use one you simply position the flash so that it fires directly into the umbrella, which then becomes, in effect, the light source. You can use the regular flash guide number, but you must increase the exposure by one and a half stops.

An umbrella is usually attached to an adjustable light stand so that it can be raised, lowered, and aimed, but there are also portable rigs that can be hand-held. Some photographers use a single umbrella for all their work; others use several.

An umbrella is very much like a large floodlight, except that it doesn't get as hot and is not as hard on the eyes. It is also a good way to get portable and aimable bounce flash. It can be used at times when regular bounce flash is impossible or the wrong choice—for example, when walls and ceilings are too far away or when they have a strong color that would be reflected into the camera.

An umbrella spreads the light, so that you can use wide-angle lenses. The light is very soft and diffuse, which makes it especially good for portraits. The diffusion minimizes facial blemishes, so that many of them simply disappear. It also softens wrinkles and lines.

An umbrella eliminates hot spots, so that the subject is lighted more evenly. It also tends to minimize lighting fall-off, so that subjects at dif-

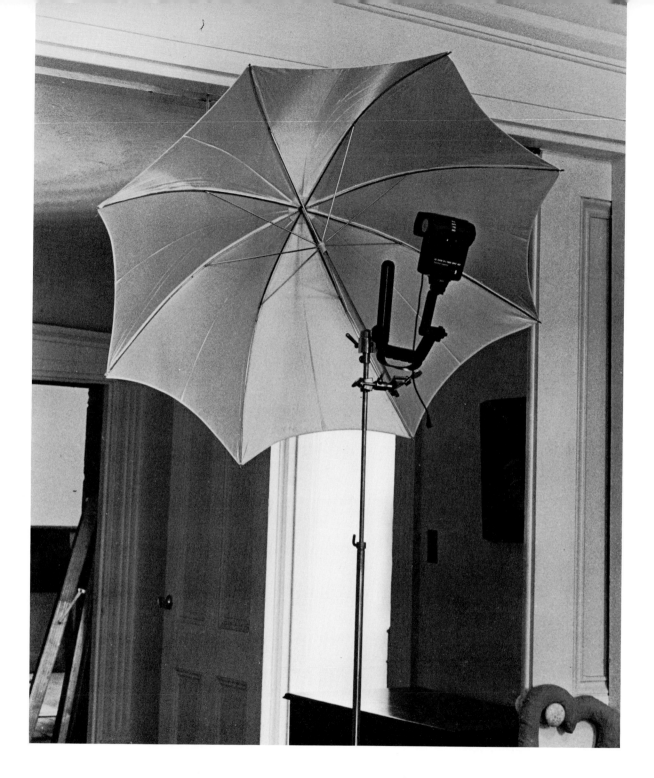

A Vivitar flash unit jury-rigged for use with a light
umbrella. This is a popular way to get portable and
aimable bounce flash. The lightings produced are
roughly equivalent to what you get with a photoflood
lamp in a large reflector. The umbrella is made of a
metallic material that reflects light very well.

ferent distances from it are more evenly exposed than with on-camera flash. There is still fall-off of illumination, but not as much.

Professional studio photographers who use umbrellas often use them with flash meters. However, many do not. Through experience they learn what f/stops to use with different umbrella-to-subject distances, and they continue to use them again and again. It is easy enough to work out the guide number for an umbrella. Just position it at a set distance from a subject and make a series of shots. Take the f/stop for the exposure that comes out best and multiply it by the light-to-subject distance to get the guide number.

There is a kind of thyristor unit that should work well with umbrellas. The flash head can be separated from the sensor unit and operated at some distance from it. With the head in an umbrella and the sensor on the camera reading exposures, the general exposure problem ought to be pretty well solved. This should eliminate the need for a flash meter, for the sensor itself is a kind of meter.

● **Two-light Flash**

For a given picture you may want more than one flash, depending on the kind of lighting you plan to use. There is not much point to it, however, unless you know how one or more additional lights will affect your subject's appearance. Some expensive studio electronic flash units have modeling lights, so that you can actually see in advance what the pattern of light and shade will look like. These are low-wattage tungsten bulbs incorporated into the units near the flash tubes. They don't give off much light, but you can still see after a fashion.

Since it is unlikely that you will ever have such a unit, you have to learn from experience what a particular lighting arrangement will do to a subject. Photographers generally get this experience by working with photoflood lamps in ordinary round reflectors. With them you can plainly see what your subject looks like. Each time you work with a subject you should mentally note the position of the lights for various effects. Placed in the same position, flash lamps would do about the same thing. So it's a matter of remembering what lighting arrangements you used and how they worked out. You use flash lightings to duplicate floodlightings.

It is convenient to think of two-light flash as an effort to simulate the outdoor condition of hazy sunlight. The light representing the sun is dominant and is usually rather high and off to one side. The light representing the sky as a source of light is on the camera and is subordinate to the other. Since the lights should be identical units, each with its own power supply, we must see how this subordination is achieved—it is a matter of distance. The sun light (also called the main light) is about one third closer to the subject than the sky light (also called the fill because it lightens the shadows). The main light establishes the main pattern of light and shade on the subject, while the fill light reduces the lighting contrast. The main light gains dominance simply by being closer.

The main light, or sun, is usually a slave unit. That is, it is equipped for remote firing by a photoelectric cell that is triggered by the flash from the light on the camera. Since it is off to one side and quite high, you need a light stand or someone to hold it for you. It is odd to think of the sun as a slave, but that's how it is in this case.

With your sun light (slave) one third closer to your subject than the other, you can use its guide number for selecting your f/stop—simply ignore the sky or fill light, which is mainly involved with lightening the shadows.

You may wonder what you accomplish with two lights as opposed to on-camera flash:

1. With your dominant (main) light coming from above and to one side, your subjects will be rounder, more three-dimensional.

2. They will generally be separated more clearly from the background.

3. Subject textures will be more strongly emphasized.

4. The underlighted background and overlighted foreground problem will probably be overcome.

5. A two-light lighting is more like available light and thus more natural-looking.

6. It has many more creative possibilities, because you can establish a large number of geometrical relationships between two lights. You can best learn what these possibilities are by working with floodlights. Then you can see precisely what you would get with flash.

One way of working with flash is to set up floodlights first, then replace them with flash units just before shooting. This is a roundabout way, of course, but it will help you to learn what various light positions do for photographic subjects. Though you could even shoot your pictures with photofloods, it might be best not to. With electronic flash you can freeze action and shoot at a much smaller f/stop.

This chapter on flash has covered its main possibilities, though there are many other things you can do with it. You have seen that there can be more to it than on-camera flash—which is good, of course, but not the whole story. There are some problems, such as guide numbers, but they are fairly easily solved. As the saying goes, a little bit of knowledge goes a long way.

More About Exposure

By now you have seen that getting the correct exposure is an extremely important part of photography. This is especially true when you are using color reversal films (positive transparency materials), because the exposure latitude is very short. That is, the margin for error is very small. As we have seen, there is about one-half stop latitude on either side of the correct exposure, which isn't very much. Since exposure is so very important, we will take it up in some detail in this chapter.

● The Law of Reciprocity

Photographic exposure is described by a so-called "law," which is actually a definition and not a law at all. The classical statement of this law is: $E = I \times t$. The E represents the quantity of light per unit area received by a photographic material and is thus the "exposure." The I stands for illuminance, or light intensity. And the t stands for time. Thus exposure equals light intensity times time. This is the definition of exposure.

As you know, you can have different degrees of light intensity and use different amounts of time. Within certain limits the lens aperture controls the intensity of light reaching the photosensitive material, but the intensity of the light source itself is also a control factor. On your camera the shutter mechanism controls the time; with an enlarger you use an exposure timer.

Light intensity and time can have a reciprocating relationship in determining exposure. They can go back and forth, as it were, and still give the same amount of exposure. For example, to get a given amount you may use a lot of intensity and little time, a little intensity and a lot of time, or a moderate amount of both intensity and time. In all three cases the amount of exposure can remain the same.

We can describe the same situation in terms of camera shutter (time control) and aperture (light-intensity control) settings. For example, all the following combinations will give you the same exposure: (1) 1/125 sec at $f/2$, (2) ½ sec at $f/16$, and (3) 1/15 sec at $f/5.6$. In the first we have a relatively large amount of intensity and little time. In the second we have relatively little intensity and a lot of time. And in the third we have a relatively moderate amount of both intensity and time. Remember, the aperture is one of the intensity controls, whereas the camera shutter controls the time.

The fact that you can get the same exposure with such radically different settings is very convenient in photography. For example, you can use a small aperture such as $f/16$ to get maximum depth of field (the plane of sharpness that extends in front and in back of the thing focused on). Or you can get a very limited depth of field

at, say, $f/2$ — which is sometimes desired for pictorial purposes. Also at $f/2$ you can get a fast enough shutter speed (in the example above) to enable you to hand-hold your camera without getting blurred images. Generally speaking, small apertures are for greater depth of field; fast shutter speeds are for freezing action, your subject's and your own. With a fast enough film and an intense enough light source (e.g., the sun) you can have both.

Let us go back to the beginning of this section for a moment. Exposure is defined as light intensity times time. This doesn't say what it *does* — it merely says what exposure *is*. Here we are not talking about the *correct* exposure but about exposure as such: $E = I \times t$.

● **The Correct Exposure**

The correct exposure is the one you need for a desired photographic effect. This is the definition in a nutshell. In color photography the correct exposure is also defined as what looks best when a slide is viewed on a standard light box or in a projector with a standardized light output. Thus if you think it looks right, chances are it meets the correct exposure standard. It is neither too light nor too dark.

It is good to know that the idea of the correct exposure has been pretty well standardized — it is based entirely on what average people like. All the books and articles that deal with it are designed to help you make your work conform to the standard. All exposure meters, charts, and guides are also designed with this in mind.

To get the correct camera exposure is usually not much of a problem, though it can be at times. There are certain things you can safely assume without thinking about them, and others that you must consciously know. You can generally assume that your shutter speeds are reasonably accurate and that the $f/$stops are of the correct size. You can usually assume that your exposure meter is working well if the needle moves in the accustomed way. It is also safe to assume that

the brand of film you are using will react to light in the usual way. If you send your film out for processing you can be quite sure it will go through a highly standardized processing line, which is important. Most of all, you can assume that the behavior of light in relationship to photosensitive materials is not likely to change.

The things you need to be conscious of are relatively few: (1) the ASA speed of your film (its relative sensitivity to light); (2) how to use an exposure meter, chart, or dial; and (3) the amount of light being reflected, transmitted, or emitted by your subject. As soon as you set the film speed on your meter you can safely forget about it for a while, which leaves you with just two problems: using your meter correctly, and setting your camera exposure controls. In this area you can safely follow the book — just do what the instructions tell you.

If you do this you will end up with the correct exposure, which consists of getting the right combination of light intensity and time for the ASA speed of the particular film you are using. It will be correct in that it will meet the standards for rightness established by the photographic industry. This applies only when you are doing the things that photographers, amateur and professional, usually do. If you are trying something different you will need a revised personal standard for correctness. In such a case you can look at it this way: if you get the pictorial effect you want your exposure is correct.

The actual techniques for getting standardized correct exposures are dealt with throughout this book. In this chapter we are mainly filling in some of the empty spots. It assumes that your knowledge of photography may not be monumental and that you may need some very basic information.

● **The Reciprocity Effect**

Once you have the correct exposure time at a certain $f/$number, you can usually apply the so-called law of reciprocity and come up with the

correct exposure times for all the other f/numbers on your camera. The easiest way is to look at the dial on your exposure meter, which is programed for the "law." Take your reading and set it on the dial. Across from each f/number you will see an exposure time, which you ordinarily assume to be correct.

Unfortunately, some of the exposures may not be correct, because the law of reciprocity only works within certain limits and assumes that film speeds are stable. However, with long or very short exposure times, a film generally loses speed. This loss of speed was once called "reciprocity failure" or "failure of the reciprocity law." Since it is not really a law and thus cannot "fail," the preferred term is now "the reciprocity effect." This term is applied to the loss of speed and several other phenomena that have the same cause: long or very short exposure times.

With long exposure times there may be an increase in contrast. With either long or very short times there may be a color shift in color films, requiring filtration to correct it. This is because the three emulsions lose speed and change contrast at different rates, throwing them out of balance with each other. Indeed, with very long exposures this shift may go too far to be correctable by filtration.

In the following chart we see how the reciprocity effect can be compensated for in certain popular Kodak films.

(NOTE: the films designated "professional" are mainly for people who use them under professional conditions, including refrigerated storage and processing very soon after exposure. Of equal quality, the other films are mainly for amateurs, who subject their films to more trying conditions, including nonrefrigerated storage and long intervals between exposure and processing. Thus the amateur films are designed to take more of a beating. Ektachrome 50 is specially designed for long exposure times. At exposure times from 1/10 to 100 seconds, for example, it requires no filtration.)

The best way to cope with the reciprocity effect problem is to avoid it by restricting yourself to exposure times that range between 1/1000 and 1/10 of a second. None of the films on the chart will give you trouble within this range, except for Ektachrome 50 Professional, which requires cyan filtration because it is color-balanced for longer exposure times. So avoidance is recommended. However, you can't always avoid longer exposures, so you should know what to do.

In all cases the filter corrections given on the chart are fairly small, indicating that the color shifts aren't great. If you can tolerate these

Exposure and Filter Compensation for Reciprocity Effect*

	Exposure Time (Seconds)					
	1/1000	1/100	1/10	1	10	100
Ektachrome 64 Prof. (Daylight)	None No Filter			+½ stop CC10B	+1 stop CC15B	Not Recommended
Ektachrome 200 Prof. (Daylight)	None No Filter			+½ stop CC10R	Not Recommended	
Ektachrome 50 Prof. (Tungsten)	None CC10C			None No Filter	+½ stop No Filter	+1½ stops No Filter
Ektachrome 160 Prof. (Tungsten)	None No Filter			+½ stop CC10R	+1 stop CC10R	Not Recommended
Ektachrome 64 (Daylight)	None No Filter			+½ stop CC10B	+1 stop CC15B	Not Recommended
Ektachrome 200 (Daylight)	None No Filter			+½ stop CC10R	Not Recommended	
Ektachrome 160 (Tungsten)	None No Filter			+½ stop CC10R	+1 stop CC10R	Not Recommended
Kodacolor II	None No Filter			+½ stop No Filter	+1½ stops CC10C	+2½ stops CC10C + 10G
Kodacolor 400	None No Filter			+½ stop No Filter	+1 stop No Filter	+2 stops No Filter
Kodachrome 40 5070 (Type A)	None No Filter			+1 stop CC10M	+1½ stops CC10M	+2½ stops CC10M
Kodachrome 25 (Daylight)	None No Filter			+1 stop CC10M	+1½ stops CC10M	+2½ stops CC10M
Kodachrome 64 (Daylight)	None No Filter			+1 stop CC10R	Not Recommended	
Ektachrome Infrared	—	None No Filter	+1 stop CC 20B	Not Recommended		

*Courtesy of Eastman Kodak

109

deviations from the norm—some people can, some can't—you can get along without the filters. These are Kodak color compensating (CC) filters of relatively low density. As you can see, the filters mentioned on the chart are blue (B), red (R), cyan (C), and green (G).

You can tell the direction of a color shift by finding the filter needed to correct it on the chart. The shift is toward the complementary color. If the chart calls for blue filtration, for example, you may be sure that the shift is toward yellow, which is the complement of blue. Similarly, a red filter indicates a shift toward cyan, etc.

Depending on your taste in color pictures, you may be able to ignore the suggested filtration, but it is not safe to ignore the exposure increases. Remember that color transparency films have a very short exposure latitude. If you neglect to increase the exposures your pictures may fall outside this latitude and be obviously underexposed.

The exposures requiring reciprocity compensation are charted in big jumps—from 1 to 10 to 100 seconds. For uncorrected exposure times that fall in between them it is safe to estimate the necessary increases. Your error is not likely to be as much as one fifth of a stop, which is negligible.

● Stop Language

In this chapter I have promised to fill in some of the gaps in your knowledge concerning exposure —assuming, of course, that there are gaps. You have probably noticed that the term "stop" has been used quite a bit, but do you know what it means? It is an essential word in the jargon of photography, one that most photographers couldn't get along without.

The term is derived from f/stops (f/numbers, or aperture settings) on your camera, which are generally called just "stops." A typical series of stops is f/2, f/2.8, f/4, f/5.6, f/8, f/11, and f/16.

These are all marked on your camera without the f's. They represent areas of the aperture at different settings. As you move from f/16 to f/2 the area is progressively doubled at each setting. Conversely, as you move in the other direction the area is progressively halved.

Enlarging the area is called "opening up"; reducing it is called "stopping down." As you open up a stop you double the aperture so that twice as much light passes through the lens in a given time interval. Conversely, stopping down one stop halves the amount of light passing through.

The "stop language" is often used to describe exposure changes by a factor of 2 (doubling, quadrupling, halving, quartering, etc.). Each time you open up a stop you double the exposure, while stopping down progressively halves it at each setting. If stop language went no further than this it would be quite simple. However, "stop" is also applied to an exposure change that can be made by changing the shutter speed. For example, changing from 1/125 to 1/250 second represents a one-stop decrease. Since the shutter settings increase in speed by doubles (or very close to it), we can use them to increase or decrease the exposure by a factor of 2.

Thus we have two different systems for increasing or decreasing the exposure by a factor of 2. In both cases an exposure change by one camera setting is called a one-stop change. It can change by two, three, or more stops too, of course. For a one-stop difference you change either the aperture or the shutter-speed setting, not both. For a change of two or more stops you can change both if you wish. For example, to decrease the exposure by two stops you can stop down by one f/number and increase the shutter speed by one setting. This cuts the area of the aperture in half and cuts the time interval in two, each step representing a one-stop exposure decrease. Together they add up to a two-stop decrease.

I am spelling this out slowly because beginners find it terribly confusing. The important thing to

see is that the word "stop" is often applied to several things: (1) the f/numbers on your camera, (2) an exposure revision made by changing the aperture setting, (3) an exposure revision made by changing the shutter-speed setting, and (4) an exposure revision made by changing both the f/number and the time interval.

Remember that shutter speeds represent time intervals and that they increase by doubling, often starting from 1/1000 second and increasing to as much as 1 second. Here you should remember that 1 is a much larger number than 1/1000. Since speeds like 1/1000, 1/500, 1/250, and 1/125 aren't printed on your camera as fractions, this can be confusing.

So "one stop" usually refers to an exposure change by a factor of 2—in terms of the correct exposure, it doesn't matter how you make the change. However, you may want to make a half-stop change. In this case you would set the aperture arrow between two f/numbers. If it looks approximately halfway between them, it will be close enough, though it actually should be a little closer to the f/number representing the smaller aperture.

There is one more confusing matter that should be mentioned in this section: light is sometimes referred to in terms of stops. For example, "The light on object A is one stop brighter than the light on object B." This simply means that A is twice as bright as B. Remember that when the word "stop" is used it usually refers to the progressive doubling or halving of something.

● **More About Gray Cards**

Though you have already been instructed in the use of a Kodak Gray Card for determining exposure, it wouldn't hurt to know a little more about the subject. For example, where did the idea come from? It undoubtedly came from the concept of light averaging as an exposure determination method. Here you take a meter reading from the lightest area in a scene in which you

want detail and the darkest area in which you also want detail and average the two readings. Then you use the average to set your meter dial and make your exposure determination. This is generally an excellent way to find the correct exposure.

The people who came up with the gray card idea had averaged the reflectance of literally thousands of photographic subjects and found that it was usually 18 per cent. This means that the average tone of the average subject reflects 18 per cent of the light falling on it. It also means that most photographic subjects can be considered average in this respect. At the same time, these experimenters found that exposing for the average tone is generally a very good thing to do.

A simple way to use this knowledge is to look for an average tone in a subject, take your reading from it, and make your exposure. If you know what tone to look for, it is a very easy and effective system, but most people don't know what represents the tonal average in the things they look at. The experimenters had an answer for this, however—you simply bring the average tone with you in the form of a piece of cardboard that reflects exactly 18 per cent of the light that falls upon it. Instead of looking for another such tone, you simply read the one you have.

However, there is a trick to keeping your portable average tone really average, for it will change in tone according to how it is oriented to the light source. For example, if you are photographing a scene and hold the face of your card nearly parallel to the ground it will look nearly black, not an average gray. On the other hand, if you face it directly upward it will be too light, looking nearly white in comparison with your scene. In both cases your exposure readings would be in error. In other words, you have to use common sense in using a gray card. In order for it to be average it also has to look that way, which you control by the way you angle it.

The usual way to use a gray card outdoors is to hold it vertical and angled halfway between the sun and your camera. If the sun is coming from

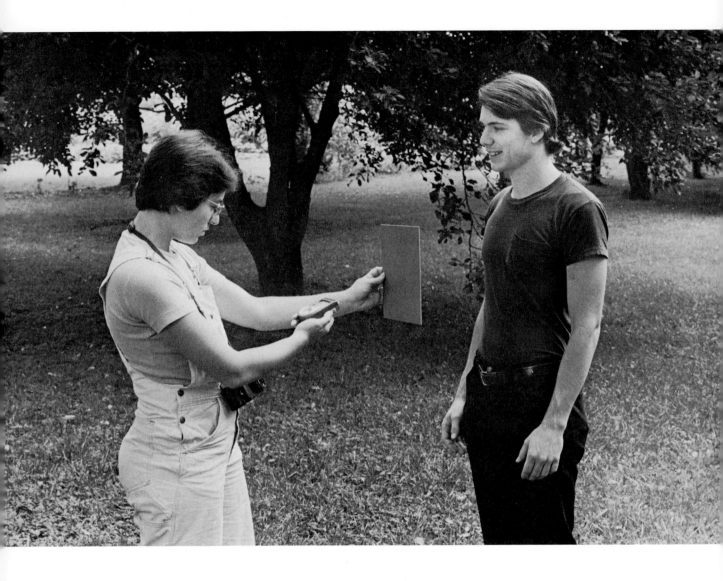

Taking a meter reading with a Kodak Gray Card. The card should be in the same plane as your subject and faced halfway between the light source and the camera position. The meter should be no more than eight inches away from it. In this type of reading you must take care not to read the background or your own shadow on the card.

directly behind you (that is, your subject is front-lighted), increase the indicated exposure by one-half stop. For other lighting angles, use the exposure indicated by your meter.

Indoors, hold the card in front of and up close to your subject and facing halfway between the light source and your camera. In a still-life setup the card should be right in the middle of it, so that both the setup and the card receive the same amount of light. This is a very important point indoors, because the light level can change radically as you move away from your subject. Outdoors, the light level is usually very even over wide expanses, so the gray card doesn't have to be close to your subject.

In all cases, your card should look average gray while you are reading it, which may call for a little angling and tilting. One way to decide whether it looks like an average gray is to sight your subject over it as if you were aiming a rifle, for then you can see how it compares with tones in the subject.

In deciding whether your card looks like an average gray it may help you to know how it should compare to certain other things when you hold it in front of them. It should look darker than some things and lighter than others.

It should be very much *darker than* whitest clouds, whitest snow, and bright-white paint. It should be quite a bit darker than light Caucasian skin, dry white sand, new unfinished wood, light-blue sky, dusty dirt, and lemons. It should be perceptibly darker than normal Caucasian skin, wet white sand, medium-dry earth, red brick, weathered wood, deep-blue sky, light grass and foliage, and oranges.

Your card should look perceptibly *lighter than* black skin, medium to dark grass and foliage, dry dark earth, and dark tree trunks. It should be quite a bit lighter than black fresh-turned earth, very black skin, and dark clothes. It should be very much lighter than most black objects and very dark clothes.

If you want to know if something is lighter or darker than average, simply lay your gray card on it. Then squint your eyes and look at the two of them together. The squinting lessens distraction by texture, color, etc., so that you can concentrate on making a tonal comparison, which is all that you are looking for. For example, you can compare your card to a piece of red cloth. Though they differ in color, they may have the same tone.

You should take all of your gray card readings from a distance of six inches, making sure not to read the background or the shadow of your hand. If you read your shadow you will overexpose. Reading a light background leads to underexposure; a dark background, to overexposure.

Perhaps the main problem in using a gray card is the feeling that it looks darker than an average gray, which isn't so. By long and rigorous tests it has been found to be about as average in tone as anything can be. That is, it really looks average if you bother to check it out. So if your card looks a little too dark to you when you hold it up, don't worry. It is truly an average gray tone – not an especially pretty one, but very good for making exposure determinations.

● How Color Reversal Film Sees an Exposure

If you use a gray card to determine an exposure, then take a picture of the card itself on color reversal film, the card should come out looking just the way it usually does: average. Indeed, anything that you take a reading from – be it black, white, or colored – will come out average in tone. For example, a black will come out gray, and so will a white. A red will continue to look red, but it will also be average in tone, possibly somewhat lighter or darker than the original hue. A yellow will come out too dark; a deep purple, too light. If you take your reading from a light Caucasian face, it will come out too dark, whereas a very black face would come out too light.

The thing to understand is that *a reading will*

always translate the thing that is read into an average tone in your transparency. The idea of using a gray card is to make average subject tones come out average and everything else proportionally lighter or darker, and this generally works very well indeed.

The notion of making average things come out average in pictures is built into all exposure meters, both incident and reflectance types. With a reflectance type you read the subject, presumably looking for an average tone. With an incident type you read the light itself, and the idea of the average is already programed into your meter. You might say that the meter assumes that your subject reflectance will average out to 18 per cent. Thus the things that are actually average in tone in your subject will come out that way in your picture, and other things will be proportionally lighter or darker.

All meters built into cameras are of the reflectance type. Remember that whatever you take your reading from will come out average in tone in your color slide, no matter what tone it is to begin with.

● Palm Readings

Many people don't like to carry gray cards with them but make that kind of reading without them. They simply read the palm of their hand as if it were a gray card. However, the palm generally reflects 36 per cent of the light instead of 18 per cent, so there has to be an exposure increase of one stop from the indicated exposure. This is a calculation you can easily make in your head. However, if you would rather not, you can divide the film's ASA speed by two and set the resulting palm speed on your meter. Thereafter, as long as you are using palm readings, you can use your indicated exposures directly.

Though the average palm in either dark- or light-skinned people reflects 36 per cent of the light, this is not always true. Therefore, you should make a comparative reading between your palm and a gray card before you set out to use this method. If you get the same reading from both of them, which is sometimes the case, then you won't need an adjustment factor.

● White Card Readings

With fast films such as Kodacolor 400 or Ektachrome 400 you can often photograph in places where the light is too dim for regular readings with ordinary exposure meters, either separate or built-in. In such cases a white card reading will often work. The idea is that you want to read something that is light enough to reflect nearly all of the light that is available. Thus it will make the meter needle register a reading.

What you want is a reading that will give you the correct exposure for the average subject. A white card will not do this directly, because it reflects 90 per cent of the light—far from average. However, you can use a conversion factor, which turns out to be 5. A white card reflects exactly five times as much light as a gray card, which represents the average tone of the average subject.

Simply divide your ASA speed by 5 and set the resulting white card speed on your meter. Thereafter, use the white card as if it were a gray card and use the exposure indications directly. No further calculations are necessary, because the conversion factor has been programed into your meter.

It is a little awkward to make a white card reading with a built-in meter, because you have only two hands. The most convenient thing is to have someone hold up the card while you set your camera controls, in the process of which you take your reading. The card should fill the whole viewfinder. In some cases, reading a white wall would be easier and just as effective.

The white card won't solve all dim-light exposure determinations, but it will help a lot. In effect, you increase the sensitivity of your meter by a factor of 5, which is quite a bit.

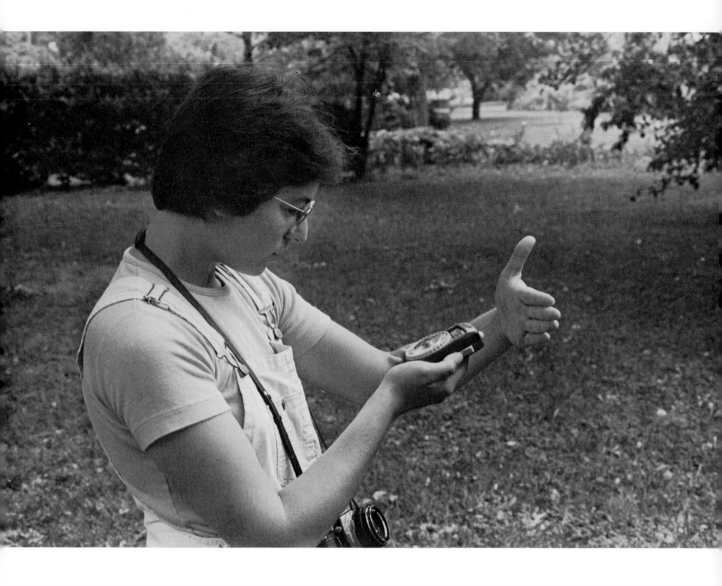

Taking a palm reading. Here the meter is a little too far from the girl's palm. The maximum distance should be the width of the palm, or about three inches. The palm is held paralled to the subject. When using this method you generally (but not always) divide the film speed by two and set this new figure on your meter. See text for details.

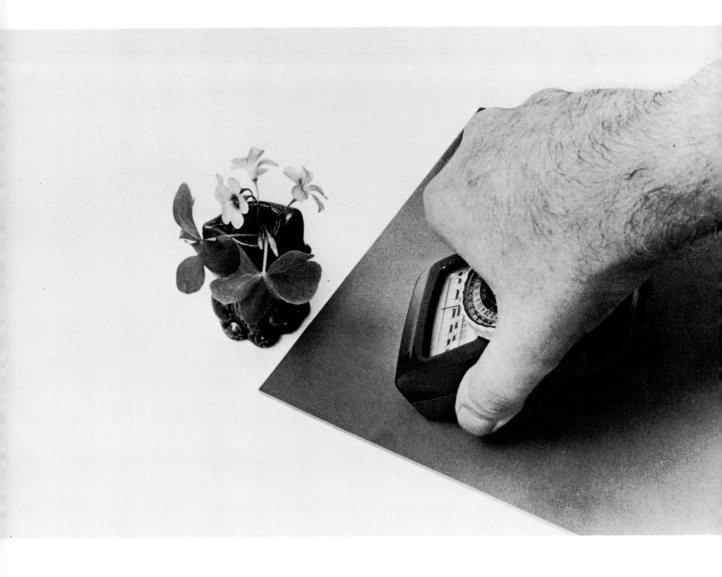

Taking a substitute reading. The subject is so small that reading it directly might include a lot of light from the background, which would lead to underexposure in this case. Therefore, the reading is being made from a larger substitute object (a gray card) that has the same average reflectance as the subject. For this kind of reading you generally place the substitute object very close to the subject.

• Substitute Readings

For a substitute reading you meter something other than the subject itself. I've already mentioned gray card, palm, and white card readings, in which you do just this. They are all substitute readings, but there are other kinds too.

You don't have to read your subject as long as you can find something else to read that reflects the same amount of light. For example, you may want to photograph something at a distance with a telephoto lens and cannot get close enough to it to take a reading. If so, you find a nearby object that reflects the same amount of light and take your reading from that. If possible, sight over the nearby object to your target, for it is otherwise hard to tell if they are of the same brightness.

If necessary, you can sight over your palm or a card (white or gray), tilting or angling it until you have a tonal match. It doesn't really matter what you match with, as long as it *is* a match. For example, you can match a distant face with the sleeve of your jacket or the back of a menu. Or you can match the side of a building with the top of a car.

When you are sighting over a white card and tilting it to make a tonal match, you don't use 5 as a conversion factor, for you are essentially using the card as an average gray, which it is indeed in comparison with something else. For example, you are in a restaurant and wish to photograph a friend several tables away without disturbing him with a meter reading. However, his table is in a brighter light than yours. In this case you may be able to match his tone very well with a white card or napkin. You should then take your reading and use it directly with no conversion factor.

You can even supply your own light for a reading if you have to. For example, you are sitting in the dark watching a stage show that is too distant to read directly. So you hold up a card or your palm, point a penlight at it to make your match, and make your reading. As I said a moment ago, the match itself is the important thing; how you

get it is a matter of indifference. In a restaurant, say, you might even use the light from a candle to get the matching tone on your card.

You can also take substitute readings with an incident light meter, which you use to read the light source itself instead of the subject. What you do is look for a substitute light source to read. For example, you may wish to make a telephoto picture of someone under a street light but are unable to get close enough to take a reading from the light — you would want to take a reading from your subject's position. The thing to do is find a street light closer to you, position yourself the same distance from it as your subject is from his, then read your own light. Since you can assume that the lights will be almost exactly the same, you can also assume that your reading will be accurate for your subject.

So far I have talked about taking substitute readings for distant or inaccessible subjects, but you can also use them for subjects that are too small to read accurately. Say you are taking a close-up picture of a small flower on a black background and that an ordinary reading would include much of the background due to the angle of coverage of your meter, either separate or built-in. If the flower is fairly light in tone, this would lead to overexposure.

To solve the problem, put a larger object (a gray card would be ideal) near the flower and take your reading from that. Lacking a gray card, almost any object will do, as long as you match up the tones. However, if the flower that you have matched is very light — yellow or pink, for example — you should double the indicated exposure. Remember that whatever you read will come out average in tone, which is too dark for a very light flower. With a very dark flower and a tonal match you should halve the exposure.

• Reflectance (Averaging) Meters

At this point it is time to look more closely at the nature of exposure meters. The discussion, however, won't be technical. There are two basic

types, incident and reflectance, and with some separate meters you can take both types of readings. Reflectance meters are of three basic kinds: averaging, spot, and weighted. All three will be discussed.

As you already know, a reflectance-type meter reads the amount of light reflected by a photographic subject. The kind that averages reflected light (actually, all reflectance meters do) reads at an angle of about 30 degrees — called the acceptance angle. If you point the meter at a scene it averages the light coming to it from all areas — everything that falls within the meter's acceptance angle is included.

The main trick in using an averaging meter is to read the subject and not the background. (You don't have to do this, of course, if subject and background have the same tonalities.) Then you can take a general reading. To be safe, however, it is best to read only the subject.

When you are shooting a landscape that includes a lot of sky you will underexpose if your metering includes too much sky. The thing to do is to angle your meter downward at the ground so that the sky accounts for only one fourth of the area read. By doing so, the sky will contribute to the average, as it should, but only to a limited degree. In figuring the area of coverage, remember that the acceptance angle of most averaging meters is about 30 degrees. With built-in-meters, which also average, you can see the area of coverage in the viewfinder window.

Spot-type reflectance meters have acceptance angles of about 1 degree, though those built into the camera have somewhat larger angles. Within that narrow angle they make averaging readings. Since there isn't much to average within such small areas, they are called spot readings. You read a small area or spot. However, it is good to know that the meter averages the reflectances included within the spot being read.

There are two main tricks to using a spot meter. One is to choose a spot or area that is strictly average in tone and take your reading from that (you can use a gray card, if you wish, thus furnishing your scene with its average tone). If your choice of an average tone is good your exposure will be good, unless the contrast range of your subject is very great. In this case, read a spot that is somewhat lighter than the average tone of your subject. It should be about two stops darker than the diffuse highlights (diffuse highlights are light tones that are not mirrorlike in nature; mirrorlike highlights are called "specular").

The second trick is to use your spot meter to read the subject area by area and arrive at an average for the whole, which you have to do by calculation. However, you don't read specular highlights or areas that are totally black. Instead, you read those lightest and darkest tones in which you hope to get detail in your transparency. From those tones you compute the average and use it to determine the exposure.

Perhaps the greatest attraction of a spot meter is that its small angle of acceptance enables you to read subjects at a considerable distance from you without including the background. Thus it is good for subjects such as stage shows and other events that don't permit you to take close-up readings.

Meters built into cameras are all of the reflectance type, and most of them are averaging rather than spot meters. The main trick to using a built-in is to come up close to your subject for a reading, then back off to make your shot. How close you should come is easy to decide, because you can plainly see in the viewfinder window what areas you are reading — your subject should fill the frame. However, if the exposure is automated you may not be able to use this method, unless your camera has a manual override.

Some built-ins are center-weighted, which means that they combine the characteristics of both averaging and spot meters. Such meters emphasize lighting brightness from the center of the frame and de-emphasize the perimeter. The idea is to get you around the problem of a subject that is considerably lighter or darker than its background. The exposure data from the subject

is weighted, so to speak, letting the background more or less take care of itself. Though emphasizing the center works rather well, it still doesn't solve the exposure problem entirely. It is still a good idea to move up close to your subject for a reading.

The problem with most built-ins is that they are not designed for reading dim light as well as bright light. In dim light you may as well not have a meter at all, though a white-card reading may solve this problem. Some separate meters will give good readings even of moonlight, but this is out of the question for the typical built-in.

● Incident Meters

As you already know, an incident meter is used to read the light source rather than the subject. You hold it right in front of your subject and aim it halfway between the camera and the light source. If the subject is lit from the back (e.g., by a hair light) as well as the front, shield the meter sphere from the back light.

We have seen that an incident meter incorporates the idea of an average gray. The notion is programed into it, so to speak. Thus when you take a reading for a scene whose tones average out to about 18 per cent reflectance, you will come up with the correct exposure for it. However, you won't get the correct exposure if the tones are all lighter or darker than average. In the first case you should subtract one-half to one stop from the exposure; in the second, add one-half to one stop. Fortunately, occasions on which you have to do this are relatively few. This is because the vast preponderance of photographic subjects average out to about 18 per cent reflectance.

This fact is so dependable that the incident-reading method is also very dependable. Indeed, it is generally the best method, especially if you can't decide how to do your metering. For example, you may be looking for an average gray to

read and have difficulty deciding which of the visible tones represents an average gray. Your incident meter is already programed for the gray, so you don't have to even think about it. Difficulty in deciding what to do is often aggravated by certain lightings—a high-contrast cross-lighting, for example. In such a case it is good to know that your meter can do some of your thinking for you.

There are also occasions when your mind doesn't work very well on technical problems such as exposure. At such times you can let your meter do most of the work. Incident readings are extremely easy to make. All you have to remember is to point the meter halfway between the light source and the camera.

Indoors, the meter should be immediately in front of the subject (or inside it in the case of a still life) and pointed halfway between the light source and the camera. I remind you that this is because the light intensity indoors can vary considerably from place to place. Outdoors, you will recall, you can generally take your reading from almost anywhere, because the lighting is usually even. For example, the sunlight striking your subject is exactly the same intensity as that falling upon you. However, you should aim your meter as if you were standing beside your subject.

● Existing-light Starting Exposures

If your meter doesn't read dim light well, or if you have no meter at all, you can still make pictures in dim light by using the following chart and bracketing. The bracketing is very important, because the exposures are only estimated. However, that won't prevent you from getting good pictures.

We will start out by describing some existing-light categories, then give the exposures for three fast films—you should use a fast film for this kind of exposure.

A: Early dusk, shortly after sunset. Skyline ten minutes after sundown. Neon signs. Bright spot-

Taking an incident reading, which means that you read the light source instead of the subject. The meter is pointed halfway between the light source and the camera position. If this were an indoor reading the meter would be held almost touching the young man's face. Outdoors the distance isn't usually as critical as it is indoors, because of the evenness of the lighting.

lit subjects at ice shows, circuses, and stage events.

B: Brightly lit theater and nightclub districts. Burning buildings and campfires. Night football, baseball, and racetracks. Floodlit circus and ice show subjects. Interiors with bright fluorescent lights. Boxing and wrestling events in sports arenas. Ground displays of fireworks.

C: Bright downtown streets. Basketball, hockey, and bowling events. Average whitelit stage events. Store windows. Bright home interiors. Fairs and amusement parks. Interior swimming pools, above water. Museum dioramas.

D: Amusement park and carnival rides. School stage and auditorium events. Church interiors.

E: Car traffic. Average home interiors at night. Christmas tree lights, indoors or outdoors.

F: Candlelit close-ups. Illuminated fountains. Lightning. Aerial displays of fireworks.

G: Subjects lit by streetlights. Floodlit buildings.

H: Subjects lit by bonfires. Skyline after dark.

I: Floodlit dark factory buildings.

J: Full-moonlit snowscapes. Full-moonlit marines and distant landscapes.

K: Full-moonlit landscapes at medium distance.

	ASA 160 or 200	ASA 400
A:	1/100, 1/125 at f/4.0	1/200, 1/250 at f/4.0
B:	1/100, 1/125 at f/2.8	1/200, 1/250 at f/2.8
C:	1/50, 1/60 at f/2.8	1/100, 1/125 at f/2.8
D:	1/25, 1/30 at f/2.8	1/50, 1/60 at f/2.8
E:	1/15 at f/2.8	1/25, 1/30 at f/2.8
F:	1/8 at f/2.8	1/15 at f/2.8
G:	1/4 at f/2.8	1/8 at f/2.8
H:	1/2 at f/2.8	1/4 at f/2.8
I:	1 sec at f/2.8	1/2 at f/2.8
J:	8 sec at f/2.8	4 sec at f/2.8
K:	16 sec at f/2.8	8 sec at f/2.8

With moving light sources such as car headlights and fireworks you should use time exposures (the shutter held open with the "B" setting) if you want to get the light patterns. For example, you should let traffic flow for a few seconds or wait for several bursts of fireworks. With lightning you have to open the shutter and wait for a bolt to appear.

Though these exposures are based on a great deal of experience, they are still only estimates, I remind you — so don't forget the bracketing. Do it in one-stop intervals, one shot on each side of the charted exposure. If the lighting contrast is high, you can use two-stop intervals. If you have any doubts about what you doing, bracket two shots on each side.

The chart plus bracketing is a workable way to get pictures under adverse lighting conditions. However, if you have a very sensitive meter such as the Gossen Luna-Pro, you are much better off. With a good reading you don't have to bracket, though it is a safeguard. Many professionals automatically bracket whenever they've got the time, and they have excellent meters.

● **Film-speed Comparisons**

Films are assigned so many different speeds that it is hard to keep track of how they compare, and sometimes you have to know. For example, you may have a correct exposure for an ASA 64 film and want to know what it would be for an ASA 50 film. The following chart will help you to figure it out.

ASA FILM-SPEED COMPARISONS
Each number is one-third faster than the one above it in the column

6	20	64	200	650	2000
8	25	80	250	800	2500
10	32	100	320	1000	3200
12	40	125	400	1250	4000
16	50	160	500	1600	5000

To double a film speed you simply skip to two numbers higher. For example, you would change from ASA 200 to ASA 400, which is double its speed. Similarly, the double of ASA 320 would be ASA 650. It is not arithmetically precise but close enough.

● Extension-tube Correction Factors for 35mm Cameras

If you use close-up lenses on your camera you don't have to make exposure corrections for them. However, if you use extension tubes you do have to make corrections, unless you have a built-in meter that reads through the lens. Such a meter automatically takes the increase into consideration. Without a built-in, you have to calculate the required increase. You can do this by measuring something in front of the camera that fills the viewfinder lengthwise and then referring to the table below. This table applies to full-frame 35mm and 828 films.

This chart is very easy to use, but an example may help. Say you are all set up for a picture and one object fills the viewfinder lengthwise. When you measure the length of this object in front of the camera it turns out to be two inches. Referring to the chart, where it is called the subject, we find that this would call for one and a half stops exposure increase, or a multiplication of the exposure time by 2.8.

The figures in the chart don't take the reciprocity effect into account, but you should do so when you are using them. Remember what was said about "stop language" and that you can change an exposure by changing the aperture setting and the time at the same time. For example, for a ½-inch subject you can open up two stops

and multiply the time by 4, which will give you a total of four stops additional exposure. The easiest way to figure the correct exposure is to use the dial of your exposure meter. Move the pointer four stops from the indicated exposure, and you will have all the aperture/shutter-speed combinations right in front of you.

● Exposure for Color Television

You can photograph color TV easily enough, but you must be careful not to get the scanning pattern. To avoid it you should use a shutter speed of 1/30 second or longer with a blade shutter, 1/8 second or longer with a focal-plane shutter. Use daylight color film with a CC40R (red) filter. A typical exposure with Ektachrome 200 is 1/8 second at $f/4$, which calls for a tripod to steady the camera. It also requires you to shoot during a momentary pause in the TV action. The color would be interesting without the filter, but it is considerably better with it—you can see that there is quite a lot of correction. Some people like to juggle the tuning to get wild color effects to photograph, and there is a lot that you can do in this direction.

● Speed Pushing with Kodak E-6 Color Films

You can underexpose certain color films and compensate for this by increasing the time in the first developer, thus increasing the effective speed of the films. For example, you can underexpose Ektachrome 400 (ASA 400) by up to two stops, increasing its speed to ASA 1600 (though Kodak doesn't recommend this).

Extension-tube Exposure Factors for Full-frame 35mm Close-ups*										
Length of Subject	11	5⅛	3¼	2¼	2	1⅜	1	¾	½	inches
Open lens by	⅓	⅔	1	1⅓	1½	2	2½	3	4	stops
or Multiply Time by	1.3	1.6	2	2.5	2.8	4	5.7	8	16	

* courtesy of Eastman Kodak

For the best quality from Ektachrome films you should use the normal film speed and normal processing. When film is underexposed, then overdeveloped, the dark tones aren't as dark as they should be. There is a color-balance shift, and there is a significant increase in contrast. There is also a decrease in exposure latitude. However, if these compromises can be tolerated, some compensation is provided by using the following developing timetable as a guide:

Camera Exposure	First Developer Time Adjustment
2 stops under	Increase 5½ minutes
1 stop under	Increase 2 minutes
Normal	None

At the camera store you can get mailers for film that you want to have pushed one stop by Kodak. Though Kodak doesn't recommend pushing, they will do it for you anyway. The thing is that pushing, either in black-and-white or color, always involves a certain amount of image degradation—the higher the push the greater the degradation. However, if you *must* have the extra film speed, pushing is a way to get it.

The above table works for all of the E-6 Ektachromes. I understand that Kodacolor 400 (ASA 400, not an E-6 film) can be pushed to about ASA 1600, though I don't have a developing-time figure for you. However, a reasonable starting point would be to double the time and see what happens—bracket your exposures to make sure that one of them comes out O.K. The best exposure will tell you the ASA speed that you can use. For expert help, go to a professional color lab that does pushing. They will tell you how far each film can be pushed, then do it for you.

Since pushing leads to an increase in contrast, it is better to do it with low-contrast subjects. An example would be an indoor swimming meet, where there is hardly any lighting contrast at all. In comparison, a spotlit stage show would give you very high lighting contrast. However, high contrast in pictures of stage shows is tolerable, so you don't have to worry about it. Even so, it is better as a general rule to avoid high-contrast subjects when you are pushing.

Some people push film just to see how much mayhem they can get away with—there is nothing wrong with this. However, it is better to think of pushing as an emergency measure—to be avoided whenever possible.

This chapter on exposure should fill in the most damaging gaps in your knowledge of the subject. Though there is much more to it than what I have told you, there is no point in your reading about things that won't help you take good pictures. This started out as a book for beginners, and I want to make sure it stays that way. The exposure information herein is all you really need.

Processing Ektachrome Film

As part of your experience in color photography you should develop your own color film at least once, just to see how it is done. Though there is quite a bit to the process, it isn't very difficult. It is mainly a matter of following instructions very carefully, much as you would have to do if you were baking a cake from scratch. If you do as you are told you will have no trouble whatever.

Ektachrome films can be developed with a one-pint E-6 processing kit. The kit consists of a cardboard box containing bottles of concentrated liquid chemicals, which you must dilute with water before using. In the box you will also find a very detailed and simply written instruction pamphlet of twelve pages. It is so complete that this chapter isn't really necessary — the pamphlet tells you *all* you need to know. However, you undoubtedly want to know what is involved in color-film processing, so I will go over the same material and add a few things for good measure.

● Equipment

Developing tank and reel(s) (Honeywell, Nikor, or Kindermann are recommended.)
Accurate photographic thermometer
1 graduate, 16 ounces or larger
7 one-pint plastic chemical storage bottles
A juice pitcher for chemical mixing
Plastic stirring rod
Plastic funnel
Rubber gloves
Clock or photographic timer
Deep tray for water bath

Though the recommended tanks and reels are your best bet, one-pint plastic tanks and reels are also good. If you have never loaded a reel before, the walk-in type (e.g., the Paterson) is excellent, for it is very easy to use.

When you buy a tank and reel set, make sure the instructions are included — camera-store customers often remove them. With these instructions you need no help in this chapter on how to load a developing reel.

A dial-type stainless-steel thermometer is probably your best bet, because glass thermometers take too long to register temperature changes. Since temperatures are very critical in two of the E-6 chemical baths, it should be accurate to plus or minus (\pm) $\frac{1}{2}$ degree. If you buy a photographic thermometer, it probably will be.

Use the kind of plastic storage bottle that is made especially for photography. Other plastics may react with the chemicals.

Since color chemicals are injurious to the skin, you should wear rubber gloves when you are mixing or using them. Kitchen-type gloves are quite satisfactory, though you might find surgical rubber gloves (available in drugstores) more to your liking. When using the latter you can powder your hands with talcum to help you slip them on.

Light from behind them turns these men into stark
silhouettes in an abstract picture. The most important
element is the design.
[Photo by Ronn Kilby]

Is this a spaceship or interior decoration? Perhaps it is manned by little green men who have come here to see what makes us tick.
[Photo by Jennie Clarkson]

Even in an abstract photograph this car has "class" written all over it. You can almost hear its engine purring softly.
[Photo by J. Bailey]

The silhouetted figures seem to be part of the abstract picture they are looking at. It must be odd to find oneself turned into art in this manner.
[Photo by Terence Knight]

A moving light pattern photographed at a very slow shutter speed, which turned the lights into streaks of color.
[Photo by Herbert Goodrich]

The person who sloshed color on these windowpanes
undoubtedly had art in mind, so we'll take his word for it
— this is genuine art. Or is it?
[Photo by David Howland]

Even the torn window shade contributes to this doorway
as a work of abstract art. The dark shadow also helps.
[Photo by Ken Salzmann]

Made with stationary lights, a moving camera, and a
very slow shutter speed, this little abstract picture literally
sparkles with light.
[Photo by Herbert Goodrich]

Equipment you need for processing color film—developing tank, timer, beer can opener for prying open film cassettes, developing reels, thermometer, and clothespins for hanging up film to dry. This particular tank (a Nikor with a Kindermann top) holds exactly one pint.

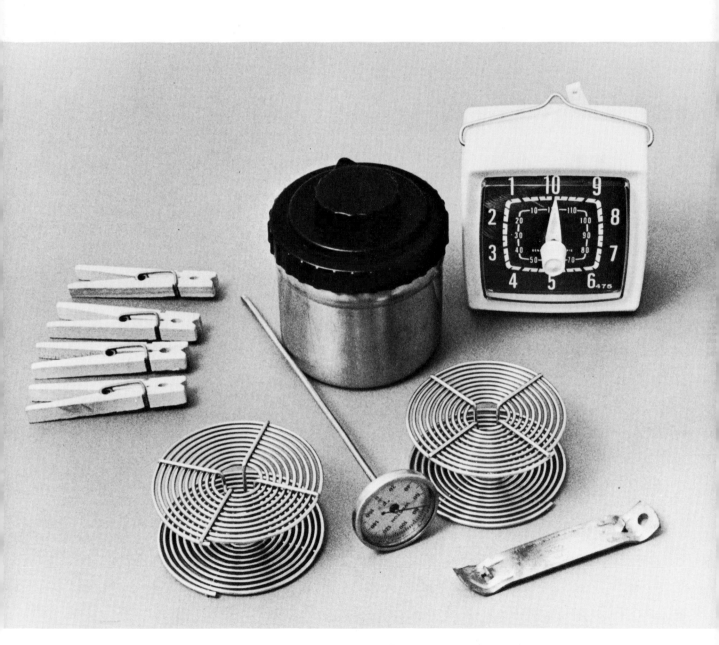

● Capacity of One-pint Kit

Though a pint of chemical isn't very much, a one-pint kit will process quite a bit of film:

Film Size	110 (20 exp)	126 (20 exp)	127
Rolls per Kit	36	16	16

Film Size	135 (20 exp)	135 (36 exp)	120,620
Rolls per Kit	12	8	8

● Mixing Solutions

In diluting your concentrated chemicals it is terribly important not to mix them together, even in the smallest amounts—this is called contamination. To avoid it, dilute your chemicals in the order in which you will be using them in processing. After you have diluted one and funneled it into its labeled storage bottle (yes, the label is very important!), wash your funnel, chemical mixing pitcher, stirring rod, and rubber gloves *very carefully.*

The E-6 instructions tell you precisely how much water to use for each dilution and that the mixing temperature can range from 40F. to 110F. However, if you intend to use the chemicals right away, the temperature should be 100F.

Though the concentrates have a water base, they don't necessarily mix well with water. You can tell when a mix isn't complete when you see oily-looking spots on top of the water—so keep stirring until they disappear.

A one-pint E-6 processing kit removed from its protective carton. As you see, the bottles vary in size and are carefully packed in a foam plastic form. To use the kit you dilute the contents of each bottle with an exactly specified amount of water and adjust the termperatures of the dilutions to the correct level.

- ## Time, Temperature, Agitation, and Solution Strength

In handling chemicals for Process E-6 it is good to know some of the things that affect their working potency, for all of these factors must be held under tight control. For example, timing affects the completeness of reactions. Temperature affects speed of reactions and completeness. Agitation affects the speed of reaction, the uniformity of solutions, and their contact with film surfaces. And the strengths of chemical olutions affect the extent and speed of reactions. All of these things work together in a complex relationship, and all must be tightly controlled.

- ## Proper Temperatures

First developer: 100F. ± ½ degree
Color developer: 100F. ± 2 degrees
Other solutions and water washes: 92F.–102F.

Put all your storage bottles in the water-bath tray and fill it with hot water (about 110F.) and wait for the solutions to warm up (wash your thermometer as soon as you take it out of a solution). When the solutions temperature reaches 100F., pour some cold water into the bath to hold it at that level. From time to time you will have to add more hot water to the bath to maintain this temperature.

Since all of your bottles will contain the same amount of solution, you only have to check one of them—the developer—for temperature. After you begin processing, keep the developing tank in the water bath when you aren't agitating.

- ## Proper Timing

Timing is very important in color processing, so you should watch it closely. Having a darkroom timer such as the Gra-Lab is very convenient.

Bottled E-6 chemicals in a water bath used to bring them to the correct temperature and hold them at that level. The developing tank is also kept in the bath to hold the temperature level. These bottles, which hold exactly one pint, are made of a plastic that is resistant to photographic chemicals. This particular make (Prinz) has spaces on the front and back for recording processing data. This data will help you to avoid possible confusion.

You can even get a program timer on which all the times for an entire process are programed, though it is not necessary to go this far. Whatever kind of timer you use, your times should be accurate within five seconds or less.

The given time for each solution includes the time it takes to pour it out of the processing tank — about ten seconds. Ten seconds before the end of a processing step start pouring, so you can end the step and start the next one on time.

● Loading Reels and Tanks

It is important to follow the loading instructions for whatever type of reel you are using. Failure to do so will lead to various kinds of processing marks, such as streaks, kink marks, etc. If you are using a multiple tank, fill it up with reels — even if you are processing a single roll. This will help you to get consistent agitation.

● Agitation: Invertible Tanks

Initial agitation: as soon as you have filled the tank with solution, put the cap on and tap the tank sharply four times on the tabletop to remove air bubbles. Then invert the tank once and put it back in the water bath. This initial agitation is all that is required for the reversal bath, conditioner, and stabilizer. *Do not* use additional agitation for these solutions.

Extra agitation: extra agitation is needed for the first developer, color developer, bleach, fixer, and washes. Use the following schedule:

1. Tap the tank on the tabletop four times.

2. Invert the tank seven or eight times during the first fifteen seconds, then put it back in the water bath.

3. Every thirty seconds thereafter, remove the tank from the bath, invert it twice, and return it to the bath.

In the first two washes, which are very short,

you can use constant agitation by inversion. In the final running-water wash no agitation is necessary, though the tank should be rapped against the sink once a minute to dislodge air bubbles.

● Agitation: Noninvertible Tanks

You can agitate with a noninvertible tank by twisting the agitating rod. One full cycle is a 360-degree turn of the rod.

Initial agitation: this is all that is required for the reversal bath, conditioner, and stabilizer. *Do not* use any extra agitation for these solutions. For initial agitation, follow this schedule:

1. Rap the tank on the tabletop four times to dislodge air bubbles clinging to the film, then put the tank in the water bath.

2. Twist the agitation rod one full turn.

Extra agitation: this is needed for the first developer, color developer, bleach, fixer, and washes. For these solutions use the following schedule:

1. Rap the tank four times to dislodge air bubbles.

2. Rotate the reel four or five times during the first five seconds.

3. At thirty-second intervals until the time is up, repeat step two, agitating for five seconds each time.

Because the tank has an agitation rod, it can remain in the water bath while you are agitating. In the first two washes, which are short, you can use constant agitation, but none is required for the final running-water wash. However, you should rap the tank once a minute to dislodge air bubbles.

● The Processing Steps

1. **First developer.** All the processing solutions should be at their specified temperatures. First developer temperature: 100F. ± ½ degree. Pour

in the developer, start timing, and follow the schedule for extra agitation. Time for this step: seven minutes. Ten seconds before the time is up, pour the developer into its storage bottle.

2. **Wash.** Fill the tank with water at 92F.–102F. and give it constant agitation for one minute, then empty the tank.

3. **Wash.** Repeat step 2.

4. **Reversal bath.** Pour in the bath and give initial agitation only. Temperature: 92F.–102F. Time for this step: two minutes. However, you can leave your film in this bath for as long as six minutes while you are adjusting the temperature of the color developer. After the reversal bath the light-tight cover can be removed from the tank, though it is more convenient to leave it on if you need it for agitation. When you are ready for the next step, pour the solution back into its storage bottle.

5. **Color developer.** Pour in the solution and develop for six minutes, using the schedule for extra agitation. Developer temperature: 100F. ± 2 degrees. Ten seconds before the time is up, pour the solution back into its storage bottle.

6. **Conditioner.** Pour in the solution and condition the film for two minutes, using initial agitation only. Temperature: 92F.–102F. Ten seconds before the time is up, pour the conditioner back into its storage bottle.

7. **Bleach.** Pour in the solution and bleach the film for seven minutes, using the schedule for extra agitation. Bleach temperature: 92F.–102F. Ten seconds before the time is up, pour the bleach back into its bottle.

8. **Fixer.** Pour in the solution and fix the film for four minutes, using the schedule for extra agitation. Fixer temperature: 92F.–102F. Ten seconds before the time is up, pour the fixer back into its bottle.

9. **Wash.** Wash in rapidly running water for six minutes. Water temperature: 92F.–102F. At the end of the wash, drain the tank into the sink.

10. **Stabilizer.** Pour in the solution and stabilize your film for one minute, using the schedule for initial agitation only. Temperature: 92F.–

102F. When the time is up remove the film and pour the solution back into its storage bottle.

11. **Dry.** Remove the film from the reel and, without wiping it, hang it from a line to dry. Attach a clothespin to the bottom end to prevent curling. The room should be dust-free, so that dust won't become imbedded in the film.

Summary of Steps for Process E-6 for
1-pint Processing Tanks

Solution	Time in Minutes	Agitation	Temperature °F
1. First Developer	7	Extra	100 ± ½
2. Wash	1	Constant	92 – 102
3. Wash	1	Constant	92 – 102
4. Reversal Bath	2	Initial	92 – 102

Remaining steps can be done in normal room light

Solution	Time in Minutes	Agitation	Temperature °F
5. Color Developer	6	Extra	100 ± 2
6. Conditioner	2	Initial	92 – 102
7. Bleach	7	Extra	92 – 102
8. Fixer	4	Extra	92 – 102
9. Wash (running water)	6	None	92 – 102
10. Stabilizer	1	Initial	92 – 102
11. Dry			

NOTE: the appearance of the film in the bleach bath doesn't indicate the degree of bleaching. Omitting the stabilizer will result in the fading of dyes and the formation of water spots. When the film is first hung up to dry the color balance and

density cannot be judged, due to opalescence, which disappears as the film dries. If heat is used for drying, it shouldn't exceed 140F.

As you can see, using Process E-6 isn't very hard. The most difficult parts are loading the film-developing reel and getting the first developer at exactly the right temperature, plus or minus (\pm) $\frac{1}{2}$ degree. You can do the latter by holding the storage bottle under either hot or cold running water. With the rest of the process it is a matter of carefully following the recipe.

• What Happens in the Baths

Now that you have seen how to develop film, you should also know what happens in the various baths, for this information will add to your knowledge as a photographer:

1. *First developer.* In this bath the silver halide crystals that have been exposed in the camera are changed into metallic silver, the unexposed crystals remaining unchanged. At this point the film looks like a black-and-white negative before it has been fixed. The temperature here is much more critical than it is for the other solutions and washes.

2. *First wash.* This stops the action of the first developer and washes out chemicals that might contaminate the reversal bath.

3. *Second wash.* This continues the action of the first wash.
 Alternate wash. The first and second washes can be replaced with a two-minute flowing-water wash in which the rate of flow is about two gallons per minute.

4. *Reversal bath.* This solution fogs the unexposed silver halides that were unaffected by the first developer, which is called reversal. Formerly, reversal was done with light, but now chemicals do the job.

After the film has been in this bath for one minute, the rest of the processing can be done in normal room light.

5. *Color developer.* In this bath the silver halides that have been fogged in the reversal bath are converted into a positive silver image, which is combined with the negative silver image formed in the first developer. As the developing agent forms the positive image, it oxidizes in such a way that it reacts with dye couplers incorporated in the three emulsion layers. In this way we get a cyan, a magenta, and a yellow image, all exactly superimposed.

6. *Conditioner.* This solution prepares the metallic silver in the film for oxidation into a silver halide in the bleach bath which follows. It also protects the acidity of the bleach by reducing the carryover of alkaline color developer.

7. *Bleach.* This solution oxidizes the metallic silver negative and positive images that have been formed, respectively, in the first and the color developer. Both images are converted to silver salts. The three color images are unaffected by the bleach.

8. *Fixer.* This bath converts the silver salts formed in the bleach into water-soluble silver thiosulfates, so that they can be washed out of the film. Note that there is no rinse following the bleach step; silver removal is more efficient without it.

9. *Final wash.* It removes dissolved silver salts and processing chemicals to prevent them from having an adverse affect on the film. Water flowing at about two gallons per minute is recommended.

10. *Stabilizer.* This solution promotes maximum dye stability, so that dyes neither fade nor shift their hues. It contains a wetting agent, so that film can be hung up directly without wiping or squeegeeing.

• Variable Speeds with Process E-6

Though most of these figures were given in the chapter on exposure, I will repeat them for your benefit:

Camera Exposure	First Developer Time Adjustment
2 stops under	increase 5½ minutes
1 stop under	increase 2 minutes
normal	none
1 stop over	decrease 2 minutes

More details on this procedure in terms of the results are given both in the E-6 processing instructions and in the chapter just mentioned.

● Other Data in the E-6 Instruction Pamphlet

As I said earlier, absolutely all the data necessary for using Process E-6 is covered in the pamphlet that comes with the kit. I paraphrased much of it only to let you know what you would be getting into if you decided to process your own color film. As you have seen, it is not very difficult.

There is quite a bit of material in the pamphlet that doesn't need repetition here—for example, a section on diagnosing problems with films that didn't come out the way they should have. There are also sections on storage and life of solutions, contamination of solutions, capacity of solutions, and a summary of chemical warning notices. The latter makes it very plain that none of the seven E-6 chemicals are to be inhaled, ingested, or even touched with bare skin. First-aid suggestions are given for each chemical. One thing is very clear: all of them should be kept beyond the reach of children.

Making a Cibachrome Print

Cibachrome is an unusual direct positive material that enables you to go directly from a color slide to a positive print. There is no reversal exposure or second developer. Only three chemicals are involved in processing, which takes only twelve minutes, including the wash time.*

The material can be used with simple enlarging equipment. The processing techniques are uncomplicated and can be done at room temperature, which is unusual for a color process. And color corrections are easily made.

Though the whole Cibachrome process is very simple, it produces remarkable results. Cibachrome prints have excellent hue rendition, high color saturation, great sharpness, and a strong resistance to fading. There is wide exposure latitude. There is also a wide latitude in time and temperature in processing, which is unusual in a color process. There is considerable contrast control, also unusual. Unlike most color-print materials, Cibachrome print material has excellent keeping qualities—it can be stored for several months without refrigeration. For longer periods, however, refrigeration is recommended.

Cibachrome has three superimposed emulsions, sensitive to blue, green, and red. The blue layer contains a yellow azo dye, the green layer a magenta dye, and the red layer a cyan dye. As we saw earlier in the book, these three subtractive primaries can form all the other hues.

The azo dye colors are not formed by coupling but are in the emulsions to begin with. They have unusual saturation and significantly superior stability. These dyes act as screens to inhibit light scattering in the emulsions during exposure, which makes for greater image sharpness than in most printing papers. The combination of less light scatter and the fact that many color slides have virtually no grain, will give you exceptionally sharp prints. This characteristic has helped make Cibachrome very popular with both amateur and professional photographers. Of course, the main factor is that the prints look good overall.

● What You Need for Cibachrome Printing

1. Enlarger
2. CP (color printing) filters
3. UV (ultraviolet absorbing) filter
4. Accurate exposure and processing timer
5. Small sable brush
6. Print processing drum
7. Photographic thermometer
8. Bottles for chemical storage
9. Measuring cups or graduates for chemicals
10. Discard bucket (glass or plastic) for chemicals

* The facts in this chapter are all drawn from Ilford's *Cibachrome Color Print Manual*, an excellent little book that you should surely investigate.

11. Water bath for chemicals
12. Retouching materials

Enlarger: should be the kind with a filter drawer between the light source and the lens, unless you can afford an enlarger head with dichroic filters, which is quite expensive. Your enlarger should also have a heat-absorbing glass, because heat from the light bulb can damage both color slides and printing filters. If your machine doesn't have a filter drawer you can use CC (color compensating) filters under the lens.

CP (color printing) filters: acetate filters in the colors yellow, magenta, and cyan, used to balance the color of the enlarger light to make it fit the Cibachrome material and the particular color slide you are printing. In each color the filters vary in darkness, the relative darkness being described as density. In order of their increasing darkness you should have the following densities for each color: .05, .10, .20, .30, .40, and .50. For heavier densities the filters can be combined. For example, a .40 plus a .50 equals .90.

UV filter: since ultraviolet light from the enlarger bulb can throw the whole process off balance, it must be absorbed with a filter, which can be left in the enlarger all the time that you are printing with color materials of any kind. The filter is acetate.

Timer: an exposure timer such as the Gra-Lab can be used to time both exposures and processing, which must be timed accurately. Counting seconds for exposures is hardly accurate enough, though you can do it if you have to. However, you can use a watch with a second hand for timing processing steps.

Processing drum: this is simply a lightproof plastic tube with removable ends. You put your Cibachrome material in it after exposure so that you can do your processing in the light. The chemicals, which are poured in one end, will stay in the tube while it is horizontal. To pour them out you up-end the drum. Naturally, the pouring spout is light-trapped, so that light won't go through it and fog the material. An additional ad-vantage of the drum is that it uses very little chemical. You agitate by rolling the tube, either by hand or with a motor base. After each use the drum must be thoroughly washed and dried. Though tubes vary in size from 8 x 10 inches to much larger, the 8 x 10 size is probably the best for you. A print of this dimension is both sizable and economical. The drums made by various manufacturers seem to be equally good, though I prefer the Ilford type. With it you can pour used chemical out of one end at the same time you are pouring fresh chemical into the other—a unique baffling system makes this possible.

Sable brush: used for cleaning color slides, for which purpose it is highly effective. If you rub it in the crease alongside your nose it will get a little skin oil on it so that it will pick up dust and lint better. Dust, lint, and hair show up as little black marks on your prints and require retouching.

Thermometer: should be accurate within $\frac{1}{2}$ degree. The dial-type stainless-steel thermometers (available from several manufacturers) are perhaps the handiest because they are durable, register temperature changes rapidly, and are easy to read. When they are new you can depend on their accuracy. However, if you treat a metal thermometer roughly, its later readings may be somewhat inaccurate.

Bottles: ideally, they should contain exactly the amount of chemical solution you wish to store, because chemicals stored in full bottles will last longer without deterioration. The brown plastic bottles sold in photographic stores are good; so are ordinary glass ones. For chemical mixing, storage, or processing, chipped enamel vessels should be avoided.

Measuring cups: you should have three—one for each chemical. Label each cup and use it for the same chemical always, to lessen the danger of chemical contamination.

Discard bucket: the Cibachrome chemicals are corrosive, especially the bleach, and shouldn't be dumped directly into a sink drain. The bleach is neutralized in the bucket with special pills that come with the Cibachrome chemistry and can

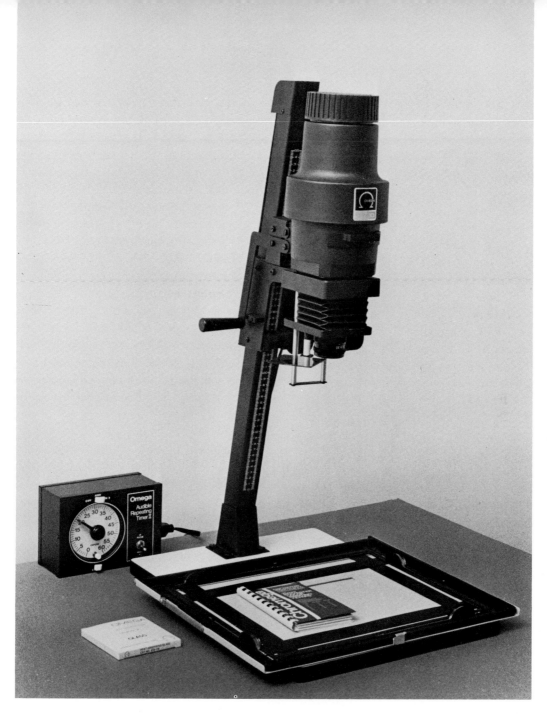

Some of the wide range of color printing equipment manufactured by the Omega Division of the Berkey Marketing Companies, Inc. Here we have a B-600 enlarger (which has a filter drawer), a Saunders-Omega adjustable easel, a set of color printing filters (in the book on the easel), a package containing a piece of heat-resistant glass that fits into the enlarger, and an Omega Audible Repeating Timer II. Fancier equipment is also available from Omega, but this is all you really need for a start.

then be dumped. However, if you have a septic tank you should dump the chemicals on the ground. Like most color chemicals, they create somewhat of a disposal problem.

Water bath: used for holding chemicals at the correct temperature, the bottles of chemical being set in water, which should be several inches deep. You can use a deep plastic dishwashing tray for the bath.

Retouching materials: mainly for covering up little black spots and lines that come from dirt or scratches on the color slide. They can best be covered with opaque colors such as artists' acrylic paints in the right shades. Retouching light spots, or adding color to ligher areas, can be done with transparent Cibachrome dyes, which have the same colors as your prints. In fact, they are the very same kind of dyes. They are water

Things used in processing Cibachrome material, including a processing drum, chemical storage bottles, a motorized base for agitating the drum, and small graduated cups for measuring out chemicals. The motor base is a luxury. To agitate, you can simply tip the drum on its side and roll it back and forth on the tabletop. Though convenient, the motor base won't improve print quality.

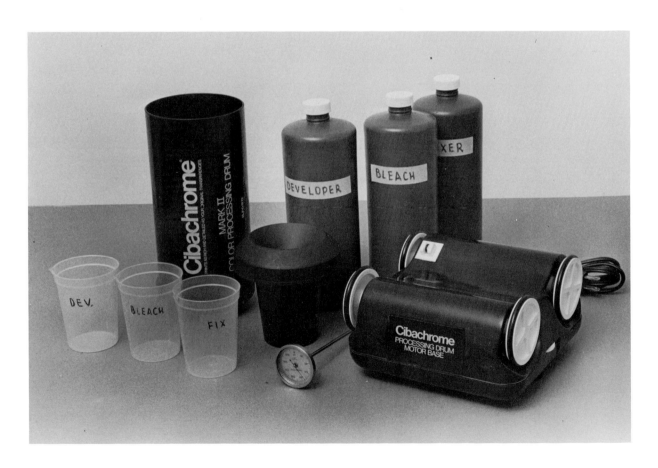

soluble and can be applied with a brush or a cotton swab—it is recommended that you start with dilute colors. If too much dye has been applied, it can be weakened by washing the print for about half an hour.

● Your First Print: The Process in Brief

1. Select a standard color slide.

2. Remove it from its slide mount, clean it, and put it in your enlarger with the emulsion toward the lens.

3. Crop the image and focus it on a piece of doubleweight paper.

4. Put a UV filter and a heat-absorbing glass in the enlarger.

5. Select the filter pack (assemblage of filters) recommended for the particular batch of Cibachrome you are using and put it in the enlarger.

6. Turn off all lights.

7. Expose a four-part test print.

8. Put the test print in your drum, pop on the cap, and turn on the room light.

9. Pour 75F. developer in the drum and agitate constantly for the two minutes' developing time. Just fifteen seconds before the time is up pour out the developer.

10. Pour in 75F. bleach and agitate constantly for the four-minute bleaching time. Just fifteen seconds before the time is up, pour out the bleach.

11. Pour in the fix and agitate constantly for the three-minute fix time. Just fifteen seconds before the time is up, pour out the fixer.

12. Wash the print in rapidly running 75F. wash water for three minutes.

13. Dry the print.

● The Standard Color Slide

If you pick a satisfactory standard slide and through trial and error assemble the right filter pack (assemblage of filters) for it with a particular enlarger and a particular batch of Cibachrome, then the same pack will also work for other slides that are like the standard. Slides unlike the standard in color balance may require modified filter packs.

Your standard slide should have good color balance, which you can tell most easily by examining neutral gray tones. If they are truly neutral—not greenish, reddish, etc.—then the color balance is good. Grays that usually work well for this purpose are sidewalks, asphalt roads, concrete walls, and tree trunks. If they are truly gray in your standard slide they will plainly look that way. On the other hand, if they are off-color, it will be relatively easy to tell.

People who do a lot of portraiture often use an area of Caucasian skin for a control tone instead of gray. If the slide is in balance the skin will generally look good. However, if it is green, magenta, yellow, etc., this will generally show up rather clearly. The thing is that untanned white skin doesn't look very good unless it is just a certain way, so you can usually tell when it is off. A forehead tone is often used for determining the color balance. Darker tones and shadow areas may be deceptive. Since it is usually far from neutral in tone, dark skin doesn't work very well for a test patch. However, if the color balance of the slide is right, it will look very good.

Your standard slide should be within one-half stop of normal in exposure. If it doesn't have a neutral or skin test area, it should at least have a variety of colors. To see if colors in a slide are coming out right, you have to have colors to look at.

When a test print is made with a filter pack that is specified for a particular batch of Cibachrome, it probably won't match your standard slide very well. That is, the colors in the print will definitely be off. This is because the color balance of your enlarger hasn't yet been considered. You have to learn what it is and add filters to the pack to correct it. We will see how this is done in a moment.

This colorful snapshot is as straightforward as can be.
Simply line up your subjects and click the camera shutter.
No need to make a great production of it.
[Photo by J. Bailey]

A simple snapshot, with the girls hamming it up a bit. The overcast sky softens the colors, making them very subtle. An easy shot to take but lots of fun.
[Photo by Ken Salzmann]

Though portraits aren't normally made in red light, this one is very interesting. In such a lighting use your exposure meter in the usual way. There's nothing to it.
[Photo by David Howland]

Surrounded by soft greens, the girl and her dog seem to
be in a fairy landscape. It would be nice if the girl's face
showed more clearly, but you can't always get what
you want.
[Photo by Rod Mann]

This engaging smile is the key to unlock our hearts. The
colors are all warm and soft — very appropriate for this
kind of portrait.
[Photo by Ronn Kilby]

Kids will generally ham it up if you let them know that it's
all right to do so. The boy in front is obviously teasing the
photographer by pretending to take a picture.
[Photo by Robin C. Barringer]

These girls are twins, as the picture definitely suggests.
You don't always have to photograph people from in
front; the back view can also be very interesting.
[Photo by Terence Knight]

The girl's pretty hair is almost the same color as the beer.
This is a fine example of service with a smile.
[Photo by Ronn Kilby]

• Identifying the Emulsion Side of a Slide

Color films have printing along the edges. If you hold a slide up facing you and the printing is correctly oriented, you are looking at the back of the film. The emulsion is a little less shiny than the back side. You can often see the image on this side in low relief, though you have to move the slide into a variety of positions to make it visible. When you see the relief, the emulsion is facing you.

• Color Correction

With your three filters—yellow, cyan, and magenta—you can make corrections in all six of the basic colors. This is because you can combine filters to get the colors that are missing. For example:

yellow + cyan = green
cyan + magenta = blue
magenta + yellow = red

Since you can get certain colors by combination, there is no point in including them in the basic color-printing filter kit. There is such a kit for Cibachrome, but you can also get one from other manufacturers.

Since Cibachrome is a positive material, it is easy enough to tell what color is missing from a print and to add it to the filter pack. If a print has too much of a certain color, you just add its complement to the pack. For example, if a print is too magenta, add green. If too cyan, add red. Refer to the color wheel given earlier to see what the other color complements are.

Fortunately, an off-color print looks as if it lacked the color that you should add to the filter pack, which makes filter selection easy. For example, a print that is too magenta looks as if it lacked green; a print that is too cyan seems to lack red. You simply add the missing color to the filter pack.

As you learned earlier, all three of the subtractive primaries (yellow, cyan, and magenta) added together will gray each other (form neutral density). Now, neutral density in a filter pack doesn't correct any color, but it does make the exposures longer. For this reason a maximum of two colors is generally used in a filter pack.

• Basic and Adjusted Filter Packs

The basic filter pack is designed to correct for the particular batch of Cibachrome material you are using. In common with other color-printing materials, there is a variation in color balance from batch to batch due to manufacturing difficulties. Making all the batches come out exactly the same would be either impossible or horribly expensive, and you would have to pay the cost.

The basic filter pack is printed on the back of each package of Cibachrome and is given for four different types of film, each of which requires a different basic pack. These films are Kodachrome, Ektachrome, Agfachrome, and Fujichrome. For GAF slide films you can use the Kodachrome basic pack. Following is some typical basic filter pack information:

BASIC FILTER PACK

	Kodachrome	Ektachrome	Agfachrome	Fujichrome
Y	60	65	55	70
M	00	00	00	15
C	15	15	05	00

The preceding chart indicates that under standard factory conditions the basic filter pack for Kodachrome would be Y 60, M 00, and C 15 for a particular batch of Cibachrome. Under these

Some Chromega polyester color printing filters. They are positioned in your enlarger between the light source and the lens to control the color of your prints. They come in the colors cyan, magenta, and yellow.

conditions this would give you optimum color reproduction from a properly exposed and processed Kodachrome slide.

But you do not work under factory conditions. You have your own enlarger which has its own color balance, and it may differ considerably from the factory norm. For a variety of reasons the factory norm is seldom the same as yours. As you will see in a moment, however, this doesn't really matter.

You make your first print using only the basic (factory normal) filter pack, and this can lead you to an adjusted filter pack that brings your own enlarger into proper balance with your Cibachrome material.

Say you are using Kodachrome and the basic pack and the first print from your slide is too magenta, requiring a green (Y 15 plus C 15) to correct it. You might call the Y 15 plus C 15 the enlarger correction factor. To get the adjusted filter pack you add it to the basic pack as follows:

Basic Filter Pack From Paper Package:	Y 60	M 00	C 15
Your Enlarger Correction Factor:	+Y 15		+C 15
Adjusted Filter Pack:	Y 75		C 30

The adjusted filter pack would then be used with all Kodachrome slides with that particular package of Cibachrome material. To shift to other types of slide films, simply add your enlarger correction factor to the basic filter packs suggested for them, which will give you the appropriate adjusted packs. For example, your Ektachrome basic pack is Y 65 and C 15; adjusted, it comes out to Y 80 and C 30.

As we have seen, Cibachrome, like all other print materials, varies somewhat from batch to batch. This means that each batch will have its own basic filter pack. All you have to remember is to add your own specific enlarger correction factor to the basic pack for the particular brand of film in your color slide. As you have seen, this gives you the adjusted filter pack.

The enlarger correction factor will tend to remain the same for a considerable period of time, but it may change after a while due to gradual fading of color printing (CP) filters, aging of the enlarger bulb, changes in processing procedures, etc. This means that you may have to adjust the factor occasionally. Since the Cibachrome system is quite tolerant to color-balance changes, you will not find the adjustment difficult to make.

Sometimes the adjusted filter pack will add up to using three colors of filters—yellow, cyan, and magenta—which would give you some neutral density. For example, you might get Y 80, M 05, and C 15. The neutral density is indicated by the lowest filter density—in this case M 05. There is a neutral density of 05 made up of Y 05, M 05, and C 05. None of the rest of the filter density in yellow and cyan contributes to the neutral. Since the neutral density doesn't correct color and does make for longer exposures, it may be wise to get rid of it, though you *can* ignore it. You simply subtract the value of the lowest density (05) from each of the colors. That is, you subtract filters that have that density value. For example, when your adjusted filter pack comes out to Y 80 and M 05 and C 15, you can subtract as follows:

Y 80	M 05	C 15
−Y 05	−M 05	−C 05
Y 75	M 00	C 10

The thing to remember is that if you have all three colors of filters in the adjusted filter pack, you have got neutral density. Depending on the amount of it and a possible need for shortening the printing exposure, you may want to get rid of it—which you can do by subtraction. In the sample above, an 05 neutral density is not very much, so it might be best to ignore it.

● Cibachrome Chemicals

Read the instructions carefully and follow them explicitly. Wear clean rubber gloves and immediately wipe up all spills. Carefully wash each mixing vessel immediately after use.

KEEP THESE CHEMICALS OUT OF THE REACH OF CHILDREN, for they can be very dangerous. Though the liquids come in bottles with child-resistant safety caps, this is but partial protection—children have a way of figuring out such devices. And your own storage bottles will probably not have the caps.

The chemicals, especially the bleach, are quite corrosive and irritating to the skin, so rubber gloves are a must whenever you are mixing chemicals or processing prints. The bleach should be neutralized before it is discarded.

The chemicals should be carefully mixed according to instructions in order to avoid various faults in your final prints.

Only three chemical solutions are required: developer, bleach, and fixer. They can be mixed to make one quart at a time (for ten 8 x 10 prints) or one-half gallon at a time for twice as many prints. You can also mix them for individual 8 x 10 prints, though this is usually done only with the developer. Mix as follows: 15 ml of Part A and 15 ml of Part B, then add water to make 90 ml (3 ounces). The developer can be mixed just before use.

All Cibachrome chemicals should be stored at room temperature in well-sealed glass or polyethylene bottles. The concentrated stock solutions will keep for several months in unopened bottles. Part B of the developer may turn yellowish after a time, but this doesn't change its strength or affect its use. Storage life of the working solutions at room temperature is as follows:

developer: full bottle—4 weeks
 partially full bottle—2 weeks
bleach: 4 to 6 months
fixer: 4 to 6 months

Remember that Cibachrome chemicals are highly toxic; you should take precautions with this in mind. Accidentally ingesting one of them could be a very serious business.

● Identifying the Emulsion Side of the Material

Cibachrome is very smooth on the emulsion side and a little less smooth on the back. This difference can be used for identification in the total darkness needed for working with the material. Hold a piece of it up to your ear and stroke it lightly with your finger. The smooth emulsion side will make no sound, but the less smooth back side will make a light whisper.

In the room light (which you don't want while you are exposing) you can tell the emulsion side easily enough; it is a dark gray, while the back side is a brilliant white. While you are exposing you can also tell if you have the right side up—a bright image indicates that the paper is in the printing easel upside down. If the right side is up, the gray emulsion will make the image quite dark.

● The Reciprocity Effect

Like many other photosensitive materials, Cibachrome loses speed during long exposure times, which is sometimes called "the reciprocity effect." You don't get the amount of exposure effect that you think you should. Your prints will be darker than you expect and will be bluish-cyan in color balance. However, you can correct by increasing exposure, adding yellow filtration, and subtracting cyan filtration.

You may need the reciprocity correction when you decide to close down a stop from the one used for an initial exposure. Ordinarily, you would then double the exposure time, but this may not be enough when the reciprocity effect is

a factor. The following time-correction figures will usually work quite well:

Initial Exposure Time	To Double the Exposure Use
5 seconds	10 seconds
10 seconds	21 seconds
15 seconds	35 seconds
20 seconds	48 seconds
30 seconds	78 seconds
40 seconds	112 seconds
50 seconds	150 seconds
60 seconds	192 seconds

These figures are only approximate, but they will usually work well enough. The best thing is to avoid using unduly long exposures by using the widest lens aperture that is still sharp, printing normally exposed color slides, and avoiding neutral density in the filter pack. With most lenses you have to stop down about two stops to get them acceptably sharp, though one stop is often acceptable. If the lens isn't stopped down far enough, the picture may be a little fuzzy near the edges, but with some images this doesn't matter very much. Unless the fuzziness is exaggerated, people pay little attention to the edges of pictures anyway.

● **Test Print**

You need a test print to help you zero in on the exposure and to make adjustments in the filter pack. One way to arrive at an initial exposure is to use an incident light meter that reads in foot candles. Leave the filter pack in the enlarger but take out the color slide. Put the meter on the easel and adjust the aperture setting until you get a reading of 0.5 foot candles (the room light should be out, of course). Replace the slide and set the exposure time at 10 seconds. If the maximum foot candle reading is lower, you have to

use a longer exposure. For example, if it is 0.25 you would use 20 seconds. This way of arriving at an exposure could give you a final print, but you may have to further adjust both the exposure time and the filter pack.

Another way is to make four separate exposures on the same piece of Cibachrome material. Use a rectangular black paper template (exposure mask) with one quarter of it cut out. Then you can position this template in various ways and expose the material by quarters—one exposure for each position. The template is furnished with Cibachrome material.

Use the same time (50 seconds) for all four exposures, but change the aperture setting for each one. Your exposures will then be:

50 seconds at $f/4$
50 seconds at $f/5.6$
50 seconds at $f/8$
50 seconds at $f/11$

After processing you should see that one of these exposures is the correct one or very close to it. The recommended 50-second exposure time is best for an enlarger with a 75-watt bulb, but higher-wattage bulbs would require less time. For a 150-watt bulb use 35 seconds, and for a 250-watt bulb use 25 seconds. However, you can simply ignore the wattage and use the 50-second time. The range of exposures you will get will take care of the difference in wattage.

For your final print use the aperture that will give you an exposure time of 50 seconds or less —if you can. Even with a heat-absorbing glass the enlarger bulb will be heating up your slide and filters, which isn't good for them. However, the final exposure time depends on several factors: the density of your slide, the amount of filtration, the wattage of the enlarger bulb, and how far you have to stop down your lens to get a sharp image. To keep the time reasonably short, don't stop down any further than you have to. With a quality lens, one stop may be enough. With a cheap lens you will surely have to stop down more.

A black-and-white rendition of a color test print made
with the exposure mask that comes with the Ciba-
chrome material. The picture segments were printed
at different f/numbers, but they all had the same ex-
posure time.

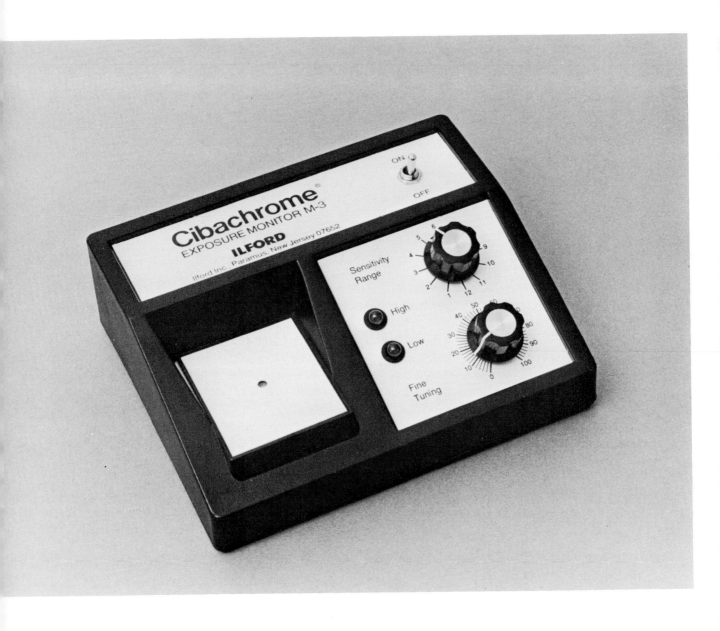

An Ilford electronic exposure computer used for printing Cibachrome. After making your first test strip with this device you don't have to make test when you print other transparencies, thus saving yourself a lot of time and money. You use this little computer, a kind of exposure meter, to get the correct setting for the enlarger lens. You can also use it when you change the filters in your filter pack, which saves a lot of computation.

Perhaps the easiest way to determine exposures and exposure changes for adjustments in the filter pack is to use Ilford's little Cibachrome Exposure Monitor M-3, a little electronic exposure computer that's as easy to use as a toothbrush. It does nearly all your thinking for you, so that you don't have to worry. Since complete instructions come with the device, there is no point in repeating them here.

● To Make Changes in a Print

You use your test print to help you decide what changes to make in exposure and in the filter pack. If a color is too strong, remember that you use its complement to subtract some of it. For example, if a print is too magenta you would add green filtration (cyan plus yellow). Put another way, you subtract a color by using its opposite on the color wheel.

The main pathways to change in a print are as follows:

To lighten a print—more light and/or more time

To lighten a local area—burn in the area

To darken a print—less light and/or less time

To darken a local area—dodge the area

To make a significant change in the density of a print—increase or decrease exposure by 1 stop

To make significant change in color balance—change appropriate filter(s) by at least .20 density

In a black-and-white print you burn in an area to make it darker. (To "burn in" means to give extra exposure time locally.) With Cibachrome, however, burning in an area makes it lighter. Similarly, dodging a Cibachrome makes it darker in that area. (To "dodge" means to hold back some of the basic exposure time locally.)

The fact that it takes a one-stop exposure change to make a significant change in Cibachrome indicates great exposure latitude. In most color materials the latitude is both short and tricky to work with. With Cibachrome you must be bold in making your exposure corrections, an unusual situation in the color field. You may even have to make as much as a two-stop change.

The fact that you need at least a .20 filter-density change to make significant color change in a print indicates that Cibachrome has great filtration latitude. This means that you can make substantial changes with less than the usual chance of error. Indeed, you will find that Cibachrome is very good in this respect.

● Other Factors That Can Make Changes in Your Prints

It would be nice if only the filter pack, exposure, and processing controlled how your prints come out, but other factors should also be considered:

1. *Enlarger bulb:* a tungsten lamp becomes more reddish-yellow with age, which is likely to affect the filtration.

2. *Color printing (CP) filters:* they may gradually fade with continued use.

3. *Voltage:* fluctuations of more than ±10 volts will significantly affect exposure and color balance.

4. *Enlarger lens:* fingerprints or dust on it can reduce contrast and make images unsharp.

5. *Slide popping:* a color transparency may pop out of focus in the midst of an exposure, making the picture unsharp.

With an aging bulb you may have to compensate in the filter pack by adding cyan or blue filtration. Since you modify your pack anyway for many pictures, this wouldn't be much of a problem.

Do not expose your printing filters to any kind of light—though you have to, of course, when you are printing. If it takes place at all, filter fading will be gradual, and you can gradually adapt your filter pack to compensate for it. Even with somewhat faded filters you can get good prints.

You can handle the voltage-fluctuation problem with a voltage stabilizer, which can turn out to be quite expensive. However, you can get

along quite well without one if you schedule your work to avoid those times when there are dramatic changes in electrical consumption in your neighborhood—for example, when factory shifts change, when people turn on electric stoves to cook meals, and when electric lights are first turned on at night. This suggests that midmorning, midafternoon, and evening after dark are your best bets. This avoidance is inconvenient, but you can do it if you have to. If you assemble a filter pack at a certain time of day, it should work well at the same time on following days.

Keep your fingers off your lens and clean it fairly often with lens tissue. Fingerprints can be corrosive and eat right into the surface of a lens, so avoid them with care.

Depending on how hot your enlarger is and how effective the heat-absorbing glass, a slide may pop out of focus in as little as twenty seconds or so. This means that with an exposure longer than this, the image will be sharp part of the time and fuzzy the rest. There is a way around it, however—pop your slide before you begin the printing exposure. This is the procedure to follow:

1. Turn on the enlarger light, focus your slide, then see how long it takes to pop. If your printing exposure is shorter than this time, you don't have to worry about popping. However, if it is longer, go on to the next step.

2. While the slide is still popped, focus the image again.

3. While the slide is popped and in focus, make the printing exposure. If the slide has cooled off and gone out of focus, simply use the enlarger light and an appropriate amount of time to pop it again before exposure.

Though this system subjects your slide and filters to more heat, there is not much else you can do if you have a popping problem. You could, of course, use a glass negative carrier to hold the slide flat, but that would present a dust problem that would be hard to surmount. Remember that dust prints up on Cibachrome as black spots and squiggles.

● Latent Image Stability

When a photosensitive material is exposed, it produces a so-called "latent image." Roughly speaking, this is an invisible image that may become visible when it is processed. We work with latent images all the time in photography. With most color materials these latent images aren't very stable—they tend to shift in color balance or in the level of exposure energy. To counteract these shifts after exposure, typical materials must either be refrigerated or processed right away. With Cibachrome, however, there is no problem. Exposed material can remain as long as two days at room temperature without any noticeable change in either overall density or color balance. This means that the material is very stable indeed.

● Judging a Cibachrome Print

How well you can judge a print for density and color balance depends a lot on the light that you view it under. If the light is bad—too dim or the wrong color—your judgment will be way off. For example, low-wattage tungsten bulbs are not good, and neither are fluorescents—they won't really show you the colors that are in your prints. Indeed, they may be way out of color balance without your being able to tell it.

People who work in color professionally—for example, in the graphic arts—have special light sources designed only for viewing color images. However, such equipment is expensive and not really necessary for the amateur photographer. A good compromise is to use a 3200K bulb for viewing. It has a high color temperature for a tungsten lamp and is quite bright. If your print looks good under this light source, it will probably look good under others.

For critical judging your prints should be dry. When they are wet they are a little too magenta.

● **Standard Processing at 75F. ± 3 Degrees**

This is the procedure for use with a processing drum. Though tray development is also a possibility, it should ideally use larger quantities of chemicals and is quite a bit harder to do correctly.

There are only four basic processing steps: (1) develop, (2) bleach, (3) fix, and (4) wash. Total time: twelve minutes. The following procedure is for an 8 x 10 or smaller print:

1. **Develop:** two minutes. After the exposed Cibachrome print is in the clean, dry, and tightly capped drum, turn on the room lights. Then pour in 3 ounces (90 ml) of developer and agitate vigorously for the first fifteen seconds—do this by rolling the drum rapidly on the tabletop. Thereafter roll the drum gently and evenly until the end of the cycle. If you have a motor base you can use it after the first fifteen seconds.

Start draining the developer fifteen seconds before the end of the development cycle, then pour the bleach into the drum. If there is an unpleasant odor, modify your technique on subsequent occasions with a short water rinse. Drain the developer as recommended, then pour in 3 ounces of 75F. water and roll the tank three or four times. Then immediately pour out the water and pour in the bleach.

2. **Bleach:** four minutes. Pour in 3 ounces (90 ml) of bleach and agitate rapidly for the first fifteen seconds, then agitate gently and evenly throughout the rest of the cycle.

Start draining the bleach fifteen seconds before the end of the bleach cycle, then pour fixer into the drum. If there is an unpleasant odor, use a water rinse between the bleach and the fixer as described in step 1. After rinsing, pour in the fixer.

3. **Fix:** three minutes. For each 8 x 10 or smaller print, pour in 3 ounces (90 ml or 90 cc) of fixer and agitate gently and firmly throughout the entire cycle. After three minutes drain for ten seconds.

4. **Wash:** three minutes. This is most easily done in a tray. Use rapidly running 75F. water. It will do no harm if you wash longer than three minutes, but you might as well stick close to the recommended time.

5. **Dry:** Take the washed print from the drum or tray and remove the water from both sides of it with a soft rubber squeegee or clean chamois. Then hang it up on a line or lay it out flat (emulsion up) on a photographic blotter. You can also lay it out on a towel, sheet, or bedspread. Don't try to ferrotype the print or run it through an ordinary heated dryer. However, you can put it through a dryer designed for resin-coated prints.

The air-drying time is about one and a half to two hours. Using an electric fan will reduce the time to about fifteen to eighteen minutes, and a blower-type hair dryer will reduce it to about seven minutes.

● **Other Processing Temperatures and Times**

The standard processing temperature for Cibachrome print material is 75F., but this can be changed if necessary. You can work at temperatures from 65F. to 85F., provided you also change the processing times. In any given processing run the temperatures of all solutions, including rinse and wash water, should be within 3 degrees of each other.

	68F. ± 3F.	75F. ± 3F.	82F. ± 3F.
Developer	2½ minutes	2 minutes	1½ minutes
Bleach	4½ minutes	4 minutes	3½ minutes
Fix	3½ minutes	3 minutes	2½ minutes

● **Handling Cibachrome Print Material**

Unprocessed Cibachrome print material should be handled only in absolute darkness. No safelight of any kind is recommended. Handle the

material only by the edges. If you want to take a firmer grip on it, wear the white cotton laboratory gloves made especially for photographers.

The processing drum should be absolutely clean. It should also be bone dry so that the material won't stick while you are loading it. Once the cap has been secured, the room lights can be turned on, for the tank is fully lightproof.

Cibachrome material wet from processing should be handled with care. Like most other photosensitive materials, it is subject to scratches and abrasions if handled carelessly. Dry prints should also be given the care traditionally accorded to photographic images.

● Measuring Chemicals

Measuring graduates come with the Cibachrome kit. Give each a separate label—developer, bleach, and fix—and to avoid contamination use it only for the chemical for which it is labeled. To further escape contamination, rinse it thoroughly after each use.

Measure the chemicals carefully—easy to do if you set your mind to it. Immediately mop up all spills.

For each chemical, the amount for an 8 x 10 or smaller print is 3 ounces (90 ml). If you already have graduates measured in cc's (cubic centimeters), you can use them, because a cc is the same as an ml.

You could perhaps use less chemical for a print smaller than 8 x 10, but the flow of solution in the drum probably wouldn't be as even, leading to processing defects. So it is best to stick with 3 ounces, which is a minimal amount as is.

● Consistency

Once you develop a technique for processing—it has been spelled out for you here—you should follow it rigorously each time, right down to the smallest details. This consistency will help you to achieve uniformity in your print quality. In contrast, an erratic technique will introduce variables—for example in color balance—that

are impossible to account for. So be as consistent as you can. If you pick 68F. as your processing temperature, stick with it. If you roll your drum at a certain rate of speed when agitating, do it the same way every time. If you hold the drum in a certain way while draining the chemicals, continue to do so. And so on. Although such things seem to be nitpicking details, they all add up to a consistent technique.

● Comparing a Slide and a Print

Before you start making overall density and color-balance corrections for a Cibachrome print, you might wish to compare your test print with the original color slide. It is not really necessary, because a print is its own kind of thing and should be judged in its own terms. Furthermore, no matter what you do, it won't look exactly like the slide. Still, it is educational to make comparisons now and then.

I have already suggested a 3200K bulb for print viewing. You should use the same light source for viewing your slide. Hold a sheet of white paper within a foot of the light and view the slide in front of it. Though the print will be held at a greater distance, the important thing is that both it and the slide will be inspected by light of the same color temperature. It would make no sense at all to view them with different types of light sources.

You may decide to make your final print look as much as possible like the slide, in which case the comparison is important. How far you can go in this direction can only be determined by experimentation, but don't be surprised if the print and slide differ in various ways. For example, the contrast may be different.

● Adjusting the Filter Pack

Remember that you make your first print with only the basic filter pack recommended on the Cibachrome package. To this pack you must still add filters to compensate for your enlarger correction factor. In subsequent prints you can use

the same enlarger correction again and again, but you have to use your first print and follow-up tests in order to work out what it is.

When you reach this point you should have examined your printing filters again and again so that you know for sure what yellow, magenta, and cyan look like. The latter two are the main problem, mainly because they have unfamiliar color names. Remember that magenta is a bluish-red, and cyan a greenish-blue. Fortunately, magenta looks sort of bluish, but cyan doesn't seem to have any green in it. You just have to remember that it is actually greenish-blue—as opposed to blue, which seems a little purplish.

You should also know what colors you get when you overlap the filters. That is, you should recognize red, blue, and green. Red and green are what you would expect, but can you see that blue is substantially different from cyan? Try not to confuse the two colors.

When you have your first test print you ought to see how it looks when it is out of color balance in different hues (it will probably already be out of balance in one of them). You can see this pretty well by viewing the print through .40-density printing filters, both single and combined. However, the fact that the print is out of balance to begin with will distort the effect somewhat. In order to see what filters actually do, it would be best to view a balanced print or a good color reproduction clipped from a magazine such as *National Geographic,* in which the color reproduction is always exceptionally good. Whatever path you take, this system of viewing through filters will help you recognize pictures that are too blue, too green, too magenta, etc. Basically, it means that they are too much this color or that according to your taste. You can use the system to refine your taste somewhat.

In a very short time you should be able to tell if a print is off-color. There is a very simple way to test your observation. If a print seems to be off balance in the direction of a certain hue, view it through a printing filter of the complementary color. For example, if it seems too reddish, view it through a cyan filter, which will subtract the excess red if it is of the appropriate density. If the filtered print looks right, then you know that you have to add cyan to the filter pack.

There is a little trick to this technique of viewing prints through filters. If you stare through a filter for more than a few seconds your eye will adapt itself to its color, thus throwing off your judgment. So just hold up the filter, look through it for about a second, then move it away again. Repeat this as often as necessary. In this way you will actually be able to see what tints of corrective color would do for the pictures you examine.

Books on photography often have illustrations showing how color prints supposedly look when they are out of balance in various colors, but they are usually worse than useless. Except in Kodak books and pamphlets, which have extremely expensive color reproduction, the illustrations themselves are so far out of balance that they distort everything entirely. For example, the print that is supposed to be normal may look reddish, and the one that is supposedly green may look just fine. Since you can learn what you need to know simply by looking through your filters, you don't need such illustrations anyway.

Before you make filter corrections to a print be sure to judge the overall density, which you can do with your 3200K lamp at a distance of five or six feet. If you have to hold the print up close to the light in order for it to look good, it is surely underexposed. On the other hand, if you have to hold it out of the light beam altogether, it is probably overexposed. The reason for judging the degree of lightness and darkness first is that beginners often get confused between density requirements and filter corrections. However, this trick with the light is no substitute for experience.

If a print is off balance into a certain color, you can either *add* the complement to the filter pack or *subtract* that color itself from the pack. For example, if a print is too red you can *add* cyan or *subtract* red (yellow plus magenta) from the pack. That is, you can either counteract the red or reduce it.

Although you can figure this all out with the color wheel given earlier, I will spell it out for you for simplicity's sake:

If the print is too:	*add:*	*or subtract:*
blue	yellow	blue
yellow	blue	yellow
green	magenta	green
magenta	green	magenta
cyan	red	cyan
red	cyan	red

When you see the corrections spelled out this way they seem almost self-evident. Remember that blue is cyan plus magenta, green is cyan plus yellow, and red is magenta plus yellow. If you find yourself still confused in such matters, you should play with your filters awhile. Hold them by their edges so that they don't get scratched, dirty, or fingerprinted. Though it is safe to have fairly dirty filters positioned in your enlarger between the light source and the lens, it is nevertheless a good idea to take care of them.

● **Exposure Corrections**

When you change the make-up of a filter pack you usually alter the amount of light that reaches the print material, which may necessitate a different exposure. This is especially true with cyan

Percentage of Exposure Change

Filter Density To Be Added or Subtracted	.05	.10	.20	.30	.40	.50
Yellow	10%	10%	10%	10%	10%	10%
Magenta	20%	30%	50%	70%	90%	110%
Cyan	10%	20%	30%	40%	50%	60%

or magenta filtration, less true of yellow. If you remove filters from the pack you should decrease exposure. If you add to the pack you should increase it. You can guess what the changes should be, which is a rather haphazard way to go about it; or you can use the following chart. It shows the percentage of increase or decrease in exposure time. If you add a certain filter you can increase by an appropriate percentage, but if you subtract it instead you decrease your exposure time by the same percentage.

Because of the wide exposure latitude of Cibachrome material, a 10 per cent change in exposure can usually be ignored. It doesn't make enough difference to bother with.

● **Exposure and Processing Faults**

If you follow precisely all the steps given here or in the *Cibachrome Color Print Manual* you probably won't have any exposure and processing problems. However, people do make mistakes and like to know their causes and possible remedies:

Picture dark-reddish and image reversed:
Cause: printed through the back of the material.

Blue spots:
Cause: static electricity, mainly in a cold, dry atmosphere.
Remedy: remove the Cibachrome material from its package slowly so as to not build up friction.

Black picture, or no picture:
Cause: no exposure, or omission of Part A in either developer or bleach, or omission of developing step, or omission of the bleaching step.

Fogged and dull print:
Cause: bleach solution too dilute, or bleach

temperature too low, or insufficient bleaching time, or developer not drained before bleach was added, or traces of fixer in the developer due to an improperly rinsed drum, or reversal of fixer and bleach steps.

Formation of a yellow stain on print after a relatively short time:
Cause: not enough final wash.
Partial remedy: rewash print to prevent further deterioration.

Dark and flat print:
Cause: developing time too short.

Print too light though exposure is correct:
Cause: developed too long.

White area in print, usually starting at the border:
Cause: the printing material was light-struck.

Yellowish appearance of the print:
Cause: bleach not drained before fixer was added, or fixing omitted, or fixing time too short.

Streaky or mottled appearance:
Cause: not enough agitation during processing, or too small a volume of solutions.

Print black with a relief image showing by reflected light:
Cause: print not bleached; bleach bath missed.
Remedy: put into fresh bleach; fix and wash recommended times.

Print colors dull and yellow-gray; whites are yellow-gray; surface not glossy:
Cause: fixer and bleach reversed, or print not fixed.
Remedy: refix in fresh fixer and wash recommended time.

Print has silver gray in whites and black print areas, and borders are normal black color:
Cause: print underbleached because of overdilution, short time, or low temperature.
Remedy: rebleach in fresh bleach; fix and wash recommended times.

Print has silver-gray in whites and blue borders; dark areas are blue, not black:
Cause: developer contaminated with fixer.
Remedy: none.

Glossy surface is matte in some areas:
Cause: print touched while drying.
Remedy: rewash and dry. If the problem is still evident, spray the dry print with lacquer.

● Retouching

The need for retouching generally stems from a color slide that was improperly cleaned—the dust particles print up black. These dust marks can be touched up with diluted white acrylic paint. However, if they are large you may have to use colored acrylics to match the surrounding areas. An alternative is to use white paint on a large spot, then to touch it up with a colored pencil—Turquoise Prismacolor pencils are fine for this. The pencil should have a long and very sharp point. If you get too much acrylic on a print you can easily wash it off again while it is still wet.

For retouching white spots or darkening light areas you can use the Cibachrome transparent retouching colors. Since they are hard to apply evenly, it is best to confine your work to small areas. Work with dilute colors, slowly building up their density. With mixtures of these dyes you can match any color in your print. If you dampen an area before painting it, the color will go on more smoothly. It also helps to have Photo Flo in the water you are using; it contributes to smoothness.

If your retouching shows up as little matte spots when your print is viewed at an angle—as acrylics surely will—you can hide them by using one of the Cibachrome lacquer print sprays, which will also protect your prints. These sprays are available in glossy, velvet luster, and matte. If you are going to mount a print, spray it after it has been mounted.

175

A rather forlorn-looking rowboat resting quietly in the mud, waiting for its owner to come along and rescue it. In the shade, which is bluish, the colors are all muted. [Photo by David Howland]

A picture dizzy with delicate color. If you would like to give your eyes a workout, try counting all the flowers — there must be a million of them.
[Photo by Michael Flinn]

Soft fall colors brighten up a sylvan glade, turning it into a healing experience for tired eyes. A wonderful place and time to while the hours away.
[Photo by Robert Bridges]

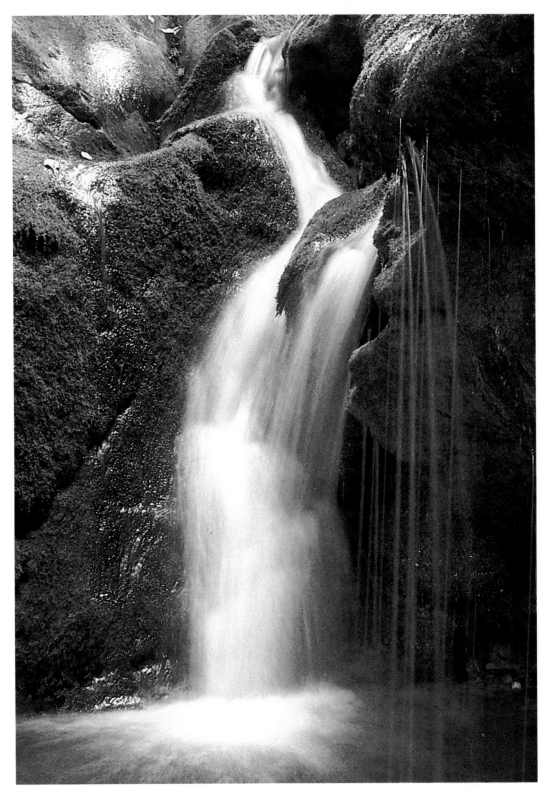

Shooting at a slow shutter speed turned the water into white velvet. This is a very simple picture, but it has a lot going for it.
[Photo by Dale Strouse]

The bare wood of this tree trunk seems to flow like a river. You can also see faces in the tree if you look hard enough.
[Photo by Dale Strouse]

A winter field dusted lightly with snow. Perhaps the picture evokes a feeling of gentle sadness in you as you wait for spring to return.
[Photo by Dale Strouse]

The sun breaks through after an ice storm that turned the landscape into jewelry. Backlighting has made the branches come out black, emphasizing the brilliance of the ice.
[Photo by Ronn Kilby]

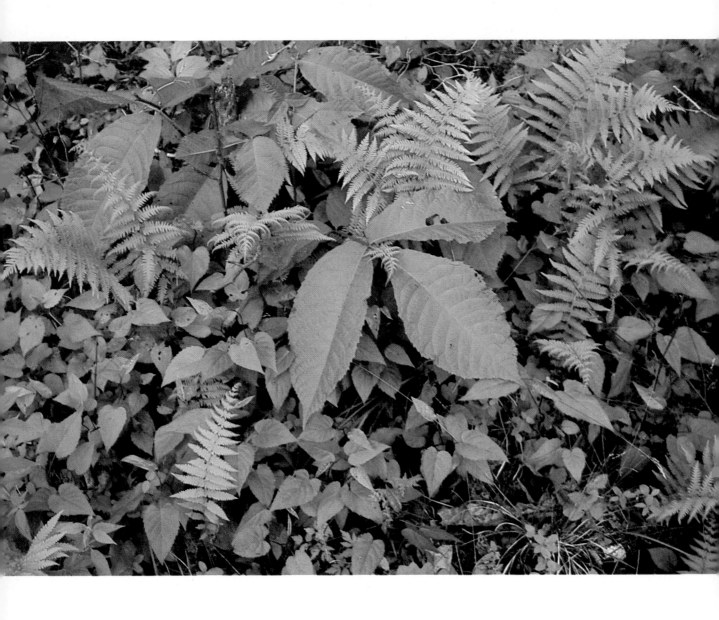

A minor symphony in green, with Mother Nature at her
most luxurious. An easy picture to take, even easier
to look at.
[Photo by Rod Mann]

• Mounting Prints

Cibachrome prints can be easily dry-mounted with the low-temperature mounting tissues made for color and resin-coated prints. Follow the instructions that come with these tissues, making sure not to get your mount press too hot.

You can also use the double-coated adhesive sheets made especially for mounting photographs without a mounting press. You strip one side of a sheet to your print, then strip the other side down on a mounting board. Nothing to it. Adhesive sprays are also good. Simply spray the back of a print, then rub it down on a mounting board.

Since Cibachrome prints are very stable and fade-resistant, you might consider using fairly permanent mounting materials—for example, heavy boards and tempered Masonite. The mounting tissues themselves are very permanent, for they are merely thin sheets of paper impregnated with a stable adhesive. If permanence is your forte, consider spraying your prints after mounting, or frame them under glass. Either approach will protect your prints from fingerprints and abrasions.

• Color Compensating (CC) Filters

The filters discussed so far in this chapter have been the CP (color printing) type, which are made of acetate and are not optically perfect. If they were placed underneath the enlarger lens they would distort the image somewhat, but they are positioned inside the enlarger between the light source and the lens, where the imperfection doesn't matter. The light isn't creating any images at that point, so slight distortions don't affect what will happen to an image after it is formed. Even if the filters are scratched and rather dirty, it doesn't matter much. So CP filters are handy to use—if your enlarger has a filter drawer. If not, you must use CC (color compensating) filters at the lens.

CC filters are made of gelatin that is optically flat so that they don't distort image-forming light. However, they will distort it if they are scratched, fingerprinted, or dirty, so they must be handled with extreme care. If you use too many CC filters at once they will cause flare, loss of contrast, and loss of definition. Though you can safely stack up nine or ten CP filters in a filter drawer, the maximum number of CC filters that can be used at the lens is three. If you use more than that, the image will definitely suffer.

The problem with CC filters is caused by the fact that the image-forming light bounces around too much from the various filter surfaces, and some of it comes through the pack at the wrong places. There is a further problem with dust and fingerprints, which scatter or diffuse the light; the more dirty surfaces you have, the greater the scatter. With CP filters in a filter drawer this scatter doesn't matter.

Since three is the practical limit for CC (color compensating) filters beneath the lens, it wouldn't do to have to use two filters to get a single color—for example, cyan and yellow to get green. Having to mix your own hues merely multiplies the number of filter surfaces. Thus the manufacturers supply you with green already mixed in a single filter; blue and red are also supplied. Thus with CC filters you can get red, green, blue, cyan, magenta, and yellow, which includes all the basic colors. However, you can mix still other hues by stacking up filters, remembering that three is the limit.

The Kodak CC filters have a greater density range than CP filters—they start at lower densities. Though densities of .10 and lower are not needed for Cibachrome with its wide filtration latitude, you should get the lower densities for other types of printing material. The complete listing of Kodak CC filters is as follows:

Red	Green	Blue	Cyan	Magenta	Yellow
CC025R			CC025C	CC025M	CC025Y
CC05R	CC05G	CC05B	CC05C	CC05M	CC05Y
CC10R	CC10G	CC10B	CC10C	CC10M	CC10Y
CC20R	CC20G	CC20B	CC20C	CC20M	CC20Y
CC30R	CC30G	CC30B	CC30C	CC30M	CC30Y
CC40R	CC40G	CC40B	CC40C	CC40M	CC40Y
CC50R	CC50G	CC50B	CC50C	CC50M	CC50Y

Perhaps these code terms need further explanation. For example, CC025C stands for a cyan correction filter of .025 density; CC50G stands for a green CC filter of .50 density. Density is a measure of a filter's ability to absorb light: the higher the density the greater the absorptance. As you have already seen, filters are used mainly to absorb their complementary colors:

> Red absorbs cyan (or blue and green)
> Green absorbs magenta (or red and blue)
> Blue absorbs yellow (or red and green)
> Cyan absorbs red
> Magenta absorbs green
> Yellow absorbs blue

In assembling CP filters to put in a filter drawer, it is often necessary to mix filters to get the right color. For example, you have to mix yellow and cyan to get green. With CC filters you already have a green, so mixing isn't necessary, though it can be done. For example, you can mix your CC green with a CC yellow in order to absorb a bluish-magenta.

However, with the six basic hues in CC filters you probably have enough colors to make further mixing unnecessary. In a CC pack the three filters are likely to be of the same hue—three filters are needed to get enough density. If the density of the available filters ran high enough (say, to 1.5), there wouldn't be much need to use more than one filter. However, this would be expensive. You could also expand the six hues to twelve, adding hues between the basic ones on the color wheel. For example, you could have orange and purple. This, too, would be expensive—and entirely unnecessary.

The important thing to understand is that with six hues in CC filters you don't have to use many filters in a pack. Remember that with more than three you are asking for trouble. You *can* use more, of course, but you should expect a certain amount of image degradation. Though a person with highly sensitive color taste might mix together CC hues that are adjacent to one another on the color wheel, such refinement is not really necessary.

NOTE: to a CC filter pack you should add a UV filter. If there is a place in your enlarger for a heat-absorbing glass, it would help protect your slides from heat during long exposures. Take great care to protect your CC filters from dust, fingerprints, and scratches.

The filter holder that you use should be perpendicular to the lens axis, so that the enlarger light goes through the filters at a right angle. If it goes through at a slant there may be some image degradation.

The exposure correction factors that were given for CP (color printing) filters also apply to CC (color correction) filters. However, you have to estimate the corrections for red, green, and blue.

● Dichroic Color Enlargers

So far in this chapter we have dealt with putting filters in a drawer or underneath the enlarger lens. However, you may have a dichroic color enlarger in which you simply dial the filter pack, which is a substantial convenience. Unfortunately, such enlargers are expensive, the typical dichroic enlarger head costing as much as, or more than, the enlarger itself.

A dichroic head won't produce better pictures than you get with CP or CC filters, but it is easier to use. A further advantage in most types of

dichroic heads is that they produce diffuse illumination, which minimizes dust marks, fingerprints, and scratches in your prints. This is a great advantage, because retouching color prints can be a horribly difficult job. In contrast, the typical enlarger without a dichroic head is of the condenser type, which shows up dust marks and other blemishes very clearly. Such an enlarger is necessary for small-format black-and-white work, where it minimizes light scatter by the silver grains in the negative's emulsion. However, with color negatives or slides there is no silver, only dye, so scattering isn't a problem. Thus a light-scattering diffusion head such as is found in most dichroic enlargers is perfectly all right for small-format color work.

With dichroic color heads there is also no problem with bulb fading, because the tungsten-halogen lamps used in them maintain a constant color temperature throughout their lives. Thus you don't have to adjust your filter pack to compensate for this fading.

Dichroic enlargers are in no way essential for color printing, though they are quite a bit more convenient. However, it is not the dichroic filters in them that make them so desirable for color printing—it is the diffuse illumination itself. After all, changing gelatin or acetate filters in a pack is no big job. Any devout amateur would be pleased to take the time. So dichroic heads are simply luxuries—except for their diffuse illumination.

● **Cibachrome Easy**

Although the explanations in this chapter have been profuse, you should realize by now that it is very easy to make a Cibachrome print. The only thing at all difficult is getting your filter pack and exposure right. However, if such things confuse you, you can solve the problem by trial and error. Final prints arrived at in this manner are as good as any other kind.

Some Questions to Ask Yourself

When you are working on something it often helps to ask yourself questions about what you are doing. Asking the right questions can help you to do a good job. They act as guidelines to help you to understand what you are doing with your photography. They help you to keep track of things. The questions in this chapter are intended especially for beginners, who haven't yet formulated for themselves the questions that photographers generally use in their work. If you treat them with respect they should prove useful to you.

● Backgrounds

As a beginner you may concentrate on a subject and pay no attention to the background, which may not look right. You may not even see it at all. However, your camera sees it in all its details, whether they look right or not. Thus you may end up with a picture that has something in it you don't want, or lacks something you do want.

Ask yourself: Have I checked the background carefully? Is my subject positioned well in relation to it? Are there things in it that I don't really want there? Would it be improved if I added something to it? Is this background the right tone and color? Does it help display the subject well?

Does it look as if it belongs with the subject? Is it properly subordinated to the subject? Will it help my picture say what I want it to?

● Distance

Beginners typically position themselves too far from their subjects, especially when they are photographing people. They figure they can crop their pictures later in printing. But this is not always good, because cropping too much may require an excessive degree of enlargement, which lessens photographic quality considerably. The thing to do is to fill up the viewfinder frame with your subject.

Ask yourself: Am I filling up the frame? Is my distance from the subject appropriate for what I want to do with the picture? Am I close enough to the subject to see all the important details? Is there some psychological reason (e.g., fear of people) why I want to stand far away from the subject? Does the subject look large enough in the viewfinder?

● Camera Angle

In shooting a picture the easiest thing to do is click from wherever you happen to be at the moment, but this is not the way to get a *good* pic-

ture. Instead, try out every camera angle you can think of until one looks just right—*then* shoot your picture.

Ask yourself: Have I tried out all the reasonable camera angles? Have I seen what difference the camera angle makes with this particular subject? Does the selected camera angle help the picture to work the way I want it to? Does it add interest to the picture? Is it also appropriate for the subject I am photographing?

• Selection

Photography is sometimes called the art of selection. Unlike the painter, the photographer can't create something out of nothing, but you can be very selective in what you choose to photograph, and in this way illustrate your visual taste.

Ask yourself: Am I being selective enough? Do I really want to make this photograph? Are the things in it all that I want them to be? Are there somewhat similar things that are also available to me that are more to my liking? Do I really care for the things that will be in this photograph? Will other people care about them? Will this picture represent my esthetic feelings well? Have I in any way deceived myself concerning my desire to take this picture?

• Cropping

Cropping is an aspect of selection. It refers to cutting all or part of something out of a picture by framing. When you crop into something you cut into it with the picture frame, getting rid of part of it. The usual reason for cropping is to eliminate or subdue something that is extraneous to a picture.

Ask yourself: Am I cropping the picture tightly enough? Too tightly? Are there unimportant but distracting things in the subject that could be toned down by cropping into them? Is cropping the best way to tone them down? Will

cropping help to clarify what the picture is about? Or will it lessen the picture's coherence? Does the picture really need to be cropped?

• Camera Steadiness

Perhaps the chief fault with beginners' photographs is unsharpness due to camera movement during exposure. This is mainly because they don't hold the camera properly. It should be held firmly and pressed hard against the cheek or forehead. The elbows should be pressed against the rib cage. The breathing should be slow. And the shutter release should be *squeezed slowly*— not shoved.

Ask yourself: Is my camera well braced? Can I hold it steady at this shutter speed, or do I need a tripod? Have I slowed my breathing enough to quiet my nerves? Am I using a grip that will permit me to depress the shutter release without jiggling the camera? Have I braced my body to steady it? Am I emotionally ready to take a picture without moving the camera? Am I slowly *squeezing* the shutter release?

• Depth of Field

The plane of sharp focus that extends in front and in back of what you are focusing on is called the depth of field. Stopping down increases it, while opening up decreases it. Generally speaking, primary subject matter should be sharp, whereas secondary objects can be allowed to go out of focus. However, it is usually wise to get as much depth of field as circumstances permit.

Ask yourself: Will the important things in my picture be in sharp focus? Should I use a slower shutter speed and stop down further in order to increase the depth of field? Or should I use a faster speed and a larger *f*/stop for less depth of field? Do I need the faster speed to freeze subject and camera movement? Will certain things in my picture look all right if they are out of focus?

Would it be good to subordinate a few things by throwing them out of focus? Will the depth of field I am using help me to achieve what I am trying to do in the picture? Will it look natural?

● Freezing Action

Unless you are using electronic flash or working outdoors, where you can use very fast shutter speeds, there may be a problem in freezing action. With slow shutter speeds and available light you may have to decide that you can't freeze it. Then you have to wait for pauses in the action, shoot blurred action photographs, or, with people, ask them to stand still.

Ask yourself: Is this action something that I really want to photograph? Will circumstances permit me to freeze it? Would my pictures look all right if the action were only partly frozen? That is, would blurred action photographs look all right in this situation? Are there peaks in the action where everything comes to a halt for a brief instant? Can I time myself to photograph them at that moment? How many photographs would I have to shoot for one to come out right?

● Focus

The photographs of beginners are often out of focus, which is usually undesirable. Sometimes they forget to focus; sometimes they focus on the wrong things; and sometimes they change their position with respect to their subjects and don't realize that they should refocus. People usually focus on the wrong thing because it is the easiest thing in the viewfinder to see and focus on. For example, in a portrait people will often focus on the contour of the head, whereas they should focus on the eye nearest the camera. However, the contour may be strongly visible and the eye less so—thus a wrong choice is made.

The general rule is that the most important part(s) of the subject should be in sharp focus,

and things of lesser importance can be somewhat out of focus.

Ask yourself: Did I remember to focus? Did I focus on the right thing? Did I remember to refocus whenever either my subject or I changed position?

● Light

A person interested in photography should become a student of light, constantly watching what it does to the appearance of things. What does it do to faces, figures, objects, landscapes, interiors, houses, flowers, trees, etc.? Light is always doing *something*—the point is to figure out *what*. The solution is to make yourself acutely aware of light, for out of this awareness comes knowledge.

Ask yourself: Beyond making it visible, what is light doing to this object I am looking at? Does the lighting have any particular quality that I can put my finger on? Should I call it ordinary or unusual? Does this lighting obscure as much as it reveals? That is, are parts of my subject lost in the shadows? What are the shadows doing, if anything? When I look at my subject, do I get the feeling of light falling upon it? That is, does the light look like light? What is light doing to the apparent three-dimensionality of the subject? Does it look more three-dimensional than usual, or less?

Is light emphasizing one part of my subject more than another? Is it making things look pretty, ugly, or somewhere in between? Do the shadows form a kind of pattern? Is the light-and-shadow pattern orderly, disorderly, or something in between? Does the lighting have a mood? Is it gay, bright, sad, somber, etc.? Does the mood seem to affect my thinking as I look at the subject?

Do I want the light source in the picture? What will be accomplished if it is? Do I want the picture to be about light and what it does to something? Was I actually noticing light before I made

up my mind to observe it? Why don't I notice light more than I do? If I could have a different lighting on the subject, what would it be? Does the present lighting make things look more or less real than they ordinarily do? Does the light have anything to do with the way I am feeling at the moment?

● Color

A person interested in photography should become a student of color, constantly watching for its effects on people and observing what it does to the visible world. Knowing about such things can only come through an awareness of color, which you can develop by persistently asking yourself the right questions.

Ask yourself: What colors are right in front of me at the moment? Are they bright or subdued? What chromatic colors can I see in the off-grays? Do I want color, as such, to be the main subject of my picture? Or is something else the main subject, with color one of its secondary attributes? Are the colors I am looking at pretty or homely? What makes them that way?

Is the light by which I am now seeing tinged with warm or cool colors — or something in between? When it falls upon things, does the light itself seem to have color? Does the color of the objects I am looking at seem to have anything to do with light? If not, why not?

Do the colors I see look clean or dirty? Why? Is the color combination harmonious or not? Why? Which colors look prettiest? Which are homeliest? Do the homely colors seem to help the pretty ones?

Will the film I am using (daylight or tungsten) record my subject in the way I see it? Or will there be a distortion of color? If so, what will be its nature?

Do I really like the colors I am looking at? Or do they leave me indifferent? Is this indifference due to lack of sensitivity? Or is it that the colors don't do anything special? To get the picture I want, do the colors have to do something special? Or can they just be there, doing whatever they do?

What would a color picture of this subject do that a black-and-white photograph wouldn't do? Is color the most appropriate medium? Or would black-and-white be better? That is, Is color really necessary? Why?

As I look at my subject, is there something that makes me more aware of color than usual? Is this awareness a good thing? Or is there something distracting about the colors I see? What is the nature of the distraction? Does it belong in the picture?

● Number

You don't always have a choice as to what is included in a picture — you often have to shoot whatever happens to be there. But when you do have a choice it is good to think about number — too many, too few, or just the right number of things for whatever you happen to be doing. There are no rules concerning numbers, but some seem to be more magical than others — for example, three and five. If you have either three or five things in a picture, it seems to work better.

Ask yourself: Do I have too many things? Too few? Or just the right number? Are there so many things that individual objects are lost in the crowd? Or are there so few things that the picture looks empty or barren? Is my choice of number appropriate for the kind of thing I am photographing? Does the specific number of things in the picture help to make it work? Is number also an important part of the picture idea? Or is it a subordinate element? How does the number of things affect the appearance of the subject? Does it help describe what the subject is all about?

● Emphasis and Subordination

Ordinarily, you should try to emphasize the main element(s) of a picture and subordinate everything else. You can emphasize an element in several ways: put it in a central part of the picture area; make it stand out by lighting; put it in front of subordinate things; give it a color that stands out from other colors in the picture; have lines in the picture that point to it; fill up the picture frame with it; make it lighter or darker than other things in the picture; position it next to things with which it contrasts; and so on.

You can also subordinate a thing in several ways: put it in a peripheral part of the picture area; crop out part of it; use lighting to make it blend with other things; put it behind more important things; give it a color that will lose itself in other colors in the picture; make sure that strong lines don't point to or intersect it; make it the same tone as other subordinate things in the picture; put it next to things with which it doesn't contrast; and so on.

The thing to remember is that emphasis involves making a thing more visible, while subordination means making it less so. Though you don't always have a choice, there are numerous times when you can employ techniques for emphasis and subordination.

Ask yourself: Have I emphasized the most important things in the picture? Did I choose the right things? Does the emphasis help people to see what the picture is all about? That is, does it help to make its meaning clear? Have I adequately subordinated things that are relatively unimportant in the picture? Have I also subordinated things that might be distracting?

Have I emphasized anything too strongly, so that it will be too obvious in the picture? Does anything need more emphasis than I am giving it? Does my emphasis look natural? Does it look forcedA Have I subordinated anything too much? That is, would it look better if it were more visible?

● Prettiness

Whatever else their pictures do, people generally want them to be pretty. Though prettiness isn't the only thing to go for in pictures, it is a time-honored goal. Though people usually recognize prettiness when they see it, this is true only to a degree. For example, some see it only in people, dogs, and cats—but prettiness can be an attribute of many things. The problem is to see it wherever it exists and discover the causes for it. If you know *why* something is pretty you may be able to make it even prettier.

Ask yourself: Is this thing that I am looking at pretty? What makes it that way (line, texture, color, contour, composition, tone, etc.)? Am I looking at it from its prettiest angle? Is there anything I can do to add to the prettiness? Are there ugly or homely elements in the subject? What causes them? Is there anything I can do to eliminate or subordinate these elements?

If I wanted to make this subject homelier, what would I do? Do other people see it as pretty or homely? What seems to be the basis for their opinion? Am I seeing this subject through my emotions or through my eyes? That is, are emotional factors affecting the way I see it? Looked at objectively, is my subject pretty or homely?

● Right Timing

When you are taking a picture there is often an ideal moment to click the shutter. This is especially true of action pictures and portraits. In a portrait, for example, there ought to be a good pose, good background, good lighting, good expression, and so on. Until all these things are brought together, it is not the ideal moment to click the shutter. Above all, the photographer should have good rapport with the subject.

Ask yourself: Is this person ready to be photographed? Is there anything I can do to improve his or her state of readiness? Would a few quiet

compliments help matters? Does the lighting on the face look right? If not, what can be done to improve it? Can I suggest comfortable improvements in the pose? Can I improve the subject-background relationship? Am I alert enough to anticipate the ideal moment? Am I letting myself be distracted by my own feelings or technical details?

Ask yourself: When is the best time to photograph this action? What things should I look for? Will the picture I want to take describe what the action is all about? Do I understand the action well enough to recognize the ideal moment to shoot? Is there anything I could do to improve the action? Since the action is fast-moving, would it be better to shoot first and ask questions afterward (it sometimes is)? Can I solve technical problems in advance so that I can catch the peak action when it happens?

● **Idea**

Pictures embody ideas, though photographers don't necessarily have this in mind. Even so, the idea is always there. In a glamour picture, for example, the idea is: "This is a beautiful and sexy woman." In a picture of a house the idea might be: "This is a handsome and well-built structure." And in a picture of a birthday party it might be: "This is a time when children are really enjoying themselves gobbling cake and ice cream."

Ideas are in your pictures, whether you want them there or not—it is the nature of the photographic medium. The best thing is to welcome them, analyze them, then shape them to your own ends.

Ask yourself: What is the idea of the picture I am taking? Is this idea to my satisfaction? What could I do to improve it? How can I make this idea clear in my picture? Would a change in the idea be appropriate?

What specific things in my picture will put the idea across? Can the relationship of these things be improved to give the idea greater clarity? What are the secondary ideas? Are any of them likely to confuse the viewer as to what the main idea is? Do these secondary ideas complement the main idea? Or do they distract?

What reasons do I have for believing that others will understand the main idea of the picture? Does this idea dominate the picture? Why?

In this chapter you have been given a series of questions to ask yourself. Though there are others of equal importance, these will provide a useful starting point. Use them to help you be more alert to what you are doing when you make pictures.

Judging Your Pictures

When people get involved in photography they soon want to know how they should judge their work. They assume that standards of excellence have been set up through the years and that they should try to measure up to them. For some, measuring up is very important, for they see photography as a game, with winners and losers. This is particularly obvious in camera clubs, where competition is very strong. Though many prefer to compete only with themselves, they still want standards by which to measure their progress. In short, they want to know if they are winning or losing.

There are some who don't care a whit about standards. They just shoot their pictures and enjoy them without asking why. Since they are happy in what they are doing, it is best to leave them alone. If you are such a person, this chapter is not for you. It is only for those who are concerned with personal and impersonal standards of excellence and who want to know where they stand as photographers. If you don't care about them, there is no reason why you should worry about them.

● **Beauty**

In color photography the most obvious standard is beauty or prettiness, for color as such is usually a very pretty thing. That is, the world is beautiful in its colors, and color pictures display this beauty very well. Furthermore, they draw your attention strongly to the colors, which the world itself often does not do. Having your attention drawn to colors is a salubrious thing. It makes you feel good, for colors are indeed something to glory in.

Of course, color pictures vary in the degree of prettiness they embody, ranging from homely to beautiful. The latter are always considered fine pictures, whether or not they have any other virtues. You might say that beauty is its own excuse for being and that a beautiful color picture needs no arguments to bolster its position in our esteem.

So prettiness is enough, according to the theory. If your pictures have that quality you are surely doing very well. However, there is more to the world than sheer prettiness. You can permit yourself to make both homely and pretty pictures.

● **The Ugliness Problem**

Though color pictures generally come out pretty, they can also be ugly at times, which is usually thought to be a sin. This is obviously because people are naturally repelled by ugliness. But it does exist in our world and should be examined now and then. How can we make it go away if we don't look at it?

However, ugliness in a color picture—not often seen—is enough to make people automatically reject it without asking what the picture might have to say. It seems that our reactions to color of any kind, pretty or ugly, are chiefly emotional and that our emotions are divorced from our minds. Whatever the reason, we do shy away from ugliness in color, which is not a good thing.

Ugliness should be thought of as one of the legitimate tools of the photographer—he uses it when he needs it. For example, if you were to do a picture story on bad working conditions in a factory, you would need some ugliness, though prettiness is a lot easier to get with modern color films. The ugliness would help you tell your story. So think of it as something you may need, and don't shy away from it with your mind turned off.

This is not to say that ugly pictures are automatically good, which is absurd. However, they can be good if the ugliness carries an important message.

● I Like It: The Irrefutable Standard

Any picture that you like is a good one. It is so important in life to like things that no one should try to talk you out of it or call you a dummy for liking something that is less than perfect. You can like an image that is a real mess when measured by most standards, but that doesn't mean it is a bad picture. For *you* it is a good one, and that is what matters most.

A short time ago a young man showed me about a hundred terrible pictures—you could barely make out the subject in most of them. I agreed with him that they were very nice—because he thought so. Should I have roundly denounced them, thus depriving him of joy? No. If a person likes a picture, it *is* a good picture—for him. If other people disagree, that's their tough luck.

You can like a picture and think it good for hundreds of reasons, and who should call you

wrong? If it doesn't measure up to impersonal standards established in the field of photography, why should you care? The important thing is that it measures up to *your* standards, and they are just as important as any. Indeed, there is one standard that no one can argue with: "I like it."

My telling you to stand by your likes (and dislikes) may sound like a copout, but it really isn't. It is a perfectly honest and reasonable position for you to take. And it doesn't matter at all if you happen to disagree with a lot of other photographers.

● Faithful Color Reproduction

Many photographers credit themselves if their pictures faithfully reproduce the colors of their subjects. This criterion appeals particularly to people whose tastes are more technical than artistic, because it can be approached objectively. The idea is to have all the grays look neutral, the flesh tones look natural, and all the other colors look as they normally do.

People who go in for faithful color reproduction as a standard of excellence may or may not care what their pictures look like otherwise. There are those who put this standard at the top of their list and think of nothing else. Others see it only as a means to the end of making handsomer pictures. Still others see faithful reproduction as relatively unimportant, as something you may not even need. All of these points of view can be easily defended. Where you stand on the issue should depend primarily on what you want to do with your photography.

All you have read so far about filters, reciprocity correction, and the like should convince you that faithful color reproduction isn't always easy to achieve. Many see this as a great challenge and do their very best to prove that color films and papers will do all the things that Kodak says they will. If you are looking for a standard by which to judge your work, this one is as good as any.

Blue light and a red violinist, suggesting perhaps that he plays a hot fiddle. A slow shutter speed didn't freeze the action, so the man is somewhat blurred.
[Photo by Benton Collins]

The man, the mike, and the guitar form a triangle, which appears to float in dark space. He seems to be chewing the music as much as singing it.
[Photo by Ronn Kilby]

Dancing and singing, the music comes out loud and clear. The bright spotlighting permitted a shutter speed fast enough to freeze most of the action.
[Photo by Herbert Goodrich]

The camera moved and blurred the action. Thus we have movement and music, the two going well together.
[Photo by Ronn Kilby]

More camera movement and more blurred action —
suggesting perhaps that the music may be strange and
more than a little wild.
[Photo by Ronn Kilby]

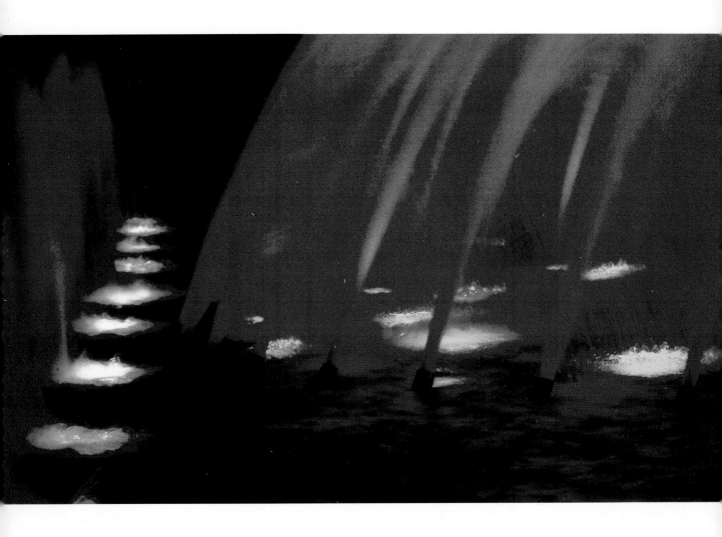

The red light shining on the fountain makes it look like fire, which is one reason for pointing colored lights at spraying water.
[Photo by Terence Knight]

Looked at directly, the fire is yellow. However, on the faces it is a rich red. The people sitting around it probably saw its light as white, but color film sees in a different way.
[Photo by Benton Collins]

This appears to be wax or glass. However, the color makes it look like solidified flame.
[Photo by Ronn Kilby]

• Stimulus to Memory

Most of the seven billion pictures made each year are designed as a stimulus to memory. Nearly all of them are family pictures destined for family memory files in the form of slides and prints. As great art they don't amount to much, but nobody cares in the least. Art is not the point; fond memories are.

The measure of a memory photo is whether it actually helps you to remember the thing you had in mind to begin with. Craftsmanship is not usually important, nor is a knowledge of the rules of composition. And it doesn't usually matter if your color balance and exposure are defective. What matters is memory, which leads us to the problem of coverage. If you really want to remember something—a children's party, for example—you should cover it from all angles. Otherwise, many of your memories will slip away from you.

Good coverage is not difficult to get, once you make up your mind to it. However, it does involve a liberal expenditure of film and flashbulbs. It also means looking for peaks of interest in the subjects and events you cover, some things being worth remembering more than others. The trick is to become personally engaged in the events you are photographing, so that you become a part of them as a reporter. With that goes the idea of recording all the action that you can.

As we have seen, the memory photo doesn't have to look like much—its main job is to aid recall. However, it should show people and events in as good a light as possible, for that is what we most want to remember. Aunt Gertrude should be smiling, and Junior should be fully visible on the other side of the campfire. Rover should be in sharp focus, so that he at least looks like a dog.

The only adequate judge of a memory photo is the person who is remembering. It is a waste of time to take it to somebody else. You may think I am leaving you without adequate criteria for judging your work, but in many cases you must be the final arbiter and make up your criteria as you go along. If your memory photos evoke memories, then you know you are getting somewhere. Who knows what you are remembering better than you?

• Accurate Description

You don't have to be engaged in photography very long before you discover that some pictures describe things and events more accurately than others do. Indeed, some photographs distort the world terribly—accidentally or otherwise. For example, it is possible to make a happy event look like a funeral, or make a handsome person look homely—you just have to wait for the right moment to click the shutter. On the other hand, some photographs record things with great fidelity. You can have distortion if you like—after all, you are the boss—but fidelity is a nobler goal.

Accurate recording isn't quite as easy as you might think. It requires intentionally trying to see the gist of an event that may be quite complex, then translating it to film. In some cases this is quite difficult to do and requires an astute eye. Most important: you have to be aware of what is really happening. For example, you should be aware that a certain "happy" party isn't very happy, or that the person you are talking to is lying through his teeth. That is, you should see the under side of the cake as well as the frosting. Moreover, you should see things impartially, which means not giving away to emotion or bias.

How can you tell if your pictures are accurate descriptions? Well, this is not so easy, for human judgment is often distorted in this sphere. The starting point is when you shoot your pictures—accuracy should be one of your primary goals. You should try to see what is actually going on in front of you, not just the superficial details. Then you should try to act like a faithful historian and record as balanced a picture of the event as possible. If you have such things in mind while you

are shooting, it will be easier to judge your pictures when you see them.

We used to have a simplistic view of this whole matter, for it was once thought that photographs cannot lie. Now we know they can lie like troopers and that the accurate recorder with a camera has to be sensitive, impartial, and dedicated to accuracy. Otherwise, his photographs will ring as false as any others. If you have this dedication you will probably find that your pictures are accurate more often than not.

Perhaps the best clue to accuracy is a feeling of wholeness in the picture. The event recorded seems all of a piece. Superficial things are there, but they have not been allowed to dominate. The picture itself tells you what is going on. Furthermore, you feel that you now *know* for sure what it is.

● **Stimulus to Thought**

The purpose of a picture may be to persuade people to think about something, usually the subject of the picture. For example, a picture may show ecological damage, and its purpose may be to make people think about how we are damaging our environment. Such a picture wouldn't be pretty, but that's not the point—destruction of nature is not a pretty subject.

There are innumerable things you might want people to think about, and each one would require a different approach. You should measure your success in terms of how successfully you have been in stimulating people to think along this line or that, which isn't as easy as it sounds. When you show photographs to people, they will often persist in thinking about everything except what you are driving at. Thus your points must have very strong emphasis.

To find out if you have succeeded in stirring up interest along certain lines of thought, you have to question those who look at your pictures. This must be done cleverly, because people will usually tell you what they think you want to hear.

Thus you mustn't let them know what kinds of answers you are looking for. Such an approach causes some people to clam up, so you must be prepared for that too. Patience is also required, because with the average picture it takes at least a half hour to find out where it led people's minds. You have to look at it for at least that long a time. Since people don't usually monitor their own thinking very closely, they may have to really dig to remember all the thoughts that were produced by a picture and to winnow out all the sidetracks taken.

● **A Specific Message**

Instead of merely stimulating thought, your photograph may be intended to convey a specific message. For example, you may want to say that misusing drugs is dangerous, or that children who play with matches may injure themselves. For such a specific message your photographs must also be specific. That is, things must be very carefully and pointedly spelled out, and all unimportant things must be subordinated.

Before embarking on such a venture you should know that photographs don't lend themselves easily to specificity. Most pictures contain so many things (objects, tones, lines, colors, etc.) that viewers are apt to think about many things other than what you are trying to say. Indeed, to effectively convey specific messages is one of photography's greatest challenges.

To see whether a photograph has effectively communicated the message you intended, you have to ask people how they reacted to it. Don't be surprised, however, if their answer includes everything except what you are looking for.

● **Fulfillment of Purpose**

A very popular standard for judging pictures is the fulfillment of purpose. If you propose to do something with a picture and manage to carry it

off, give yourself credit. This criterion doesn't question your purposes, which may be very personal, strange, or even objectionable. All it asks is that you fulfill them.

You may intend to make a picture that no one likes, a purpose strange but legitimate. Or you may wish to confuse people concerning what a picture is all about. Though these are rather odd things to do, you can consider yourself a success if you manage to do them. Except in fun, people don't usually try for such offbeat effects. Probably the commonest purpose in color photography is to make a pretty picture of someone you care for.

One of the chief advantages of the fulfillment-of-purpose criterion is that it leaves the whole world of photography open to you, leaves you free to try anything you please with the knowledge that you can consider yourself a success if you manage to pull it off.

I once knew a man who liked to use his photographs to start arguments among other photographers, and he was very successful at it. His approach was to simply violate all the canons of good photography that he could think of—except one: fulfillment of purpose. He proposed to disturb people and provoke them into quarrels, and that is what he did. It took a considerable amount of genius. Though his pictures were abominable, they were also resounding successes—in *his* terms.

Since there can be a nearly infinite number of purposes for photography, the fulfillment-of-purpose criterion is very broad. Depending on what you are proposing to do, you may or may not have difficulty in determining your degree of success. If you have made a beautiful picture, people will generally tell you so. However, there are many categories of purpose, such as provoking dismay or doubt, that tend to make viewers clam up for fear of hurting your feelings if they say what they think. There is another thought to be considered: many kinds of pictures leave people totally at a loss for words. They haven't the foggiest idea what to think or say.

● **Good Composition**

In an earlier day, people had great difficulty saying anything at all about photographs, so they went in strongly for composition because they could manage to think and say something about it. Composition refers to the way a picture is organized—things in front, things in back, the distance between things, the directions taken by lines and edges, centers of interest, and so on.

You can visualize the organization of a picture as something that can be changed, and photographers clutched these potential changes to their hearts because they had something to think and talk about. But times have changed. Because of their long experience with the visual media (mainly TV), people can now say more about images, but they still find composition important.

I can't tell you how to decide whether your compositions are excellent, acceptable, or indifferent—you either have an eye for such things or you don't. However, you can develop such an eye. In the meantime you can ask more experienced photographers what they think of your compositions. Since this is one of the few subjects that photographers talk about well, you are likely to get some interesting answers.

How much faith should you put in good composition as a criterion of excellence? Well, that depends on your pictures. Some images are made by good composition and require nothing else. More frequently, composition is just a means to an end. You want a picture to have a certain effect, so you compose it in a way that will produce that effect. If both the composition and your picture come off as you intended, you should certainly consider yourself successful.

The commonest use of good pictorial organization is to make pictures pretty or beautiful. When most photographers speak of pictures they usually do so in these terms. Indeed, some get carried away by the idea and go for beautiful compositions even when they aren't appropriate. For example, I know two photographers who,

working separately, proposed to show the miserable squalor of New York slums. However, both made well-composed and beautiful pictures, thus defeating their own purposes. Beauty and squalor just don't go together.

The thing to see is that composition can be handsome, so-so, or ugly, and that how you compose should depend on what you are trying to do in the picture. Though composition *can* be an end in itself, it is usually better to consider it as a means to some other end. For example, the way you organize a picture can make it more coherent—this might be your goal.

● Effective Propaganda

Perhaps you like to take sides on social issues and use your photography to support your point of view. Photography can be very good for this—it is an excellent instrument for propaganda of all kinds, good and bad. In this type of usage you should judge your pictures as propaganda and not as something else, since you are intentionally using them to make people adopt your way of thinking. Do you manage to pull it off?

In propaganda photography things are usually seen as either good or bad—there is no middle ground. As a photographer your job is to make "good" things look good and "bad" things look bad. Naturally, you have to have strong feelings about which is which. The fact that you may have accidentally chosen the bad guys instead of the good ones is not our concern here. The thing to see is that propaganda photography, good or bad, generally involves strong feelings in the photographer and is designed to evoke similar feelings in the viewer.

How do you tell whether your pictures evoke strong feelings in others? Well, your supporters may tell you so, and your enemies may tear your pictures off the wall. In the main, however, you have to rely on your own feelings as judge. If your pictures give you a belt in the stomach or bring a tear to your eye, you can be pretty sure

they are having an effect on others. The strength of the feelings is a measure of your ability as a propagandist. The term "propagandist" is slightly derogatory, of course, but people who run around rearranging society and the landscape are not usually concerned with fine points of delicate behavior. Battling for people's minds can be a brute business.

Do your photographs convince people that you are right? If so, it means that you are an effective propagandist, whether you like the term or not.

● Documentation

Photography can be used as a means of keeping records. It can show that certain things exist, how many there are, where they are, how they relate physically, their state of physical repair, what they are being used for, who is using them, and so on. Perhaps the main reasons for such documentation are to keep track of things, understand better what they are, and see what they do. Thus a photographic document is a compilation of visible evidence. It is a collection of data.

Though photographic documents are occasionally handsome, this is not the primary idea. If you are using a camera to make, say, a visual inventory of the contents of a warehouse, you shouldn't be in the least concerned whether your pictures are pretty or not. All that matters is the organization and completeness of your inventory. The visual data should all be there in a readily usable form.

Making something look pretty or interesting usually means juggling the visual information that it presents to you. It may be necessary to compose it, adjust the lighting, subordinate or eliminate certain details, choose an unusual angle of view, move things around, and so on. However, this is not the documentary approach. In a document you generally try to leave things the way they are without editorializing. It should have an impersonal quality, like evidence presented in court.

A great many photographic subjects can be treated in a documentary way—everything from a family vacation trip to an attempt to photograph a frog. The thing that mainly distinguishes a document from other types of photographs is your intent. If you intend to record information and subordinate other things in your pictures, you are chiefly a documentarian. Since documentary photography is highly regarded by photographers, you have a solid basis for respecting your work if your interests run in this direction.

How should you judge a documentary photograph? By the amount of pertinent information it contains. That is, there should be abundant information concerning the particular thing you have selected to record in a scene or event. For example, in documenting an old folks home you might gather photographic information about the old people and their environment with the intention of showing as accurately as possible just what it is like to live in such a place. Good documentation would involve impartially recording all the visual information one would need to form an opinion.

One way to judge a documentary photograph is to verbally list all the things you see in it. If the list is fairly long you know you have recorded a lot of data. The relative importance of the data doesn't have much to do with the documentation process as such. To document is simply to record. To assign importance to things falls within the realm of interpretive photography.

● **Interpretive Photography**

When you photograph something you can often interpret it at the same time. You can show its meaning, measure its value, place it in a social context, show its effect on things, etc. Generally, interpretation involves penetrating the surface of something in order to show what it is all about. Consider people, for example—they are always playing roles in order to give certain surface impressions. A photographic interpreter might try to get beneath these roles to show what people are really like, for better or for worse.

Nearly anything can be interpreted, which is about the same as saying that it can have its meaning expanded. A leaf can be seen as a symbol of nature; an egg, as a symbol of fertility; a machine, as a symbol of industry. One person can be seen as all people; a child's hand, as a symbol of all children; a pile of garbage, as a symbol for an eroded ecology. This list could go on forever. The field for photographic interpretation is very large indeed.

How should one judge an interpretive photograph? First of all, it should say something worth attending to. And it should say it in an appropriate way—forcefully, tenderly, subtly, abruptly, unemotionally, eloquently, etc. The means of expression should fit the message. A bitter message may call for an abrupt interpretation; a loving message, a tender one.

Furthermore, an interpretive photograph should make its point. There is not much point in interpreting things if nobody understands what you are talking about. Tell people what your pictures are supposed to mean. If they can readily see what you and the pictures are trying to say, you are probably getting somewhere. Even better, they may read your pictorial interpretation without your verbal help.

● **A Decisive Moment**

There are moments, usually very brief, when you can make a picture that will sum up a complex event exceptionally well. Something happens that describes what the whole event is all about. Capturing it on film is somewhat like compressing a whole movie into one frame. Some photographers are very good at this.

If you are good at capturing decisive moments you should give yourself a lot of credit. But how do you know when you have done it? Consider the old adage "One picture is worth a thousand words." Most pictures aren't, obviously, but a

213

few are. Successful pictures are like good books in that they start you thinking, your mind wanders in all directions, and every time you see them your mind turns off into new channels. Since they represent a considerable compression of ideas, they give rise to ideas whenever you look at them. Furthermore, you get the feeling that they are summations of events, and that they stand alone in their completeness. If you can make such pictures, consider yourself at the top of the photography ladder.

● **Self-expression**

Many people turn to photography as a means of self-expression. Though this is a very personal and private thing, they still need criteria to judge their progress. Self-expression doesn't necessarily have anything to do with the creation of beauty, so we can't always use pretty pictures as a sign of progress, though they are germane at times. I've known people who made ugly pictures in order to express themselves, but this is not usual.

The usual standards for judging pictures shouldn't apply to your efforts to express yourself. For example, you shouldn't judge your work in terms of prettiness, color balance, accurate rendition, correct exposure, and so on—unless they happen to be of considerable importance to you. In this case you should think about them. The only vital question is whether you are expressing yourself well, and this may have little or nothing to do with whether your pictures are good or bad according to the usual standards.

How can you tell if you are expressing yourself? Well, it's a good sign if you are deeply involved with photography. You wouldn't be if it weren't serving you as a means of self-expression. It is the nature of the medium to work very well for this purpose, and it does so almost automatically. You don't even have to think about it. Being deeply satisfied with one of your pictures is another good sign—you are probably expressing something positive about yourself. Being disturbed by a picture may mean that you are saying something negative, but it may also mean that you simply failed in something you tried.

Many things can be expressed through photography, including the yearning to create beauty, the desire to communicate well, the urge to master a technical process, the desire to own sophisticated machinery, the urge to record things visually, the desire to manipulate symbols, the need to possess things by photographing them, and so on. Indeed, photography has grown into a complete language, so that it will express almost anything that a language can convey. As I said, if you find yourself deeply involved in it you are probably expressing yourself very well. Precisely *what* you are saying about yourself must be discovered through self-observation.

● **Poetry**

Many people think of their photographs as poetry, which is entirely legitimate. But what is a visual poem? Those who use the term usually apply it to obscure pictures of driftwood, broken tricycles, moldy windows, weeping women, ancient doorknobs, empty park benches, dead birds, and the like. Since poetry itself is often obscure, it is all right to make visual poems with the same quality.

Ordinarily, visual poems are very handsome, though they don't have to be. They also have a kind of eloquence that moves the viewer. Perhaps the photographer's main intention is to quietly inspire his audience or help it transcend itself. However, with many a visual poem the photographer who made it is the only audience. His audience is to speak only to himself. Though this is legitimate, it doesn't help others to understand his photographs.

Most so-called visual poems have a quality of dead seriousness. You can see that the photog-

rapher was committed to creating art—which is perfectly all right. Creating art is a noble endeavor, especially if you are successful. And considering your own work as art is also all right, though one can be a little stuffy about such things.

How can you tell if your own photographic poems are successful? Well, people who dig poetry will usually like them—this is a good sign. So-called serious photographers will also like them. Most important, you yourself will think that your pictures are saying something, even if you can't explain what it is. When you feel strongly that you have created a visual poem, chances are that you are right.

In this chapter I have outlined some of the kinds of photographs there are and have given you some basis for judging your accomplishment in these realms. However, there are many kinds of photographs that weren't discussed, so you should leave yourself open to other critical standards.

Storage and Care
of Film and Slides

Photographic films are perishable products that can be damaged by heat, humidity, and harmful gases. Unprocessed color films are more subject to damage than black-and-white films, since adverse storage conditions can affect the three emulsion layers in different degrees, causing changes in speed, shifts in color balance, and changes in contrast. Moisture at any temperature may cause such defects as mottle, abrasions, and fungus.

To prevent damage, unprocessed color films should be properly stored before and after exposure. In temperate climates the precautions are few and simple. However, greater care must be taken in hot and humid conditions.

Processed films also need protection to prevent them from deteriorating. One insurance is to follow film-processing instructions very carefully, for the processing has a lot to do with the life of both transparencies and color negatives.

● **Store in Original Package**

Follow the recommendations printed on the package: "Protect from heat." Kodak amateur films (those not designated as "professional") can be stored at room temperature, provided the temperature stays at 70F. or less. These films are manufactured to permit this kind of storage. However, small changes do occur. If you wish to counteract them, refrigerate your film.

Kodak professional color films should always be stored under refrigeration, with the temperature ranging from about 55F. to below freezing — the latter is best. Professional films are designed to give their best results soon after the time of manufacture. To hold films at that quality level and to minimize the differences between emulsions, refrigeration is necessary. The cold stabilizes an emulsion, thus inhibiting subtle and not-so-subtle changes.

High relative humidities are usually more harmful than high temperatures. Thus film must be protected against moisture. With Kodak films the protection is provided by foil pouches, snap-cover plastic cans, or taped metal or plastic cans. While films are thus packaged they are quite safe from moisture, so you should leave them in their original packages until you use them.

Protect all color films from excessive heat. When traveling in a car keep them in an insulated bag or chest. Don't put the container in the direct sun or on a hot spot on the floor. If you are going to park your car in the hot sun for an hour or two, the temperature inside can reach 150F. — so take your film with you. If this is impossible, put it in the coolest part of the trunk. However, the trunk can also get very hot. If you are using a Kodak professional film, refrigerate it with dry ice or some other cold pack.

● Warm-up Times

If the package of a refrigerated roll of film is opened too soon, moisture condensation may form on the film surfaces — which might cause the film to stick to itself like glue, or some other damage. To avoid such problems the film should be permitted to come to room temperature before the package is opened. When you warm up a roll of film you should stand it on end by itself.

WARM-UP TIMES (HOURS)

	For 20F. Rise	For 75F. Rise
Roll film, including 828	$\frac{1}{2}$	1
135 magazines; 110 and 126 cartridges	1	$1\frac{1}{2}$

After you have warmed up the film, continue to protect it from excess heat and humidity before and after exposure. Despite the previous low temperature, high temperature and excess moisture can cause unsatisfactory results. Low temperatures and dry surroundings protect the film only when they are being applied.

● Protection from X-rays

If you are traveling by plane you may have a film-fogging problem due to low-dosage X-ray inspections, though only two or three doses should not cause visible results when your film is processed. However, if you expect more inspections in the course of a trip in which you change planes several times, you should ask for hand inspection by the security officials. When you are traveling outside the United States request manual inspection of unprocessed films. When mailing a package of film across international borders mark it "Unprocessed Film: Please Do Not X-ray." With commercial film mailers this isn't necessary, because inspectors generally recognize them.

● Protecting Film After Opening the Package

After you take film out of its package it is no longer protected from high humidity and harmful gases, which can cause undesirable changes in the latent image both before and after exposure.

You should not leave the film in your camera any longer than absolutely necessary, especially under adverse heat and humidity conditions. Your camera bag can get very hot in the sun, so you should keep it in the shade. Whatever you do, don't put your film in the glove compartment of your car on a hot sunny day. It becomes as hot as a furnace, so that in an hour or two the film is ruined as far as reproducing quality results is concerned. That is, the speed, color balance, and contrast are likely to be way out of line.

You should keep your film away from industrial gases, solvents, paints, motor exhausts, and cleaners, even if it is still in its package. The package will not be 100 per cent effective in keeping out these fumes over a period of time. Vapors from mothballs and mildew preventives have a harmful effect on films, so you should not store film in drawers and closets that contain these compounds.

Under very cold picture-taking conditions film may become quite brittle, so that it may break or the perforations rip out if you operate the film-winding mechanism too rapidly. This can also cause static discharges, which show up as marks on processed film. They look like flashes of lightning, little dots, or localized fogging. Operating the rewind mechanism too rapidly in cold weather will also cause these marks.

When you come indoors out of the cold there may be moisture condensation on your film (and on the lens too). Wait for it to disappear before either cocking the shutter or rewinding. This will

take at least a half hour. However, an ounce of prevention is even better—keep your camera warm outdoors by carrying it under your coat. Then you won't have the condensation problem.

Exposed film should be kept cool and dry. If the weather is hot and the relative humidity over 60 per cent, the film should be desiccated and kept under refrigeration, if any is available. If you can't desiccate your film, cool it anyway. Put it in a jar with a screw-on lid before putting it in the refrigerator (or the icebox you use when traveling by car). Make sure that the friction lid of the jar is on tight enough to make a good seal.

Though refrigeration helps a lot, you shouldn't rely on it any longer than you have to after your film has been exposed. In hot and humid weather you should dispatch it to your processing lab by air mail or air express as quickly as possible. Haste is especially advisable with Kodak professional films.

• Desiccating Film with Silica Gel

In climates where the relative humidity is moderate, the desiccation of films is seldom necessary. However, in exceptionally humid regions it may be highly advisable. Humidity does even more damage to latent images than does excess heat.

Silica gel is a convenient and cheap desiccant sold by numerous chemical supply houses. You can also buy prepared drying units such as those sold by Davison. Write to Davison Chemical Division of W. R. Grace & Company, 10 East Baltimore Street, Baltimore, Maryland 21202, for the name of a local distributor. These units are perforated metal containers holding about one and a half ounces of silica gel. There is a color indicator that turns from blue to pink when the gel needs reactivation.

Silica gel works by absorbing moisture from the air around it. It dries up the moisture released into the air by film, thus drying the film itself. Silica gel lasts indefinitely, though it does get to a point where it will absorb no more moisture. When this happens it can be reactivated by driving off the moisture with heat. Put it in a baking dish in the oven at 350F. For small quantities a half hour is long enough; large quantities may require several hours.

The idea is not to completely desiccate the film, for that would make it brittle, but to dry it enough to inhibit emulsion changes due to humidity. For five rolls of 620 or 120 film, one and a half ounces is enough. For five 135 magazines, 828 rolls, or 110 or 126 cartridges, one-quarter ounce is about right. The drying time is approximately two weeks, but your film may be on the way to the lab before that time is up. However, any desiccation you do will be helpful, even if the time is short. You can send your film right to the lab packed with silica gel. Though the gel won't be returned, it is cheap and expendable.

If you are using bulk silica gel it is good to make packets of it with paper napkins and tape—this will prevent the dust from reaching the film. For more permanent packets you can use fine muslin. After your silica gel has been reactivated, put a packet of it in a Mason-type jar with your film and screw the lid down tight. Magazines of 135 film and spools of 828 film should be removed from their individual cans. After the films have been dried for a while they can be returned to their cans for mailing.

For films that don't come in cans you can use aluminum foil to make airtight packets for your dried film. Fold the ends of the foil double and seal all the joints with waterproof adhesive tape. In such a packet your film will stay thoroughly dry.

Film to be shipped to a lab with silica gel should be put in a can, which should then be sealed with waterproof tape. If you use the bulk form of the gel, be sure there is no dust in the can. In other words, be sure that your silica gel packet is well sealed.

When not in use, reactivated silica gel should be stored in an airtight jar, where it will stay dry for long periods of time.

• Protection of Processed Films

Over a period of time all dyes in processed films undergo hue and saturation changes (sometimes to a considerable extent), mainly due to light, moisture, and heat. Faulty processing will also contribute to this deterioration. To delay these image changes, store your properly processed films in a cool, dark, dry place.

1. *Protection from Light:* You should avoid long slide-projection times, for the light and heat will cause dye deterioration. Where unavoidable, use duplicate slides, thus protecting your originals. Do not use a higher-wattage bulb than recommended for your projector, and do not remove the heat-absorbing glass. Be sure that the air intake for the projector cooling system is not obstructed.

When glass-bound slides are used, there may be moisture condensation on the inside of the glass. Combined with heat and light, this moisture is harmful to slides. However, it can usually be removed by storing the slides with activated silica gel.

Ektachrome films are more stable to light than Kodachrome films. According to Kodak, a slide made on Kodachrome will take from 250 to 500 fifteen-second projections in an ordinary projector before there is significant dye fading.

Color negatives should also be protected from light and heat. When a negative is in your enlarger, don't leave the light turned on any longer than necessary. And don't leave negatives on lighted illuminators for long periods of time.

2. *Protection from Heat and Humidity:* Slides and color negatives should never be stored in basements, which may be damp, or in attics, which may be hot. The relative humidity recommended by Kodak is between 15 and 40 per cent; and the temperature, 70F. or less.

One problem with high humidity is the danger of fungus growth, for fungi dearly love photographic emulsions. In humid areas it is advisable to have a moisture-proof storage box of some kind in which silica gel can be used as a desiccant. A large plastic picnic box that can be sealed with waterproof tape might do the job, and an equally good bet is a discarded half-size refrigerator, provided the seal is still good. Such containers will protect your slides and color negatives from outside air, and the inside can be dried out with silica gel. Remember that the gel has to be heat-dried from time to time in order to retain its effectiveness. Whatever form of container you decide to use, it should be kept in a cool place.

3. *Protection from Physical Damage:* Processed film should be kept as clean as possible. Keep slides and color negatives free of dust—the gritty particles can cause scratches. Handle films only by the edges, because fingerprints can etch themselves permanently into film. Store strips of film in special polyethylene sleeves made especially for photography—they give good protection against dirt and finger marks. Slides should be stored in boxes with tops to keep out dust. Photo dealers sell a variety of containers for 2 x 2 inch slides.

Processed films shouldn't be stored in ordinary envelopes, because impurities in the paper and glue used in making them will eventually cause the images to deteriorate. So it is best to use envelopes and sleeves made especially for photographs.

If you have carpet beetles in your home, protect your film from them, because they too dearly love to feast on emulsions. Do not store your film near moth-preventive chemicals, for they tend to crystallize on surfaces and will damage adhesives used in mounts. Nitrous oxide, hydrogen sulfide, and sulfur dioxide gases may cause slow dye fading. Keep slides away from hypo dust, which may cause dye fading after a time. Slide-mounting glass should be carefully cleaned before slides are mounted. Use plain soap and water.

Slides made on Kodak films should hold up for many years, provided they get high-quality pro-

cessing and are stored in the dark at temperatures less than 70F. and in a relative humidity of between 15 and 40 per cent. Under these conditions Kodachrome slides have the best dye stability — they should hold up well for fifty years or longer. However, Kodak Ektachrome Duplicating Film 5017 approaches the dark-storage stability of Kodachrome.

With original Ektachrome slides there may be perceptible dye fading after ten to twenty years. Color negatives kept under the conditions described above will make satisfactory prints for at least four to six years. Much longer periods of dye stability are possible for both slides and color negatives if they are stored under refrigeration.

4. *Long-term Keeping:* Processed film intended for long-term keeping should be dried with silica gel and frozen. A color negative treated in this manner should maintain satisfactory printing characteristics for several hundred years, and a transparency should hold up even longer.

Store your slides and color negatives with silica gel for about two weeks, then wrap them in three thicknesses of heavy-duty aluminum foil. Press all the air out of the package, seal it with waterproof electrical tape, and store in the freezer. Avoid excessive pressure on the film during the storage period.

When slides and color negatives are taken from the freezer they should go through a warm-up period (to prevent moisture condensation) before the package is unwrapped. The length of the period depends on the size of the package — an overnight warm-up is about right for a large package.

Before returning your materials to the freezer, dry them again with silica gel. However, if the room humidity is between 25 and 30 per cent or lower, this special treatment isn't necessary. In very dry climates this is likely to be the case.

● **Cleaning Films**

You can remove dust or lint from a slide or color negative with a clean sable-hair brush. To remove fingerprints or oiliness use Kodak Film Cleaner sparingly on a cotton wad. If you feel that your color films need special protection, coat them with Kodak Film Lacquer or its equivalent.

In this chapter we have covered basic information on the storage and care of film before and after processing. If you want your color materials to hold up well, you should use at least some of the techniques that were discussed.

● **Conclusion**

As you have seen, there is more to color photography than you might have supposed. Indeed, it is a very complex subject. This book simplifies things as much as possible, and at the same time tells you the basic things you should know in order to advance yourself in the art. I hope you find it useful.